Study Skills for Art, Design and Media Students

Study Skills for Art, Design and Media Students

Stewart Mann

University of Hertfordshire

Longman
is an imprint of

Harlow, England • London • New York • Boston • San Francisco • Toronto • Sydney • Singapore • Hong Kong
Tokyo • Seoul • Taipei • New Delhi • Cape Town • Madrid • Mexico City • Amsterdam • Munich • Paris • Milan

Pearson Education Limited
Edinburgh Gate
Harlow
Essex CM20 2JE
England

and Associated Companies throughout the world

Visit us on the World Wide Web at:
www.pearsoned.co.uk

First published 2011

ISBN: 978-0-273-72272-4

British Library Cataloguing-in-Publication Data
A catalogue record for this book is available from the British Library.

Library of Congress Cataloging-in-Publication Data
Mann, Stewart.
 Study skills for art, design, and media students / Stewart Mann. -- 1st ed.
 p. cm.
 ISBN 978-0-273-72272-4 (pbk.)
 1. Art--Study and teaching--Handbooks, manuals, etc. 2. Design--Study and teaching--Handbooks, manuals, etc. 3. Study skills--Handbooks, manuals, etc.
I. Title.
 N87.M27 2010
 707.1--dc22

 2010039432

10 9 8 7 6 5 4 3 2 1
14 13 12 11 10

Typeset in 10/12 Helvetica by 30
Printed and bound in Great Britain by Henry Ling Ltd., at the Dorset Press, Dorchester, Dorset

Brief contents

Brief contents

Contents

Contents

Contents

Contents

Contents

Dedication

Above all, many thanks to my past and present students, colleagues at the University of Hertfordshire, professional friends, and family who have supported me in the preparation of this book.

Foreword

'What university gave me was a desire to learn, a creative mind in problem solving, an ability to talk well about my work and to work well with others, along with a good degree to get my foot in the door.'

Graduate student

My experience of teaching practical and academic aspects of art, design and media, and supporting students in their studies, has demonstrated to me that students come to higher education with many skills. They have creativity, enthusiasm, curiosity and practical skills, but also uncertainty. They may not be sure how to organise a complex project or write an essay, how to prepare for a 'crit' of their work and how to use criticism in the development of their learning. This book brings together a discussion of the wide range of activities that you, the student, must undertake and the skills that are required to be successful at college and university, and in working in the creative and cultural industries.

For a rewarding career in higher education, take control of your learning by using this book and the experience of students and staff who have contributed to it.

Stewart Mann

How to use this book

Why this book?

This book focuses on study skills for art, design and media students. It provides a means to develop your skills across a range of areas that will provide benefit and support during your studies in higher education but also into your career ahead. It draws on students' experiences before university, as they tackle projects at the beginning of their studies through to preparing for a degree show, and on to a career and the workplace. It provides an introduction to key areas such as creative and critical thinking; practical and academic projects and how to develop and manage them; and how these are assessed. The technology and processes of specialist media are developing continually, but these core skills will help you to adapt to and maintain what is required to live and work in the changing world of the arts, design and media.

For you – the student

The book is divided into parts and chapters that discuss:

- preparation for study in higher education;
- what to expect at interview and when you start university;
- how to tackle day-to-day studies, practical and academic project work;
- how to understand the project brief;
- working in the studio;
- improving your research;
- reading and essay writing skills.

The book will:

- help you to reflect on your skills, take ownership of your learning and decide what skills you need to develop;
- introduce ways of approaching your art, design and media work as a creative and critical professional;
- provide an introduction to critical, cultural and contextual studies, with the key ideas, writers and theories explained and illustrated;
- discuss ideas, theories, concepts and student experience of specialist media;

- describe the assessment process and help you to prepare your work for it;
- discuss ways to help you to prepare for the workplace and your career.

It will encourage you to develop these skills, reflect upon your abilities and plan your learning to meet your personal aims. You can use the diagrams, charts and tables to demonstrate your organisational abilities and improve your grades as you present your work.

For you – the tutor

Higher education programmes demand much of our students, creativity, technical skills, organisation, academic writing ... As lecturers we have subject-based teaching at a demanding level in practice and in theory, but also many of our students are uncertain as to how to study at degree level. Do we teach study skills and if so, how much? This book is designed to cover the important aspects of study at degree level, both practical and academic. It provides an introductory primer of how to analyze and contextualise visual and media artefacts, explains theoretical and critical concepts and models for analysis using examples related to visual and media culture, and introduces aspects of practice and education applied to specialist media. It is written on the basis that all students will gain confidence in their abilities by using this book to further all aspects of their studies.

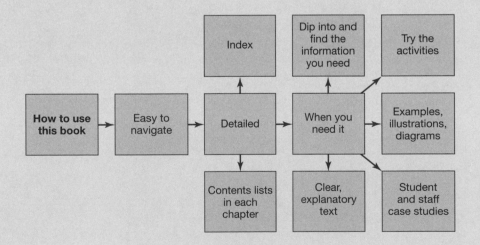

Finding the information you need

One way to prepare for university is to read the opening sections of this book to gain an understanding of what you can expect and what will be expected of you. The book is designed to be accessible and to help you to find the information you need quickly and easily.

There is a contents list and a comprehensive index to help you locate specific information, but each chapter also has an introduction describing its content, plus a brief summary of the chapter's contents. You will find numbered section headings, explanatory text, diagrams and checklists. Examples highlight key issues and worked examples, case studies allow students and staff to talk about their experiences, and if you want to try the activities you can put into practice ideas and techniques for your ongoing project work and assignments.

Acknowledgements

Thanks to Richard Adams, Sogol Agahairashti, Anitta Alexander, Richard Allen, Ben Anderson, Christopher Banks, Christiane Barbknecht, John Beaufoy, Matthew Beech, David Bell, Paul Bennett, Lindsay Bloxham, Katie Bristow, Yulia Brodskaya, Susannah Burton, Michael Carter, John Chapman, Nadra Chowdry, Beth Coles, Simmi Cropra, Alison Dalwood, Kate Easterling, Cathy Felstead, John Flyn, Jamie Field, Kate Ford, Emma Jackson, Jessica Kelly, Neil Gallagher, Kelly Gibson, Sarah Gilbert, John Gill, David Grover, Hinna Haider, Tom Hedges, Stephen Hunt, Joana + Farah, Lisa Hill, Elinor, Hayley Johnson, Catherine Jukes, Danny Lai, James Lee Kennett, Julian Lindley, Patrick Loftus, Debbie Longville, Ruth Marks, Joshua Marlow, Paul Miles, Jonathan Miller, Zara Paracha, Michael Parkin, Inan Phillips, Mark Prior, Diane Rafferty, Sharon Rosaleas, Sarah Pearce, Lorraine Perry, Jason Pogue, Rebecca Thomas, Anna Maria Reikonen, Norma Regault, Tony Rosella, Sharon Rosales, Emma Rudd, Heidi Saarinoen, Martin Schooley, Pal Simpson, Laura Joanne Smith, Laura Trinder, Anna Ware, Mandy Weeks, Michael Wright, Ekaterina Yyutyunnik.

Publisher's acknowledgements

We are grateful to the following for permission to reproduce copyright material:

Figures

Figure 11.7 adapted from *Film as Social Practice*, Routledge (Turner, G. 1993) p. 77; permission from Taylor & Francis Books (UK).

Text

Materials drawn from University of Hertfordshire documents, such as programme documents, student guides, and course projects, specifically: Electronic databases (p.60), Risk assessment (pp.88–90), Health and safety procedures (p.91), A project featuring the use of materials and equipment safely and creatively (pp.92–3), Marking criteria (p.104), In your writing (adapted) (p.110), Citation and referencing (adapted) (pp.115–19), Assessment criteria (pp.130–1), Work placement approval form (p.143), The brief assessment criteria in the Appendix (pp.293–4); with kind permission from the University of Hertfordshire.

In some instances we have been unable to trace the owners of copyright material, and we would appreciate any information that would enable us to do so.

1 Preparing for Higher Education

There are many things to be considered when making an application to your chosen degree course. You will have spent time selecting a university, carefully assembling your portfolio, attending an interview, considering finance and where you will live.

You have now been accepted. Congratulations!
What do you need to do and what will happen next?

Within this first part of the book you will find discussions on making a university application, the differences in approach compared with school and college, learning requirements and disabilities, joining instructions, arriving and orientation, the organisation of your studies and contact with staff. As part of your preparation for degree study there is a series of activities designed to help you to reflect upon your skills and identify where you feel you work well, as well as those areas where you need to gain experience. This idea of you reflecting upon your skills and taking control of your learning is an important part of the philosophy of Higher Education.

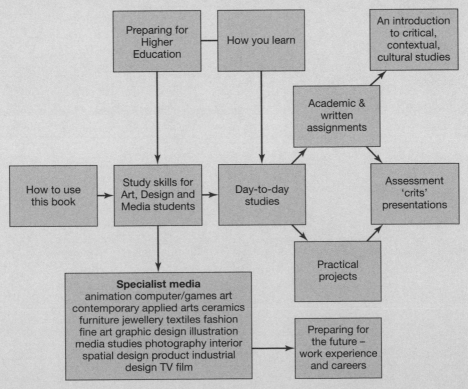

1 Before university – application and arrival

Students going into Higher Education come from a variety of backgrounds: they may be straight from school, from National Diploma courses and Foundation Studies in Art and Design at further education colleges, have worked for a period and wish to change career paths, have spent time undertaking child care, be retired and wish to pursue a particular interest or ambition, or from overseas and wish to gain experience of studying in the United Kingdom. They will be of different ages, backgrounds, experience, motivation and personal goals, and will be studying either full or part time.

In this chapter you will cover:

1. what to expect in higher education and how to prepare for it;
2. arriving at university – orientation and induction;
3. the university year and week;
4. communication with staff;
5. learning difficulties and disability.

USING THIS CHAPTER				
If you want to dip into this chapter	**Page**	**If you want to try the activities**	**Page**	
3 What to expect – differences between school or college and university	6	1.1 What you need to take with you	8	
		1.2 Key staff – contact details	16	
4 Your aspirations	7			
7 Students with disabilities and learning difficulties	9			
9 Induction and orientation sessions	11			
12 Communication – staff and you	14			

1 Application for higher education

You will have had a period of preparation and a decision to make on application to your chosen degree course and university. For some students the decision is based in part upon a need, or wish, to stay in their home area or to leave home for the first time. They will have visited possible universities offering courses in their chosen subject area, formed impressions about suitability, researched reputations, completed UCAS (Universities and Colleges Admissions Service) application forms, prepared portfolios and been for interviews. Where students cannot visit in person, most universities offer virtual tours on their websites that give an impression of the site.

Figure 1.1 shows you all the aspects involved in your decision to go to university.

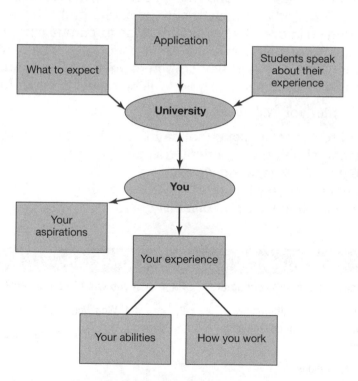

Figure 1.1 An overview of your university experience

'Following sixth form I worked for a year as a technician on gaming machines to help finance my education. I did A levels in Art and Design, Photography, English Language and Maths.'

'I did art at school but never saw it as more than a hobby. When the children were at school I did painting and drawing classes but for only two hours per week, but followed on with a part-time Foundation Course and decided to go on, having enjoyed it. On reading the syllabus and visiting for the open day I considered fine art, but there the emphasis seemed towards sculpture, video, photography … and I did not want to do that. Applied Arts had the things I wanted to do. I would call myself a "hands-on" practical person and I like to make things.'

'I worked in Berlin on an unpaid placement in theatre on props and make-up and was supporting myself through stacking shelves in a supermarket, cleaning and working in an art gallery. I decided I needed to study and develop my interests and applied to study in England. I sent slides and an essay and was accepted. I was not able to visit the university, but the virtual tour allowed me to view the facilities.'

'I did an HND (Higher National Diploma) before I came here and so I did have many of the skills that were needed for the course, but the way of thinking and the emphasis were different. I entered the second year and I had quite a lot to get used to, and I did not feel ready to deal with some of the demands. Buildings, staff, people and ways of working are different between different colleges or universities and it does take time to get used to. Others in your year have had a year to get used to it.'

Student Experiences:

My decision and interview

'I visited the university on an open day and 'liked the vibe' – the tutors were friendly and I liked the student entertainment areas. I was interviewed by one member of staff and it was not as nerve-racking as I had thought it would be. They looked at my work and asked how I approached it and my other interests. I do have a real interest in design as it is in the family.'

'I came to interview and it was less formal than I had expected and I brought a portfolio of my work and this included 3D work. My teacher encouraged us to do things that were different and did not make us sit down and draw all the time. I had made a life-size figure by casting a friend of mine and also large foam sculptures of ordinary objects such as a toothbrush.'

'There is a very diverse range of experience of students and the first year is about bridging these gaps. I am taking marketing as well as this adds to the possibilities after university. I have a small child and I am finding the costs high.'

2 Before joining

Some students will have visited the university of their choice during degree graduation shows (this is a good time to visit as you can view students' work and it can give you an insight into what you can aspire to), open days or at interview. Talk to students if you can and you will find they are willing to give the inside story on their experiences.

At interview, make sure you are aware of the nature of the programme you wish to join and think about questions you can ask staff when you are with them. From this you can build up knowledge of the course ethos and how it is run.

3 What to expect – differences between school or college and university

There are many aspects involved in your arrival at university, as shown in Figure 1.2. What differences should you expect between this and school?

- There will be more people.
- Students will come from a wide age range – from teens to 70+ – different national, ethnic, religious and cultural backgrounds, and some will be living away from home for the first time.
- Students will have different interests, aspirations and expectations.
- Generally there will be large campuses.

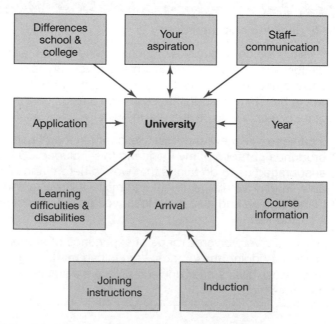

Figure 1.2 Things to consider before and on arrival at unversity

- You will get less individual attention.
- You will see less of your lecturers.
- You will encounter different teaching styles and methods – e-learning and distance learning.
- There will be contact with visiting lecturers and representatives from industry.
- You will frequently work with other students, at varying times and in different groups.
- You will work with other students independently and support each other.
- You will be expected to organise your time and take responsibility for and manage your own learning.

4 Your aspirations

From the beginning it is worthwhile considering your aspirations and expectations. Reflect upon your abilities and skills so that when you enter higher education you will have considered your strengths and weaknesses and will be able to build upon your experiences and achievements.

Ask yourself: who is the real you?

- How would you describe yourself?
- What do I do well?
- What do I find difficult?
- What do I need to do?

Be self-critical, but not negative.

(See Chapter 2 *How you learn* p. 17.)

5 Joining instructions

Once you have accepted a place at university you will receive joining instructions, which you must read carefully. These will include a list of documents you will need to take with you, including:

- a means of identification;
- copies of correspondence;
- evidence of your qualifications;
- details of accommodation in halls, on and off campus, and what you will need to bring with you (for instance, is linen supplied or are cooking utensils provided?);
- advice on dates for joining and details of support services, such as medical facilities (if you have special needs you should inform the university to enable them to make any necessary arrangements);

- details of student support, such as counselling and financial advice;
- information on the course you will be attending.

There will be additional information for overseas students, which will include advice on travel, visa requirements and aspects of what to expect when living in the UK.

Talk to the university of your choice if you need to apply for funding through the Disabled Students' Allowances (DSA) before you arrive as this will speed things up so that support is ready when you start your course.

(See *Students with disabilities and learning difficulties*, p. 9.)

6 Course information

The course information you will receive from your chosen university is designed to provide you with an indication of what you will need in order to get off to a good start. Read it carefully. It will advise you on the following:

- equipment or materials that you might purchase before joining. If there is a particular specification, make sure you follow it as there may be an issue of compatibility with systems such as software used at the university;
- equipment or materials to purchase on arrival, when there may be discounts available through the university. If you are unsure, wait and talk to your tutors so that you get the most appropriate equipment for your course, and perhaps for your future professional life;
- whether you need to bring any of your work;
- a project to undertake before you join the university – this may have the purpose of providing material to work with at the beginning of your course.

ACTIVITY 1.1 What you need to take with you

You will require documents, specialist equipment and perhaps examples of project work when you join your university course. A checklist may prove helpful to ensure you have what you need.

Checklist –
Documents

Equipment	Have already	Need to purchase
Project		
Previous work		

7 Students with disabilities and learning difficulties

The system for support for students with disabilities or specific learning difficulties such as dyslexia is based upon the Disabled Students Allowances, which are directed at individual needs and centred on the student. The UCAS application form provides an opportunity to declare any disability or learning difficulty and universities will have a Disability Support Officer who should be contacted initially. They can advise you on the nature of support and can organise support around your study needs.

Funding is through the DSA and has to be applied for by the student, who will need to provide evidence of the nature of their disability or specific learning difficulty. For example, with dyslexia there is a requirement for a recent educational psychologist's report followed by a needs assessment on what is required to support learning, such as dyslexia software and one-to-one specialist study support. This can take time, so it is advisable to initiate the process by making an application some time before the academic year starts and the support can then be in place when you join the university.

Within further education the funds are directed to the college, with the college providing support directly, whilst within higher education the funding is allocated to the individual student.

Example

DISABILITY SUPPORT

'When a student with a disability is accepted on one of our degrees we invite them as early as possible to discuss their needs. We have made arrangements to support students, such as a Fine Art sculpture student who was visually impaired, a Graphic Design student with Asperger's syndrome, a photography student who uses a wheelchair, and there are a significant number of students with dyslexia within the art school. The disabilities are varied and we make an agreement with them as individuals as to the nature of study support needed. It is important that they contact us as soon as possible so that we can advise them on making an application for the Disabled Students' Allowances.'

Disability Support Officer

8 Arriving at university

You may be arriving from overseas or from another part of the UK, or alternatively travelling from home, but early on things will tend to be confusing for you and other students who are joining. Remember, however, the university staff will endeavour to ensure as smooth a transition as possible. Certain registration processes may be available online and you should use these if possible.

At some universities first-year students are scheduled to arrive one week ahead of returning students, which gives staff an opportunity to concentrate on helping new arrivals to settle in.

Student Experiences:

At first I was homesick

'At first I was very homesick and missed home, but now I live in a flat on campus. My flatmates and I get on very well and are moving to a house next year. We knew a little about each other at the beginning because we were informed by the accommodation people at the university as to who we would be living with and we set up contact through Facebook before we arrived.'

9 Induction and orientation sessions

There will be university-wide orientation sessions, such as how to find central services, and details of freshers' weeks, which feature social events and the array of societies run by students through the Students Union.

You will need to consider what you wish to engage with at this stage. Your academic work will be of primary importance, but there are other aspects of university life that can be both rewarding and career enhancing. Most Art, Design and Media students will have initial and developing skills that can be applied in many contexts. It is worthwhile considering your long-term goals and how you can give your CV that something extra, such as volunteering within the community, working on publicity for a society or the Students' Union, sports activities or extending your work experience and earning money to help you support yourself.

Think carefully and be selective.

You will be issued with an *identity card* and you will be expected to carry it with you – it may be required to gain access to facilities, as a form of credit card for university purchases and as the means for you to register your attendance. Keep it safe as you are likely to be charged for a replacement. You will also be issued with a university email address and this will be used to communicate with you at a personal level.

There will be *student guides and handbooks*, which detail important information about your studies and the university. These will cover a wide range of issues, from details of your responsibilities, including a code of conduct for students, to assessment information such as handing in coursework, the grounds for asking for an extension to a deadline and how examination boards are conducted. There will also be health and safety issues and information on how to access counselling services. Keep these guides, refer to them, you may need them later.

Course induction

Your school or faculty will also have specific induction sessions, usually organised by the teaching team. These will include tours of facilities, meeting key staff, undertaking group orientation projects and meeting fellow students. You will be at a disadvantage if you miss any of these sessions as it will be assumed that you have received this information. If you do miss them for any reason you will be dependent upon your fellow students to fill you in on what has happened and you will need to ask staff for any handouts, such as student guides, for future reference.

There will be some waiting for things to happen, but all new students will be in the same position, and staff will endeavour to make you as welcome as possible.

> **Student Experiences:**
>
> **The first project**
>
> 'When I arrived I was quite nervous, but we were put into groups of four for a project, which was to illustrate what we had done through the summer. We included various things that we had done, like jobs and holidays, and then finished with the university logo. We had to present it to the whole year and five tutors and there was a vote for the top three.'
>
> 'I was attracted to studying in England because the teaching approach seems much more relaxed. The induction programme was great fun and helped us to get to know each other. As I was from overseas I had felt nervous, but this got me talking to people. We were divided into groups and had to work together to build a tower out of wine gums and spaghetti (it was dry), designed to be as tall as possible but to support a specific weight. We also had to design packaging for eggs so that they would not break when thrown and the staff had to catch them!
>
> I joined the Students Union and the clubs and this also allowed me to meet people from different parts of the university. I also work as a student ambassador, which means I show people around the University on Open Days, and this helps with my expenses.'

10 How degree courses are organised – credit-based systems

Degree study in most universities is delivered at levels four (first year full-time study), five (second year full-time study), and six (third year full-time study). Part-time study requires the same study time but is spread over a longer period. For each unit or module of study that a student completes successfully, credit is awarded at the appropriate level. The system generally employed in the UK is based upon the successful completion of 120 credits per level of study over an academic year for an honours degree or 90 credits for an unclassified degree.

Study content is divided into self-contained modules of 10, 15 (single modules) or 30 credits (double module). If the work for the module achieves a pass grade, the total credit is awarded independent of the level of the grade. If the module is failed then no credit is awarded. A student builds up credit of the required level to achieve a given full degree, including successful completion of all levels. Once the study is complete, a formula based on the pass grades will be used to arrive at the degree classification – for example, high grades will result in a second- or first-class honours degree, with lower grades resulting in a third-class honours or an unclassified

degree. If for any reason a student has completed only part of a degree programme, a Certificate (level four) or Diploma (level four and five) of Higher Education can be awarded.

11 The university year and week

The university year is divided into terms – autumn, spring and summer – and most universities organise their academic year around two semesters, with modules of study running for one or two semesters.

During a typical university week you will be expected to work on your academic studies from 35–40 hours per week. Teaching time in contact with lecturing staff will vary according to the subject and the stage you are at in your course. This may vary from 5 hours up to around 20 hours per week. Many programmes provide more teaching time at the early stages as students settle in and less as students become increasingly independent in their study.

A 15-credit *practical module* might typically be divided into:

- 5 hours – lecture (briefing, contextualising lectures);
- 1 hour – seminar /tutorial (progress and feedback tutorials);
- 10 hours – workshop/practical instruction;
- 134 hours – independent study (including research, design development and making in the workshop).

Total 150 hours of study time.

As this illustrates, there is a significant amount of time available to you to use as you wish, so you need to organise yourself and manage your time.

There will be practical sessions featuring the following:

- **briefing sessions** – most important so that you know what you have to do, these help you to gain understanding of the language and meaning behind the project brief;
- **studio sessions** – at certain times you may be expected to be in a studio space and staff may be there to discuss what you are doing as you work or to give technical help if you need it;
- **workshop induction/instruction** – these may be obligatory to teach you how to use equipment and processes safely;
- **critiques** – these give you feedback on the work you have done.

There will be lectures:

- size from 25–300 people;
- varying from 1–2 hours;
- some requiring attendance, some being optional.

There will be seminars:

- size 10–30 people;
- varying from 1–2 hours;
- requiring preparation and involving discussion.

There will be tutorials:

- individual and small group;
- varying from minutes to an hour at the most;
- to discuss your progress on an individual project or essay, or to give feedback on completed work.

Make full use of everything available to you. If you do not attend sessions, it will be you who loses out.

Registration will be required on a weekly basis to prove you are at the university and to note your attendance at individual teaching sessions. You will be expected to work independently at times and this may be in the studio or learning resources centre (LRC) or library, at home or away from the university. Apart from scheduled sessions you will be expected to organise your time to get the work done and to meet deadlines.

12 Communication – staff and you

How will lecturing and administration staff communicate with you?

- By noticeboard.
- By intranet – this will provide a means of access to your course information, study guides, access to the LRC and emails using your university email address.
- By letter – usually when it is important that you are informed of something. Make sure you let the administration know of any changes to your address or telephone numbers so that you can be reached if required.

How will you contact staff? Administrative staff offices will have scheduled hours of opening and for many enquiries they will be able to help you:

- by email to individual lecturing staff;
- by telephone – but remember, staff are not always in their offices as they have a wide range of duties, both on and off campus. To be sure of seeing lecturing staff you may need to make an appointment.

Example

STAFF YOU WILL MEET

You will come into contact with the following:

- **Programme/degree course leader**: would normally be full time and would have responsibility for the organisation, content, delivery and assessment of your degree.
- **Administrative staff**: have a wide variety of duties, such as reception, maintaining student records, preparing assessment information for examination boards, university finance and acting as a liaison between students and staff or university services. Normally, administrative offices are open during office hours and may well be the first point of contact when you need information, help or to report your absence due to sickness.
- **Lecturing staff/tutors**: depending on the number of students there will be further contracted staff who may have a proportional post, for example 0.5, 0.75 up to a full-time post. They will have responsibility for particular aspects of the course, such as a subject area and/or a year group, or to perform the role of personal tutor. These staff will be available on a regular basis and can be expected to have detailed knowledge of the programme and university procedures. They will also have various duties that they undertake during university vacations.
- **Visiting lecturers**: are contracted on a temporary basis that may be for a few hours for a specific session, or teaching a whole semester, which may total approximately 3–9 hours a week. They tend to have specialist expertise and work in industry at other times. They will have been trained to undertake their academic duties but may not have detailed knowledge of wider university procedures.
- **Module leaders**: are responsible for the organisation, teaching, assessment and student progress within individual modules.
- **Technical staff**: provide technical support and are usually responsible for workshops, darkrooms, print rooms and other facilities and have detailed experience of particular media. They are usually employed on a full-time basis.
- **Study support staff**: will be qualified to support students in a number of ways in areas such as developing skills in English (for students with English as a second language), academic writing skills and working with students who have disabilities.
- **Senior staff**: may have various titles, such as head of department or school, dean, pro vice chancellor, vice chancellor, and have responsibility for the running of the various units and developing the policies for the university. A vice chancellor will have responsibility for the whole university. Students do not generally come into contact with these staff on a day-to-day basis unless they become involved in the committee structure for the school or student forums which address issues of student concern, at which some of these staff may be present. In addition, there will be senior staff who chair examination boards which have responsibility for the conduct of assessment and there will be a published process of communication if they need to be contacted.

ACTIVITY 1.2 Key staff – contact details

It could be helpful to make a note of the details of key members of staff.

Key staff/contact numbers	Name	Phone number/ extension	Email
Course administrator			
Programme tutors			
Year tutor			
Personal tutor			
Chair of examination board			
Other staff roles			
Emergency numbers			

To sum up

You will need to:

- prepare for the new experience of higher education;
- familiarise yourself with different ways of working, staff and methods of communication;
- remember that successful participation in Higher Education will change you!

2 How you learn

A key difference between higher education and other modes of study is that you will be expected to consider your skills and abilities to develop an approach to your learning with decisions made by you, for you and related to the requirements, both academic and professional, of your subject area. To do this, a process of self-evaluation is required. This will enable you to get the maximum out of your degree study.

In this chapter you will cover:

1. how to find out about yourself and how you work;
2. your learning requirements;
3. what is expected of you;
4. how to identify skills you need to develop and develop action plans
5. taking responsibility for your learning.

1 Learning to learn

It may sound strange to be discussing the idea of *learning to learn,* but in higher education students are expected to make decisions for themselves as to how they approach their studies – a different concept for learning than is applied at earlier stages of education.

Rebecca Attwood in her 2009 *Times Higher Education* article, quotes Professor Alison Halstead, a Council Member of the Higher Education Academy and Pro Vice Chancellor for Learning and Teaching Innovation, Aston University: 'Learning how to learn' is the single most important teaching objective for universities as they prepare for (the) 21st century. Today's students need much more than knowledge of their subjects. This statement is made in the context of earlier educational experience where knowledge is presented in a ready-made form with the aim of passing examinations and 'this takes them (students) further away from being independent learners.' (Attwood, 2009).

The learning cycle

The Greek philosopher Confucius (551–479 BC) is quoted as stating:

I hear and I forget

I see and I remember

I do and I understand.

Practitioners working within the arts, design and media see and do, and we learn best through the experience of seeing and doing (Figure 2.1).

Consider the learning cycle and see how this reflects your process of working. Effective learning depends on a number of factors, including your interest and engagement with the subject, your wish to progress and develop your potential, and taking responsibility for yourself and your learning. You have ambitions towards advanced study and a future career, and this is dependent upon you, the student, taking control of your studies.

Ownership of your learning means that you make decisions for yourself and how you undertake your course work (Figure 2.2). Staff will provide a structure and content for your course of study, but they will expect you to consider what you know, and what you need to know, in order to undertake the work. You will need to assess your strengths and weaknesses through a process of initial and continuing self-evaluation and appraisal. On the basis of this understanding you will be able to manage your learning as demands change and you advance through your programme of study.

Figure 2.1 A learning cycle

Figure 2.2 Learning to learn

2 Know yourself as a learner

There are various stages involved in getting to know yourself as a learner, as Figure 2.3 illustrates.

Figure 2.3 Know yourself as a learner

Start off by stepping back to assess your abilities objectively, not negatively but realistically. See Figure 2.4. On this basis you can make reasoned judgements about your development and learning requirements.

Planning for personal development

Universities are required to provide a system of personal planning and development, often online, with the aim that students should be in a position to set learning and career goals and plan their studies to achieve them. Start using the personal planning system at the beginning of your university career and then at regular intervals. The information you record can be used when you start developing your cv.

(See *Preparing for the future – work experience and careers*, p 134.)

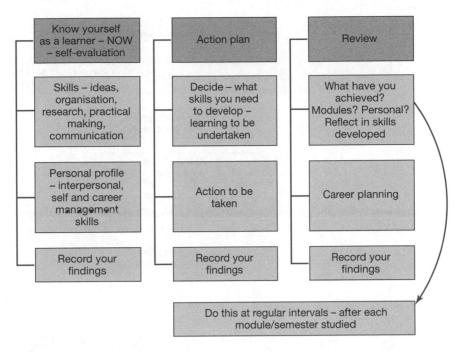

Figure 2.4 Review your learning regularly

Student Experiences:

Early on I learned to take responsibility

'One of the most important things I learned early on was that I had to take responsibility for what I did. Lecturers did not give detailed instructions on what we had to do at every stage, we had to decide how to approach the project, organise ourselves and then to give reasons why we had worked that way. When that was clear I understood what was expected of me.'

You will need to consider the issues outlined in Figure 2.5.

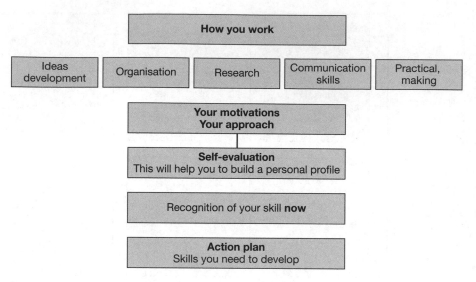

Figure 2.5 Take time to consider how you work

3 Self-evaluation: your ambitions – your choices

Undertake the following activities, answer the questions and reflect on you, your approach and your skills. This will take time but will lead to greater understanding as you approach a new experience and as you progress through your studies.

ACTIVITY 2.1 Your ambitions – your choices

You have made a number of choices and decisions about what you want to do and then have worked towards gaining a place at university. Take time to consider what you need to do now and what you would like to do in the future as you start your degree studies. What are your ambitions and choices and why have you made them?

I have ambitions to

I wish to start/continue my studies because

I have chosen to study the following media:

because

My options are

I have researched possible course choices and have chosen this university

because

I hope to develop the following skills:

I hope to develop as a person in the following ways:

I have considered how I work best:

My long-term career goals are:

My main skills are:

To sum up:

Experience			Skills	Timescale	
Little or no	Some	Significant		Immediate	Long term
			I am considering my career choices		
			I have considered the skills that I wish/ need to learn to forward my aspirations/ career goals		
			I am considering my options – and choice of university		
			I am clear as to my reasons for going to university		
			I have decided on what I need to do to prepare for university study		
			I am clear as to how to apply to university		
			More…		

I plan to:

How will you do this? What are your strategies for gaining these skills?

4 My approach: my motivations

We are all individual in the way we approach our studies and we all have our hopes and anxieties about the work we undertake. Will we cope with the demands of our course? Think about how you have worked in the past: what are your strengths and difficulties and where can you improve them? Make use of discussion with fellow students and criticism and suggestions from staff. By doing this you are assessing your abilities and recognising what you need to do in the future. This is an important factor in managing your learning and achieving your goals.

Reflect on why you are undertaking study in art, design and media, what you hope to gain from your time at university, how you approach the experience and your priorities.

Consider your motivations:

- To gain knowledge and skills related to my subject
 - Art, Design and Media courses require maximum commitment – this will be expected as a minimum;
- To get good grades
 - doing what staff 'want' does not guarantee this. You will have to make your own judgements and give reasons for your decisions;
- Just to do enough to get through
 - this may be your choice due to other commitments, but remember, your employment prospects will depend on the work in your portfolio and the breadth of your experience.

Consider your worries:

- I will not be able to cope with the demands of the course.
- I dread giving my opinions and talking in front of a group of people.

Answer Yes or No to the following:

- I look forward to the challenge of new things.
- I am open to new ideas.
- I like meeting new people and sharing ideas.
- I understand better when someone tells me about an idea or a subject.
- I understand better when I read and work things out for myself.
- I do not always understand the basis of criticism of my work.
- When I do not understand criticism I ask questions.

ACTIVITY 2.2 Motivation and concerns

Have you considered how you think and work and where you have concerns about your ability to cope with higher education? Having reflected on these you will have a greater understanding of the skills you may need to develop and will recognise areas of potential difficulty. What are your motivations and concerns?

Describe in positive terms your most important motivations and concerns about study.

My approach
I work best when…
My main skills are…
To sum up:

Experience			Skills	Timescale	
Little or no	Some	Significant		Immediate	Long term
			Taking on new things		
			Meeting new people		
			Using criticism		
			More…		

I need to develop the following skills:
How will you do this? What are your strategies for gaining these skills?

5 How I work

We all work differently and you may find it of value to consider whether you are a quick starter or a careful planner.

Are you a **quick starter** – who gets on with the first idea? This could mean you may not:

- explore and experiment in depth;
- give time to develop other ideas;
- be able to sustain a project over a period of time.

+ plus points

- You will be good at brainstorming
- or short-term projects and make quick decisions.

– minus points

- You may have difficulty in sustaining and developing the full potential for long-term projects.

Action: Develop a plan of what you need to do that provides ample time for exploration and research.

Are you a **careful planner** – who likes to explore all possible ideas and research the topic? This could mean you may:

- see many possibilities;
- hesitate to commit;
- have difficulty making decisions.

+ plus points

- You will be good at undertaking long-term projects, which require investigation and in-depth exploration.

– minus points

■ You may have difficulty meeting certain deadlines.

Action: – Develop a time plan, which gives a series of personal deadlines for decision making, and stick to it.

(See *Organisation and planning*, p. 75.)

Student Experiences:

How I work

'I like to get going as soon as possible when given a project. I work in ceramics and enjoy using the materials. The problem is that the process of making takes a long time with use of the clay, throwing, firing and glazing, and my tutors have said that the way to improve the work is to spend more time thinking about the idea.'

'As part of our course in graphic design we are sometimes given three-hour projects to get us used to working quickly as in industry. We are given a topic and have to present our ideas on that day, having decided which is the best one. I have had difficulty presenting my ideas clearly and am working on visualisation techniques, working with markers.'

'I am undertaking a major project which requires studio still-life photographs of food for a cookery book. I have researched many of the books, looked at celebrity chefs and how they work, design and layout, and the style of the photography. I need to decide what atmosphere is right for the type of food I have chosen and experiment as to how to produce it. There is still so much to do.'

(See *Approaches to project work*, p. 62)

6 Ideas

Do you consider your self an ideas person? Do you struggle to get going at the beginning of a project? Much creative thinking starts with a problem to be solved and a number of authors have described techniques for approaching ideas development, both as individuals and in group work. It is of real value to consider your approach.

(See *Ideas development – creative and critical thinking*, p. 70.)

ACTIVITY 2.3 How I work – ideas

As individuals, we will have different approaches to the development of ideas as part of the creative process. In reflecting on our experiences we can consider how we work best and where we can develop alternative ways of thinking. How do you develop your ideas?

Ideas	+ or – Action needed?
■ Many come quickly	
■ Hard to decide which idea to develop	
■ Struggle to start	
■ After research they start to come	
■ An idea comes and I develop it immediately	
■ Other ideas come from it	
■ I like to develop my own ideas	
■ I do not see the need to look at other people's work	
■ I sometimes become dissatisfied with my ideas and want to start again	
■ I like to develop the idea and then select the medium or materials	

I work best

If I can talk about my ideas

On paper using these materials:

Using the following software:

With a camera to explore and record my ideas/using the following materials/techniques

My main skills are:

To sum up:

Experience			Skills	Timescale	
Little or no	Some	Significant		Immediate	Long term
			Ideas development		
			Methods of recording my experiments		
			How to evaluate my ideas		
			How to evaluate ideas in other people's work		
			More…		

I am not confident of the best way to explore and express my ideas and I need to develop the following skills:

How will you do this? What are your strategies for gaining these skills?

7 Organisation

There are different views on the relationship between organisation, planning and creative work. Creativity can be seen as something that happens spontaneously and instantaneously, and pre-thought would impede this process. The counter argument is that by planning and organising ourselves, particularly for long-term or more complex projects, we make free space in which to allow our imagination to work.

Student Experiences:

Organisation

'As students advance in their studies, one of the key areas of importance is developing the ability to organize themselves and their work. Frequently there is a great deal going on, both personal and course based, and they need to think about the way they work best and where there are areas which have caused them difficulty in the past. This needs to be ongoing as demands change as the course progresses.'

College lecturer and personal tutor

ACTIVITY 2.4 How I work – Organisation

There are many qualities needed to be successful within an educational career. How we plan and organise ourselves is important in meeting the demands made on us as we undertake our course. How well organised are you?

Organisation I tend to	+ or – Action needed?
■ start quickly, reach a stage and struggle to continue	
■ start quickly, then understand the problem more clearly as I work and may have to go back and start again	
■ move from one task to another and have difficulty in completing any of them	
■ spend too much time making lists of what I should be doing	
■ start organised and struggle to keep track of the work	
■ do the most interesting and enjoyable things first	
■ do the hardest or most important things first	

Answer Yes or No to the following:

- ■ I like to plan my work in detail.
- ■ I aim to be systematic when I try to solve a problem.
- ■ I like to follow my instincts and work spontaneously.
- ■ I think planning gets in the way of creative work.

I need to develop the following skills:

How will you do this? What are your strategies for gaining these skills?

8 Time management

An important factor in the management of your study is how you use your time. You will know if you tend to have problems in meeting deadlines, or that you work most effectively at a particular time of day. It is worth reflecting on this as it makes for more effective use of your time.

Answer Yes or No to the following:

- I work best in the morning.
- I work best in the evening.
- I work best at night.
- I can work well at any time.

ACTIVITY 2.5 How I work – time management

There is a lot happening and you will need to manage a variety of demands. Students frequently report in their self-evaluations that if they had managed their time better they would have presented a better project or assignment. How can you improve your time management skills?

Time management	Yes / no Action needed?
I have problems in ensuring that I make enough time for work, leisure *and* pleasure	
I think I waste far too much time	
I tend to work in short bursts, doing a great deal one week then very little the next	
I put things off until the last moment and then have to work all hours until I finish	
I need a deadline to get me working	
I work best to deadlines	
Deadlines make me panic	

My main skills are:

To sum up:

Experience			Skills	Timescale	
Little or no	Some	Significant		Immediate	Long term
			Planning projects		
			Organising short-term projects		
			Organising long-term projects		
			Assessing how I use my time		
			More…		

I need to develop the following skills:
How will you do this? What are your strategies for gaining these skills?

(See Approaches to project work, p 62.)

9 Research

There are a number of synonyms for the word research: these include analysis, examination, experimentation, exploration, fact-finding, enquiry, investigation, scrutiny, searching and study, (Elliott, 1997). All of these can be said to describe the process of research undertaken within art, design and media. Research may include an enquiry into the qualities of materials used in furniture design, an analysis of content in a media product such as a magazine, or the context in which a sculptor works. Alternatively, visual research may consist of experimenting with collage, studying the landscape through drawing, or taking photographs to investigate movement. It is the

depth and quality of research that distinguishes everything we make, the objects and images, and the essays we write.

Answer Yes or No to the following:

- I like to find out about the history of my subject.
- I enjoy finding out what other people are doing now.
- Sometimes I become so involved in research I do not know where or when to stop.
- Finding the information I want is very satisfying.

ACTIVITY 2.6 How I work – research

As your subject skills develop you are required to investigate in depth and breadth in both practice and in theory. This means that you need to know what to look for and where to find it; and this is research. Research is a real skill and is both demanding and rewarding. Ask your self what your skills are now, and how to improve them.

Research	+ or – Action needed?
■ I do not always know where to look.	
■ I sometimes find it difficult to decide what to look for.	
■ I like to decide on a theme and then find out what other people have done.	
■ I find that thinking about other people's work helps me to develop my approach.	
■ When looking at other people's work I try to find out and describe what they were trying to do and communicate, and how they did it.	
■ I have difficulty deciding what questions I should be asking.	
■ I have difficulty recording and organising my findings effectively.	

I need to develop the following skills:

How will you do this? What are your strategies for gaining these skills?

Experience			Skills	Timescale	
Little or no	Some	Significant		Immediate	Long term
			Deciding what to research		
			Deciding what questions to ask		
			Deciding where to look		
			Books		
			Internet		
			Magazines, journals		
			Films, TV		
			Visiting exhibitions and galleries		
			Recording my findings		
			More…		

I need to develop the following skills:

How will you do this? What are your strategies for gaining these skills?

(See Chapter 3, *Gathering information* p. 45.)

10 Practical – making

For most of us who like engaging with ideas, materials and techniques this forms the basis for our practice. How we make our work using our chosen practical medium is very important to us and we spend time developing the knowledge and skills we require in using appropriate techniques. We have to match the medium and technique to communicate the concept or idea. Different qualities of making are also required at different stages in the production of project work. For example, we need to visualise initial ideas quickly – these have to be exploratory and indicative, while being able to generate the high production values of a finished object, image or production.

ACTIVITY 2.7 How I work – practical making

Our practice involves making, the use of skills, techniques, equipment and materials, and our approach varies according to personal preference and subject specialism. Consider your approach and how you can develop it.

Answer Yes or No to the following:

- I like experimenting with materials.

- I like to experiment with new techniques.

- I like to master a technique before I use it.

- I like to know exactly what I want to do before I start.

- I enjoy taking things apart to see how they work.

- I aim to produce highly detailed finished work.

I need to develop the following skills:

How will you do this? What are your strategies for gaining these skills?

To sum up:

Experience			Skills	Timescale	
Little or no	Some	Significant		Immediate	Long term
			Using my chosen materials		
			Working with new materials		
			Using new techniques		
			More…		

I need to develop the following skills:

How will you do this? What are your strategies for gaining these skills?

(See Chapter 4, *Approaches to project work*, p. 62, Chapter 5, *Practical projects*, p. 83.)

11 Communication skills

When discussing the ability to communicate within advanced and higher education we focus on a number of aspects. One is to express our ideas through our practical work, to articulate them verbally; another is in the academic reading and writing required at this level. To fully participate in your course work you will be involved in discussion with staff and other students at seminars, tutorials and presentations, and you will need to account for your decisions during criticisms of your work. This requires practice – the more you engage in this way, the more your confidence will grow, so that you will be able to express yourself with increasing clarity. Different people approach academic reading and writing with different expectations. Some have a particular curiosity and they enjoy investigating ideas in an abstract context, others see themselves as more practical in their approach and find this difficult, and may question the need for such study. It needs to be remembered that this is advanced study and it is important to be able to communicate in all forms in a professional and careers context and to develop these skills to the best of your ability. Many students come to the end of their courses and are surprised to see how much they have achieved in this area and how valuable they have found this work.

(See Chapter 4, *Approaches to project work*, p. 62 Chapter 6, *Academic and written assignments*, p. 96.)

ACTIVITY 2.8 How I work – communication skills

Art, Design and Media requires different forms of communication and your degree course reflects this. This concerns use of both verbal and written language to explore ideas and explain the concepts behind your work. Students need to develop these skills and you will be more or less confident in discussion and written aspects. Reflect on what you need to do to develop your potential as a communicator. Do not put this off as communication in all its forms is a very important skill which can be worked on and improved.

Communication skills	+ or – Action needed?
■ I am worried I may not understand the language used	
■ I have problems understanding theoretical ideas	
■ I find the reading difficult	
■ I do not know how to structure an essay	
■ I have not written an essay for a long time – I do not know where to start	
■ I am worried about the quality of my writing	
■ I do not understand why there is a written requirement for my course	
■ I am/I think I may be dyslexic	

I need to develop the following skills:

How will you do this? What are your strategies for gaining these skills?

Experience			Skills	Timescale	
Little or no	Some	Significant		Immediate	Long term
			Putting my ideas across in presentations and discussions		
			Participating in group work		
			Essay and report writing: analysing essay title, structure, writing style, proofreading, referencing sources		
			Reading skills: selecting what to read, making notes		
			IT, word processing		
			More…		

I need to develop the following skills:

How will you do this? What are your strategies for gaining these skills?

12 Personal profile and action plan

You have reflected upon your skills and can draw up a personal profile giving an appraisal of your abilities, such as the one in Figure 2.5. From this you can draw up a personal action plan to highlight your needs and develop personal goals. To make the most of your studies it would be valuable to do this on a regular basis.

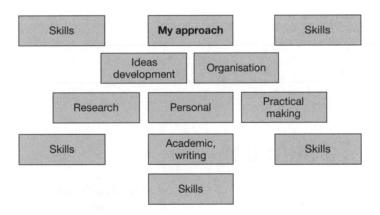

Figure 2.6 Personal profile
Source: Maier and Warren (2000).

ACTIVITY 2.9 My personal profile

Drawing up a personal profile sums up the results of your reflection on your skills and how you work. Are you surprised about the sum of your abilities? This should be a confidence builder as you have gained a place on your chosen programme of study and you know that you have real abilities to build on.

Action plan – what skills do you need to develop.

ACTIVITY 2.10 Action Plan

Now consider what you think are your most important learning needs. List these and consider what action you need to take in order to achieve them. Keep this list to discuss with your tutor.

Learning need	Actions to take

Further action

To sum up:

- After a period of study on your degree course, reflect on what you have achieved by conducting a self-evaluation similar to the one shown above.
- Establish a new action plan.

References

Attwood, R. (2009) 'Learning how to learn vital for student survival', *Times Higher Education*, 1 (903), 2–8 July 11.

Elliott, J. (ed.) (1997) *The Oxford Compact Dictionary & Thesaurus*, Oxford, Oxford University Press, p. 644.

Schwarz, C. (chief ed.) (1991) *Chambers Concise Dictionary*, Edinburgh, W and R Chambers, p. 513.

2 Day-to-day studies

There is a wide range of activities that forms a part of your degree studies and all of these will make demands on you. You will be learning new skills in the studios and workshops, attending lectures, be expected to research and read philosophical writing around visual culture, write essays and reports, work with others in groups and devise your own projects and present your work. These form the basis of your day-to-day experience as you establish yourself and work towards your intended career.

Your programme of study will be divided between two broad areas: practical studies and related academic, critical and cultural studies. Practical studies will involve you working with specialist equipment to undertake your project work, be it staff- or self-initiated. Critical and cultural studies include the exploration of visual and media culture related to your specialist area and its practices, both contemporary and historical. There will be a combination of structured time in contact with staff during lectures, workshop demonstrations, studio discussion, seminars and tutorials, and a significant amount of independent study time when you are expected to organise yourself in undertaking your course work.

The chapters in this part of the book will help you to work effectively on a day-to-day basis in managing the diverse range of demands that forms your degree study. They are designed to help you develop key skills to undertake all forms of project work, understanding and making use of its assessment while developing towards your creative future.

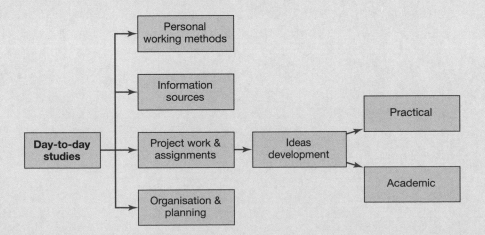

3 Gathering information

In the course of your studies you will be given information during lectures and seminars and will also be expected to find out information for yourself. This will include technical information about processes from textbooks or manufacturers' instructions, from study visits to galleries, companies and studios concerning your specialist interests, reading magazines, journals, books and searching online. As a degree student you will be expected to go beyond the immediate and to engage with your course material, take decisions and work with a purpose.

In this chapter you will cover:

1. a variety of note-taking techniques;
2. how to make best use of lectures;
3. a range of reading techniques to help you locate the information you need;
4. the use and evaluation of different information sources;
5. issues related to intellectual property rights.

1 Lectures

Lectures are an important means of disseminating information, but they tend to be one way: lecturer talks – students listen actively (good) or passively (probably time wasted). Lecturing styles may vary, with some lecturers seeing this as an opportunity to enthuse, entertain and inform, with the aim that students will then engage with the topic and undertake further work themselves, while other lecturers regard their role as imparting as much information as possible, and no more. Whatever the approach, good preparation by you, the student, will enable you to gain the most from lectures.

Lectures can be divided into three areas:

- **Guest and visiting speakers** – these will include practitioners who will talk about their work and careers from a personal point of view. They form a basis for you making contact with the working world and gaining insight into work prospects. Though their particular specialist interests may not be precisely your own, take the opportunity to broaden your thinking.
- **Faculty- or school-based lectures** – many universities and faculties provide a range of general lectures, open to all students, on a wide range of topics from film to music, literature to business, design to sociology. Take advantage of these and endeavour to extend your interests whenever possible.
- **Course lectures** – these will be specific to your programme of study and aim to meet your particular needs. Study the lecture schedule beforehand, undertake any suggested additional reading and think about how one lecture may link to others.

2 Note taking

Note taking is not only a means of gathering information (Figure 3.1) but also a way of organising it for future use and making sense of it.

- Note taking keeps your mind engaged.
- Your note-taking methods will make lectures and reading part of your active learning.
- Note taking helps you take ownership of your learning.
- It keeps you active, thinking and engaged in the content.
- It helps you evaluate, organise and use the information in your learning.
- You will have a basis for following up any issues in seminars or tutorials.

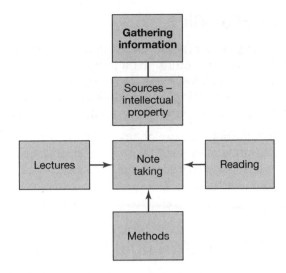

Figure 3.1 Information gathering

ACTIVITY 3.1 Self-assessment – note taking

Consider the way you take notes during lectures, seminars, technical workshops and when reading as this is an important component of your learning. How will you engage more closely with the note-taking task and make your studies even more interesting?

	Yes	No	Action
I try to take down every word			
When I try to take notes I miss what the lecturer is saying			
I use the lecture notes to formulate questions			
Questions to ask the lecturer			
Questions to research myself			
I find it difficult to understand my notes after the lecture			
I add to the lecture notes given by the lecturer			
I organise the notes into files each week			
I use different colours when making notes			
I use bullet points when taking notes			

Lecturer's notes

It is considered good practice for the lecturer to provide lecture notes, preferably before the lecture takes place, so that you can prepare by reading them and formulating ideas and questions around the topic. If you do not understand something or would like further information, you can concentrate on this and prepare to ask questions if you need to.

Not all lecturers provide lecture notes before the lecture, but you may be asked to undertake specific reading in preparation. Some suspicious lecturing staff may think some students might not attend if lecture content is published in advance.

Making your own notes

You will not be able to take down every word, so your note taking needs to be selective and a personal response to what is being said. Some lecturers do not object to you using a recorder, but always ask first. This is particularly recommended for dyslexic students. It can save time if you log key points in the lecture so that you can refer back to important information on the recording. If possible, take notes to meet your personal requirements and the recording can supplement these.

Consider what your purpose is in making notes:

■ to describe how a particular practitioner approaches their work, their influences and career;
■ to stimulate you to research names of movements, theories: artists, designers, film makers; what to follow up, where to find more information;
■ to take in information about technical processes: where to research, how to apply it;
■ in preparation for an essay: you will have to focus on a particular aspect to answer the question.

Keep your page of notes organised:

■ use arrows, lines and different colours;
■ give yourself space, as in the table opposite;
■ keep your handwriting clear enough to read.

Make notes on your computer only if you can touch type at an adequate speed, and also manage your files with care.

Divide your page of notes like this:

Title, date, topic	
Key ideas, arguments	Notes
Action to be taken	
Relevance to you and your work Sum up contents: what connections can you make?	

Pattern notes

Pattern notes are similar in format to mind maps (Buzan, 1993) and can be used as you develop your ideas. See Figure 3.2 for an outline of how to use them, and their pros and cons.

(See *Recording and developing your ideas using mind maps*, p. 72.)

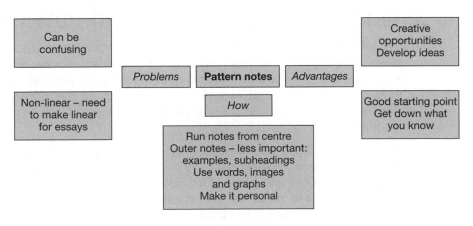

Figure 3.2 Pattern notes

At the lecture

The lecturer may provide an outline of content at the beginning, either through a slide or notes indicating the order of material presented, which can provide a structure for your note taking.

- Make use of the lecturer's notes.
- Listen out for 'These are the key features', 'Be aware of these important points', 'This is a theme or topic you might wish to follow up'.
- Include examples, illustrations, sources.
- Listen for the language used within the subject area in order to gain further understanding of the subject.
- Use the lecturer's words – you will not have time to put the content into your own words; if you need to do this, do it later.
- Write in phrases that mean something to you. Keep them concise.
- As soon as possible, tidy up. Note down key questions and actions to be taken.
- Make connections with what you are doing on other aspects of your course. Talk to other students, ask questions in seminars, challenge.
- Organise your notes so that you have easy access to them in the future.

To sum up: Reasons for taking notes

- To take ownership of your learning.
- To keep you active, thinking and engaged with the content.
- To evaluate, organise and use the information you have noted in your learning.
- To allow you to follow up on any issues raised in seminars or tutorials.

3 What you need to read and how much

Most Art, Design and Media courses emphasise practical aspects, so there is less reading required than on an arts humanities degree, although you are expected to work with similar material. However, you will be expected to read about topics that extend your knowledge of the subject area and aspects related to it. This will include something of the history of the medium through to what is happening today.

There is a particular skill in reading for academic purposes. With so much material available, it is important to be aware that we cannot read everything, but need to focus on what we need for any particular assignment (see Figure 3.3). Not all students have these skills, so it is beneficial to assess your particular abilities in this area.

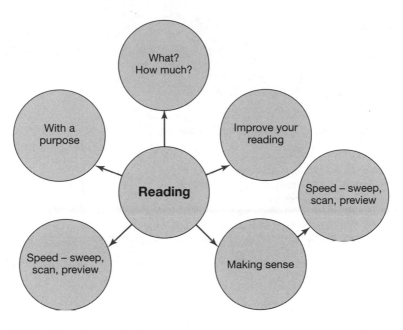

Figure 3.3 Reading – how and why

ACTIVITY 3.2 Self-assessment – your reading skills

We all know how to read, but when you are reading to support your coursework and assignments it is necessary to be selective and purposeful. With a significant amount of text to work with it is worthwhile to consider your current approach and how you can take on different techniques to increase understanding and save time.

Your approach	Yes	No	Priority		Action
			low	high	
I do little reading beyond that which is required for assignments					
I try to understand everything in the text as I read					
I read a sentence or paragraph and cannot remember what it says					
I read a sentence or paragraph, do not understand it and want to give up					
Before I start reading I try to think what I want from the text					
I seem to read so slowly and do not feel I can afford the time					

Your approach	Yes	No	Priority		Action
			low	high	
When I am new to a subject I try to find the most straightforward explanation so that I gain an understanding of the ideas behind it					
I scan the text quickly to try to decide whether it is relevant to what I need					
I scan each line and highlight words/phrases/names that I am not familiar with. I then look them up and I start to understand what the author means					
It helps me to understand a text if I make notes as I read					

4 Ways to improve your reading

Students frequently comment that there is 'so much reading' and 'I do not understand the content of what I am asked to read'. It is important to recognise that some of the material you will be asked to work with will introduce unfamiliar ideas and vocabulary and understanding will come only if you work at it.

The key is to locate a source that explains the *concept* or *terminology* in a form that you do understand. This could well be in your class lecture, in seminars where you can discuss the ideas, in encyclopaedias, dictionaries and glossaries. You then need to fully commit to thinking through why you are undertaking the reading, decide what you are looking for and read quickly to find the information you need.

Reading techniques

Decide what you are looking for – key words, ideas, names, places. Be selective – read to find the information you need.

Practise the methods below at speed to improve your reading techniques.

Double line sweep

In the double line sweep you move your guide (usually a pen but it can be your finger) along a line and then you bring it to the start of the next line down + 1 (hence 'double line'). Take in more lines if you can (Figure 3.4).

The word **institution** has two meanings both of which can be applied to art, design and media and its production, distribution and consumption. In one sense institution can be applied to organisations such as arts funding bodies or galleries, film production companies and cinema owners, or industrial companies that clearly have considerable effect on the cultural and economic climate. Within media studies there is a different use of *institution* and this refers to the conventions both cultural and politilocal under which the media product is produced and distributed. These are self or externally regulated conventions of what is 'acceptable' in society, and artists.

Figure 3.4 Double line sweep

Selective sweep

Scan the text, running your eye over the page looking for key words, names, phrases, then highlight them (Figure 3.5).

Laura Mulvey applies **feminist psychoanalytical theory** to film. In '*Visual Pleasure and Narrative Cinema*' she writes in 1975 as a political act in analysing pleasure and states that her aim is to destroy it. She argues that within popular cinema there is an exhibition of women, the object of male sexual desire, for the '*pleasure*' of the '*male gaze*' and this forms an unconscious presentation of a **patriarchal** society The pleasure of looking (**scopophilia**) is a 'controlling gaze' in which women are presented within a '*voyeuristic fantasy*'. They become objects (*objectification*) to be looked at within the darkened experience of the cinema (**apparatus**). This draws on **Lacan's Mirror phase** (the child recognises **its self in** the mirror but also is aware that they themselves are superior to the image) in a resulting **narcissism** (love of self). Mulvey argues that the male child, as a **spectator**, identifies itself with what is on the screen as a form of likeness of its self. Popular cinema is therefore 'structured around...**narrative and** moments of spectacle' with action associated with the male **hero** and the spectacle of the female heroine's body. The male spectator satisfies his ego as he gazes on the hero, he satisfies his libido and the erotic look' at the heroine '. This confirms women as sexual objects. Mulvey (1989) Storey (2006c: 81-83) Men look, and women are presented to be looked at.

Figure 3.5 Selective sweep

If you have problems understanding your reading, take a look at Figure 3.6.

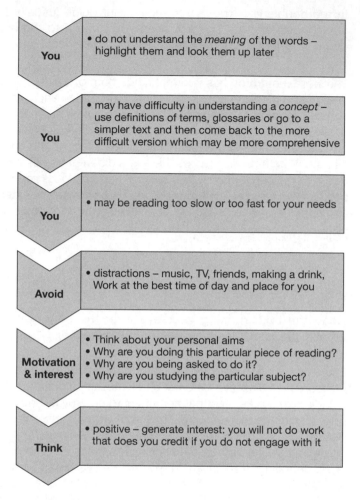

You
- do not understand the *meaning* of the words – highlight them and look them up later

You
- may have difficulty in understanding a *concept* – use definitions of terms, glossaries or go to a simpler text and then come back to the more difficult version which may be more comprehensive

You
- may be reading too slow or too fast for your needs

Avoid
- distractions – music, TV, friends, making a drink, Work at the best time of day and place for you

Motivation & interest
- Think about your personal aims
- Why are you doing this particular piece of reading?
- Why are you being asked to do it?
- Why are you studying the particular subject?

Think
- positive – generate interest: you will not do work that does you credit if you do not engage with it

Figure 3.6 Solutions to reading problems
Source: Based on Buzan (2006).

To sum up: Note taking

- Be active.
- Take notes.
- Keep thinking.

5 Read with a purpose

You should read with a purpose to:

- support a general interest in your subject – this means you will read the whole book or the text of an article in a journal or magazine to provide a general understanding and context for your studies;
- find information about a process, technical information, or a named practitioner to support project work;
- research ideas for an essay topic – consider your ideas, list key words, changing them as you go.

Focus on what you require and be *selective*. Know when to stop. Remember, you may not need to read the whole book. It is valid to be selective: *use the contents and index*, read the *introduction* and this should indicate the approach for the whole article or book. Then read the sections *relevant to your needs*.

Photocopying

It can be useful to copy some of the material and file it for future reference. Photocopying gives you continued access to key texts, but it is not a substitute for taking ownership of the sense of the material through personal note taking.

6 Reading to understand

It is important to remember that there are different types of reading with different levels of difficulty. Go to Parts 3 and 4 of this book for an explanation of key ideas related to critical and cultural studies and specialist media.

- **In-depth reading** – Photocopy key sections (you could enlarge the copy) then there is more space for you to make notes on the copy.
- **Read** – Sentence by sentence/paragraph by paragraph. Highlight key information and make notes.
- **Asking** – what argument is the author trying to make?
- **Questioning** – what are the reasoning and information presented? Does it support an argument?
- **Being critical** – it can help you to sustain active interest.

Make notes of key points for further research, keep referring to what you need from the article and make sure you take down full *details of the source* for use in the future.

Example

MAKING SENSE OF YOUR READING

As you read, highlight **key ideas** and *people* indicating areas for further research.

'One designer whose work has been the subject of a great deal of academic analysis is *Martin Margiela*. He features in no fewer than four articles in *Fashion Theory* to date, and it is easy to see why: garments designed by Martin Margiela depart **radically** from or even overturn accepted **conventions** in the design, construction and presentation of fashionable clothes. *Alison Gill* for example associates Margiela's work with '***deconstruction fashion***' and considers the parallels this style has with the 'influential French style of philosophical thought, **deconstruction**, associated with the writings of *Jacques Derrida*.'[1]

Use other texts, glossaries, dictionaries and encyclopaedias to locate the information you need. See also Chapter 10, Structuralism and post-structuralism and Chapter 16, Fashion design.

Source: White and Griffiths (2000).

ACTIVITY 3.3 Reading with a purpose

To get the most from your reading requires a decision about what information is relevant, focusing on this and in doing so starting on the all-important process of both understanding and critical analysis. How are you going to approach this aspect of gathering information?

Note down your key ideas/words related to your subject area. The clearer these are, the easier the information is to find.

Select a text and scan it to decide its relevance.

If it appears to meet your needs, you could note the following:

Checklist

Topic/project			
Source in full – Author, date, title, medium, place of publication, publisher web address, page number – so that it can be found in future			
Your questions – what do you expect to find?			
Key words/ideas			
Reading speed	Preview	Scan	In depth
Level of difficulty			
Introduction	General account	Critical analysis	Technical

Key points the writer is making	
Is there an overall argument presented?	
Note relevant detail	
Rewrite key sections in your own words	
Relationship to other research done	
Other notes	
Category for filing	

To sum up: Reading

■ Put into practice different reading techniques.

■ Remember that slow reading equals less comprehension, less understanding.

■ Read with a purpose to understand.

7 Information sources and intellectual property

There are different types and quality of sources. We use these in collecting information, facts, opinion and visual reference material in a variety of forms, and it is here we see the products of the creativity of others. It is standard practice and valid to do this as part of our studies and in professional life. However, we are in an age of appropriation and manipulation through conventional and electronic media and it is particularly important that the work we produce and the work of others is protected from illegal reproduction and theft of ideas because these creative works form the basis of the arts and media economy.

Example

INTELLECTUAL PROPERTY – COPYRIGHT, PATENTS, TRADEMARKS, INDUSTRIAL DESIGN RIGHTS

Intellectual property rights form a range of laws that protects the creators of 'original' works such as artworks, designs and products from copying for a period of time so that they can be exploited economically. This is important commercially in that as a professional you have to be fully aware of the law to gain a licence to use certain material or otherwise risk facing legal action if this permission is not obtained.

As students in education, always make sure that you acknowledge sources that you use as this indicates you are aware of these legal requirements.

(See *Evidence, citation, referencing, plagiarism*, p 114.)

8 Types of sources

The sources we locate in our research may have varying degrees of complexity and some times difficulty, so you will need to judge their relevance and importance to you and to the work that you are undertaking.

Before using any source, consider who has prepared it. University research groups are usually refereed and company websites as sources are valid for certain types of information. Be critical and think about whose interests the site may serve. Always record when the information was entered, as although it can be the latest information, it may also be out of date. Also note the date you viewed it as the site can be changed or disappear overnight.

- **Books** – tend to be favoured because there is time taken in their preparation and in the main the ideas and approaches are reviewed by experts on the topic refereed. In addition, there is a possibility of reflecting on the content to allow time to gain a deeper understanding. The book list provided on your course will recommend particular titles.
- **Exhibition catalogues** – provide a source of information centred on an artist, or group of artists, and will normally include reproduction of the work, a related essay and a list of previous exhibitions and publications. This can be of considerable value in providing additional sources for follow-up research.
- **Monographs** – centring on individuals, may include introductory essays and these can be a valuable source of analysis and contextual information as well as providing an overview of the work. They will also provide a bibliography, which lists exhibitions and publications.
- **Journals** – tend to be focused upon a particular academic discipline and will include essays and reports of particular research. The important element is that they are refereed by other academics, which indicates that the material presented is valid. These can present the most up-to-date information, but you should remember that they are written for a specialist audience. Some are available in print form and others in electronic form.

- **Internet sources** – provide rapid access to a wide range of information and sources that can be a good starting point. However, you need to be discriminating in the type of searches you undertake and cautious about the use of material as sites can be established by anyone. Wikipedia is one such source – it is an encyclopaedia open to many contributors and can be used as a starting point, but any information gleaned from this should be confirmed from other sources that are recognised as being authoritative. Many academics will not accept Wikipedia as a source and so citing it is best avoided.
- **Newspapers and magazines** – are written for the general reader, but through reviews and reporting on the arts, media cultural and business coverage it is possible to gain insight into current developments and issues. Many business sections include coverage of the media and advertising.
- **Introductory** – a way of starting when you are new to the subject because it provides an understanding of the principles and will usually include an explanation of the concepts and terminology for the subject. You can then move on to more challenging material.
- **A general account or history of the topic** – will provide background information about your subject area and should include illustrations and perhaps brief biographies of the main practitioners, together with an explanation of the context in which they have worked.
- **Collections of critical essays on specific topics** – are recommended as they are written by academics and critics interpreting and developing concepts and theories, but vary in difficulty depending on the intended audience and the personal writing style. For example, Roland Barthes and Judith Williamson have written for popular magazines and also presented papers to academic conferences, as well as publishing these papers in the form of essays. One way to judge any essay is whether it includes references and a bibliography that cite sources used in its preparation as this indicates its academic origins; these can also provide sources for further research.
- **Technical information related to your subject area** – is important in you developing knowledge of your area of practice and will come from manufacturers' brochures, instructions and textbooks.

Different sources are written to meet different requirements and for different degrees of difficulty:

Types of sources	Books	Journals	Exhibition catalogues, monographs	Internet	Newspapers, magazines
Introductory	X			X	X
General account or histories	X		X	X	X
Critical analysis	X	X	X	X	
Technical	X	X		X	X

9 Electronic databases

Your university will provide a service that will allow you to search for information online and you should seek sources that are considered authoritative. Make use of demonstrations on how to use these; usually there will be self-help guides. In some cases you should be able to access these sources from off campus.

In some cases there is a subscription for full access to recommended sources, but your university may well pay for this. It would normally be accessed through your internal intranet information system. Check which journals are available to you via such sources as JSTOR and Project Muse. Some sources provide a full text, others provide abstracts and a bibliography.

General sources

Google Scholar: http://scholar.google.com

Google Book Search: a valuable source with access to a wide range of books page by page: http://books.google.com

Newspaper articles

Nexis UK: English-language newspapers in full text but without photographs or illustrations.

Business Source Complete: full text business and media magazines.

Specialist sources

Art Full Text – Art Abstract (Wilson Web): some articles full text

Art Bibliographies Modern (ABM) (CSA Illumina): also lists some exhibition catalogues and websites.

Design & Applied Arts Index (DMA) also from CSA Illumina.

FIAF.

For film

Film Indexes Online.

Film & Television with Full Text.

These form a powerful tool when looking for information of all kinds when used in a selective and considered way.

To sum up: Sourcing information

- Use a range of sources and evaluate their accuracy and value in academic terms.
- Be questioning and critical.
- Use your sources in a focused and considered way to best meet your needs.
- Remember that you cannot read everything, so be selective.

10 Your learning resource centre/library

Your learning resource centre should become an important component in your studies – make good use of the facilities available to you.

- Make sure you undertake any available induction courses.
- Become familiar with the information-retrieval systems in operation.
- What can be accessed online? Or from off campus?
- What kind of research requires a personal visit to gain access?
- How do you access/obtain a research paper, book or journal if your LRC does not have it?
- How do you gain access to specialist libraries, archives and databases?
- Check the availability of self-help guides.
- Find out how to contact specialist staff in your LRC who may be able to assist you in your research.

References

Buzan, T. (2006) *The Buzan Study Skills Handbook*. Harlow, BBC Active, pp. 80–87.
White, N. and Griffiths, I. (ed) (2000) *The Fashion business*. Oxford and New York, Berg, p. 79.

4 Approaches to project work

You will have developed ways of undertaking projects and as your degree becomes more demanding you will find it valuable to continually review your methods of working. Consider the approaches suggested here as you work on both practical and academic projects.

In this chapter you will cover:

1. analysis of the requirements of the brief;
2. how to undertake group work;
3. approaches to critical and creative thinking in your ideas development;
4. organisation, planning and time management;
5. methods of project development and production.

1 Art, design and media work – the process

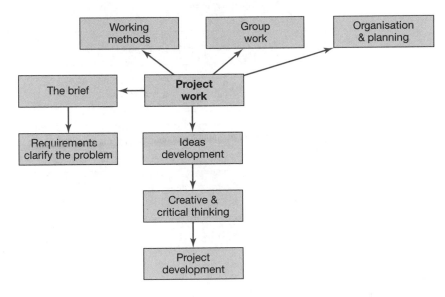

Figure 4.1 Project work

There are different ways of approaching art, design and media work, as Figure 4.1 illustrates, but it is useful to consider the possible stages in the working process as outlined in Figure 4.2.

An important factor in studying is to devise working methods that suit you and your learning style. Some students favour the *sketchbook/journal/ notebook*. This is a means of collecting information on a more or less continuous basis. It forms a visual and written diary in which you record your thoughts and observations, points of interest, images, visits and concerns for current and future reference. It is valuable in the sense that once an idea has been noted, you can assess and evaluate it more readily, keep it, mull it over and use it later. Then you can go on to thinking of other things, the next idea, observation and so on. You may choose to work on specific projects in this format and staff may ask to see the sketchbook as evidence of the way in which you are working.

Evaluation is to consider the value of something. In education this is considered to be a challenging task as it calls on you to consider the process of undertaking the project, what strategies you have used to complete it, where the approach has gone well and where it could be improved in future work. **Realisation** is the process of making thorough use of appropriate techniques and materials so that the idea, artefact or product is realised as well as possible.

(See Chapter 2, *How you learn*, p. 17.)

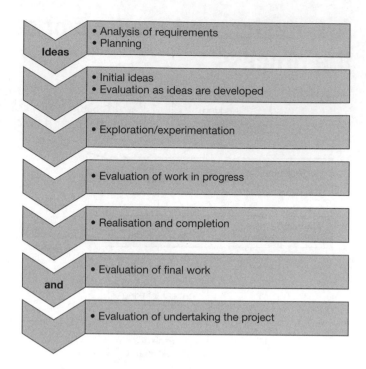

Ideas
- Analysis of requirements
- Planning

- Initial ideas
- Evaluation as ideas are developed

- Exploration/experimentation

- Evaluation of work in progress

- Realisation and completion

and
- Evaluation of final work

- Evaluation of undertaking the project

Figure 4.2 Ideas – analysis of requirements

Some project work may require the use of a *log book* to record your observations on a regular basis during the work on a project or placement. Students can then draw on this to produce a report when required.

Design or worksheets are required for some projects to show how you have approached its requirements and these are focused on demonstrating the process of the development of ideas through to a realisation of a specific project.

When undertaking work requiring sequences of images, as in film making or animation, *story boards* may be required as part of your submission. These provide a breakdown shot by shot of your intended approach to the project and may include choice of camera angles, lighting, dialogue and sound.

What is important is that you find a working method that works for you and is adaptable to project requirements and your needs. Keep thinking, making the evaluation, as you develop your methods.

2 The brief

The brief is the starting point for all projects (although in some areas of study formal projects are not set but students keep to a self-motivated programme of work that is personally devised and developed through a project proposal and brief). This may vary from verbal instructions, such as 'I would

like you to prepare for tomorrow...', to a detailed written brief with specific instructions and requirements, including learning outcomes, details of assessment criteria, built-in deadlines and stages over an extended period of time.

Alternatively, you may be required to write a project proposal. This will require careful consideration and research and for major projects considerable detail as it may map out your activities over a long period of time (see Figure 4.3). You should also remember that the assessment of the work will be related to your personal aims, how you have developed the project as you undertake it and how you have achieved your personal objectives.

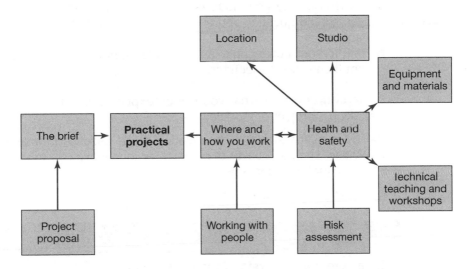

Figure 4.3 Practical projects

ACTIVITY 4.1 Writing a brief/project proposal

When you are writing a project proposal you need to provide certain information. The following should be addressed.

You will need to formulate a proposal that includes:

- an area for the study, theme or idea for investigation

- the purpose of the project, personal aims

- issues/problems to be investigated

- a literature review related to the topic

- sources for research, such as library and internet, practitioners to be investigated, critical analysis

- techniques, materials and media to be used

- planning stages, process of ongoing evaluation, presentation of intended outcome

- industrial contacts/sponsorship
- outcomes and presentation details

The proposal will need to be approved by tutors and may be assessed.

(See Writing your brief; p 121.)

At all stages as you approach the brief:

- take notes, highlight key words and ask questions – ask the lecturer;
- remember the key issue is that you understand what is required: you should question and clarify any issues that occur to you – ask the lecturer;
- talk to your colleagues: is your understanding the same as theirs? If not then – ask the lecturer.

Learning outcomes – what you will be expected to have learned through undertaking a project or module.

Criteria for assessment – when work is to be assessed these are individual qualities, such as quality of research or innovative use of materials, that staff use to make judgements.

(See Chapter 7, *Assessments*, *'crits'*, *presentations* p. 123.)

Student Experiences:

Make sure you understand the instructions

'Me and my friends were discussing what was required for the project. One of us who always seems so certain of themselves was sure that they knew what was expected. We did it that way and we all got it wrong. We should have asked the lecturer.'

3 Break down the project requirements

The project will include instructions on the following:

- **Content** – what you have to do. This could consist of a theme or a question to investigate. You could also be set a task, such as 'Design a ... for' or you might be asked to 'Write an essay on the following topic...' or 'Write a report on your work placement'.
- **Whether it is a personal or group project** – the project may be an individual one in which you work on your own so that you have to take

responsibility for all aspects, from the formulation of your ideas to final presentation. However, the design and media industries involve much group work, so you should expect certain projects set by staff to reflect this in requiring you to gain the skills of cooperating and working with others.

(See *Group work*, p. 68.)

- **Time** – a deadline for completion, possibly with staged points for discussion of your progress (formative assessment).
- **Materials** – the medium/media to be used.
- **Format** – the required size and scale of the project. This could be given as the number of pieces to be presented or the number of words required.
- **Presentation** – how the work should be presented and in what form. Do the brief and the learning outcomes specify supporting evidence of research, such as mind maps, worksheets and a finished product?
- **Assessment detail** – what are the criteria for assessment? How will you obtain feedback? Will you need to present the work in person or will the work be assessed in your absence?

Remember that in one form or another you will need to describe what you have done, with areas of questioning such as:

- What have you produced?
- Why did you approach the project in this way?
- How did you make it practical?
- What is the context for the project?
- What are the areas of strength and weakness in the project?
- What areas could be improved?

4 Clarify the problem

When you start the project you will need to consider what is required, the constraints and the possibilities. You will be thinking about:

- what you have to do;
- what materials you will be using;
- what the timescale is and the deadline for completion of the project.

Remember to check the details and keep checking them, and to keep thinking about the problem. You should *dissect it*, *take it apart*, *highlight key terms*, put it into your own words – this is all part of the process of understanding what is required of you. You will also need to *plan your time* carefully to ensure that you complete the project by your *deadline*.

ACTIVITY 4.2 Project checklist

To manage your projects effectively you need to plan your work and you should be able to monitor your progress at the various stages to completion. Check your next project against the following list to ensure that you accomplish your aims and more.

Project title		
	Your notes	**Progress**
Content/topic/theme		
The problem in your own words		
Questions – needed to clarify the brief		
Deadline		
Time plan		
Medium/materials		
Format size/scale Number of words		
Presentation		
Assessment details		
Limitations/requirements		
Other points		

5 Group work

When you are asked to work in groups there are a number of factors that you need to take into account. Group work requires cooperation and organisation, with members of the group recognising the importance of gaining this experience in preparation for working in industry.

The group will be advised to work in the following way:

- hold meetings to discuss the project and analyze what is required;
- allocate the tasks, agree a schedule and hold further meetings;
- make notes of the meeting;
- make full notes with sources;
- agree a method of communication and use it;
- share information;
- perhaps make a presentation of findings and/or a report;
- possibly keep a personal log of what you and other members of the group have contributed. This may form part of the assessment process.

If there are any difficulties with other group members not cooperating, it is important that this is reported to the lecturer.

ACTIVITY 4.3 Group work

In group work it is important that you and your colleagues keep organised, work together, note decisions taken and act on them. These notes can form the basis of any written report or presentation.

Project title	Date	Deadline
Project requirements		
Group's approach		
Group members	Role	Contact information
Schedule	Notes	Action
Meetings held – dates	Minutes taken	Action
Decisions taken		

6 Ideas development – creative and critical thinking

A dictionary definition will give a number of alternative meanings for the word 'idea'. These range from everyday use, 'I have no idea what is happening', to philosophical discussion of the 'varieties of existence in the real world' (Plato). The most useful part of the definition from an art, design and media point of view is 'any product of intellectual action, of memory and imagination' (Schwarz, 1991) in that in seeking to communicate we attempt to express ourselves and present information in a different and imaginative way. The idea or concept is the basis for all the decisions on content and visual interpretation that we make in producing creative work.

We tend to consider that developing the idea is the starting point for the creative process and we may be reduced to worried inactivity by its absence. But the idea may come in a flash, at any time and in any circumstances and we will need to be ready to record it. We may be envious of others who seem to find it so much easier than we do and we end up thinking: 'What a good idea, I wish I had thought of that.' There are methods of working which open up possibilities for creative thinking and you will need to find what is right for you. One of these is to analyze the topic or problem initially and not think of how to solve it.

Creative and critical thinking

Creative and critical thinking come together in your ideas development, as illustrated in Figures 4.4 and 4.5. There are approaches to these ways of thinking that can help you to develop your skills.

Creative thinking leads to and needs critical thinking. In developing an idea you must make judgements and decisions – you will need to develop a point of view, an approach or an argument.

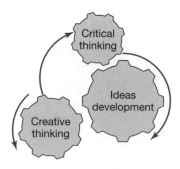

Figure 4.4 Critical thinking

Ideas development – creative and critical thinking

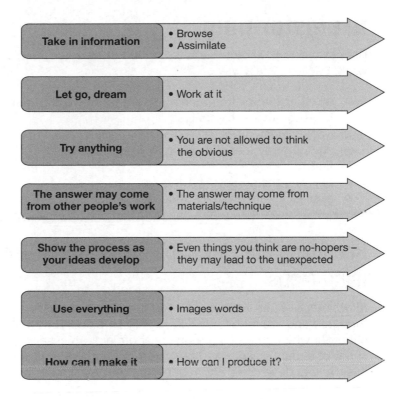

Take in information	• Browse • Assimilate
Let go, dream	• Work at it
Try anything	• You are not allowed to think the obvious
The answer may come from other people's work	• The answer may come from materials/technique
Show the process as your ideas develop	• Even things you think are no-hopers – they may lead to the unexpected
Use everything	• Images words
How can I make it	• How can I produce it?

Figure 4.5 A step-by-step guide to creative thinking

Critical thinking

There is a need to be critical and assess the value of the ideas in providing a solution to the problem:

- Is it appropriate?
- Does it provide a solution that works?
- Is it also different, abnormal, atypical, bizarre, distinctive, eccentric, extraordinary, fresh, individual, new, original, peculiar, personal, revolutionary, strange, uncommon, unconventional, unique, unorthodox, unusual (selected from a thesaurus)?

And

- Can you make it?
- Can you assemble a logical case? Can you convince your fellow students, member of staff or client?

7 Brainstorming

Brainstorming is an approach that is much favoured, particularly for group work, because it is a way of:

- giving room for free-ranging thought, perhaps to get in the mood by tackling other subjects first;
- getting ideas down (recording them all);
- allowing any ideas to come forward, however silly they may seem at first;
- enjoying the process, having fun;
- assessing and evaluating the ideas when you have finished.

Recording and developing your ideas using mind maps

Mind maps, such as the one in Figure 4.6 allows you to record your thoughts and ideas as they flow and then place your material into a logical order when developing a practical project, an essay topic or a report. A sheet of paper, a pencil and an eraser or computer software provide a flexible route to developing and recording your creative thinking.

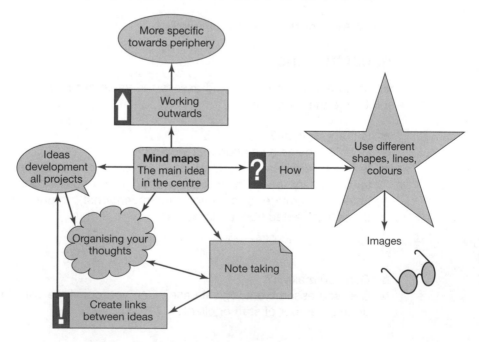

Figure 4.6 A mind map

The main idea is placed in the centre, with other ideas radiating from it. These can then be placed in an order of importance, depending on your needs.

Example

DEVELOPING IDEAS USING LATERAL THINKING

Edward de Bono proposes different methods for developing ideas related to a particular problem and to create innovative solutions in solving problems. The aim is to move outside the limits of the normal box.

Example

Take an object or word at random from the dictionary and associate it with the problem.

Illustrate city life

Adding a word can transform the problem.

City + colour
City + wild
City + harmony

Select an object from anywhere: your room, your pocket...

What does this trigger in your thinking when considered in relation to city life?

Select a series of words at random – cut from a newspaper or magazines.

What does this do when associated with the problem?

Deliberately put forward an idea that is 'ridiculous' or impossible, opposite to conventional thinking, to provoke a response. Make a case for it. Ask others to respond.

Challenge the conventional idea and the way things have been done – not to say this is wrong but to try to stimulate thinking about other approaches.

ACTIVITY 4.4 Lateral and creative thinking

The thinking that goes into the inception of a project is paramount. There is a variety of ways to approach it to develop your creativity. It is worthwhile trying this method because it may provide the answers you need now and in the future.

Read the example on lateral thinking before trying this activity.

For your next project:

- Select a word or phrase that sums up the theme or content of the project.
- Take a word from the dictionary + word or phrase = ?
- Select an object at random + = ?
- Assemble a series of words and images at random + = ?
- Think the ridiculous or impossible + = ?

Example

CRITICAL THINKING: DE BONO'S SIX THINKING HATS

De Bono argues that critical thinking requires looking at problems from different points of view. To change the focus of thinking he suggests that a series of actual or metaphorical hats is adopted.

- White: information gathering – logical, objective, considered and planned.
- Red: opinion – feeling, emotional, subjective decisions.
- Black: negative thinking – critical, what might go wrong or not work; looking for problems; objective decisions.
- Yellow: positive approach – looking for the good points; why it will work.
- Green: creative approach – when you cannot move forward; is it different?
- Blue: an overview – looking at all factors.

ACTIVITY 4.5 Critical thinking

Having developed ideas, there is a need to be critical and decide which ones to take further. Try this structured method and assess your ideas from different points of view.

Project title			
Hat		Points	Notes
White	Considered and planned		
Red	How do you feel?		
Black	Why it won't work		
Yellow	Why it will work		
Green	Is it different?		
Blue	To sum up		

Make sure that you record these points as they are important when undertaking an evaluation.

8 Organisation and planning

In order to manage your academic and social life properly, you will need to consider short-, medium- and-long term planning of your time (Figure 4.7).

- Short-term planning requires you to revisit your schedules or calendar on a daily basis.
- Medium-term schedules need to be checked on a weekly basis.
- Long-term plans will need to be revisited every term or on a semester basis.

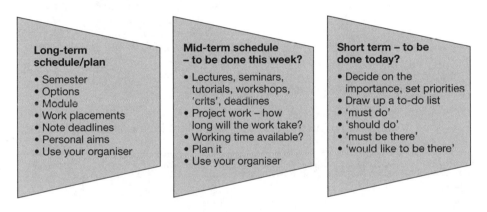

Long-term schedule/plan

- Semester
- Options
- Module
- Work placements
- Note deadlines
- Personal aims
- Use your organiser

Mid-term schedule – to be done this week?

- Lectures, seminars, tutorials, workshops, 'crits', deadlines
- Project work – how long will the work take?
- Working time available?
- Plan it
- Use your organiser

Short term – to be done today?

- Decide on the importance, set priorities
- Draw up a to-do list
- 'must do'
- 'should do'
- 'must be there'
- 'would like to be there'

Figure 4.7 Planning for the short, medium and long term

So that work does not build up it is important to plan your time across these periods of time. In managing your life and workload it is important to ensure that you use your time effectively and efficiently. To do this you will have to organise your personal time, your study time and your project working time (Figure 4.8). You will need to establish your own priorities. But don't forget to consider the balance you want in your life.

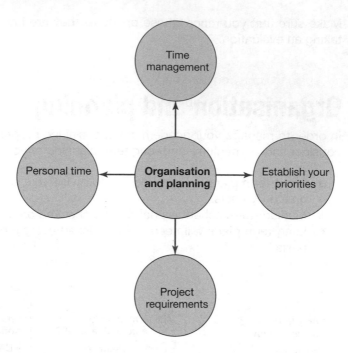

Figure 4.8 Time management

Your weekly timetable or calendar might look something like this:

Times	Monday	Tuesday	Wednesday	Thursday	Friday	Saturday	Sunday
08.00 – 10.00		Lecture 09.00 – 10.00					Sleep
10.00 – 12.00		Seminar 11.00 – 12.00		Studio	Workshop demon-stration 10.00 – 12.00	Paid work	Sleep
12.00 – 14.00		LRC	Sport	Studio	Workshop practice	Paid work	Sleep
14.00 – 16.00	Tutorial 2.00 –3.00	LRC	Sport	Studio	Workshop practice	Paid work	See friends
16.00 – 18.00		LRC		Criticism / presentation			
18.00 – 20.00	Paid work						
20.00 – Midnight			Student Union				

ACTIVITY 4.6 Complete your personal timetable

In planning your time, note what you actually do on an hourly, daily and weekly basis. Are you surprised at how you use your time? This can be revealing in helping to make decisions in managing your workload and your social life.

Fill in the blank spaces: what did you actually do?

Times	Monday	Tuesday	Wednesday	Thursday	Friday	Saturday	Sunday
08.00 – 10.00							
10.00 – 12.00							
12.00 – 14.00							
14.00 – 16.00							
16.00 – 18.00							
18.00 – 20.00							
20.00 – Midnight							

Consider how you have used your time – was it effective and/or efficient? Efficient use of your time means avoiding time-wasting activities. Do not avoid thinking about what may be required and then panicking to get things done.

- Does it need to be done now? *Then do it.*
- Does it need to be done in the near future? *Then make a time.*
- Enter it into your organiser, diary or planner. *Then do it.*
- If it does not fall into the above – *then don't do it.*

To sum up – organisation and planning

- Analysis and development of the brief:
 - Define and clarify the problem.
 - Put into your own words.
 - What is your interpretation?
- Ideas development:
 - What are your first ideas? Explore alternatives.
 - What do you know?
 - What do you need to know?
- Research:
 - Exploration of methods you can use.
 - Areas of investigation: keywords, key practitioners, sources, lectures, books, journals, web visits, galleries, note taking.
- Development and testing the approach:
 - Practical experiment.
 - Essay/report, mind maps, plans and drafts.
- Production:
 - Making.
 - Writing.
 - Presentation requirements.
- Completion and evaluation:
 - Meet deadline.
 - Reflect on learning, achievements/difficulties.

Establish your priorities

There will be demands from different modules, courses, projects and assignments, and you will need to decide on the time and effort required to undertake them.

Your degree programme will provide an indication of the value given to the various components by the assessment weighting placed upon different course work. If the weighting is 30% of the total for a module then it will be expected that you spend around 30% of your time undertaking it. For instance, many degree programmes allocate 75% to practice-based modules and 25% to theory-based modules. In general terms this should be reflected in your study time. A student is expected to study 1,200 hours per year. Divide this by the number of weeks and days you spend during the academic year so that you can consider how much time you might be expected to spend on average in any week or day.

You will need to undertake different projects from different parts of your course at the same time and some projects will appear to be more interesting or engaging than others. Be careful that you do not allow this to dominate your thoughts and affect your priorities. Plan within particular projects, plan within individual modules, plan the term or semester.

ACTIVITY 4.7 Establishing priorities

Think about what you have to do and when you have to do it in relation to your projects and assignments. If you do this you will be able to ensure that you put in the right amount of work when it is needed and avoid any last-minute rush.

Complete for each module.

Briefing (B)	Deadline (D)	Time available	Short term	Medium term	Long term	Priority
Project 1						
Project 2						
Project 3						
Project 4						
Other						

Mark the stages for the module and project (B) briefing, (IC) interim criticism, (FC) final criticism, (D) deadline.

Week	1	2	3	4	5	6	7	8	9	10	11	12	13	14	15
Module/ Project 1															
Project 2															
Project 3															
Project 4															
Project 5															
Project 6															
Project 7															

Project requirements

Take time to plan the project before starting – allow the right amount of time for each stage of the project. Look at learning outcomes and assessment criteria for an indication of this. With some shorter projects the emphasis may be on ideas development and visualisation, whereas longer projects may require more production time in proportion. You need to consider what is required and plan and break down the project requirements into stages.

9 Project development

There are a number of methods that will help you to plan and manage all of the various activities and deadlines involved in project work. You should choose the method which is best suited to your learning and working style and to the project that you are undertaking.

A *Gantt chart* (Figure 4.9) is a useful planning method – you decide on the range of activities required to complete the project and the time that should be allocated to them. These are plotted on a graph with a series of interim deadlines and these help you to manage the progress of the project. This can be presented as part of the backup work to your project.

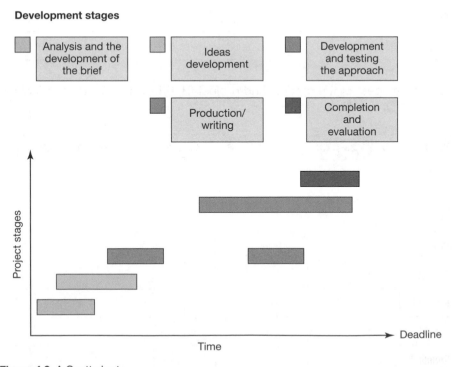

Figure 4.9 A Gantt chart

A **network chart** allows you to plan a number of stages taking differ-
ent lengths of time in the preparation and development of project work
(Figure 4.10).

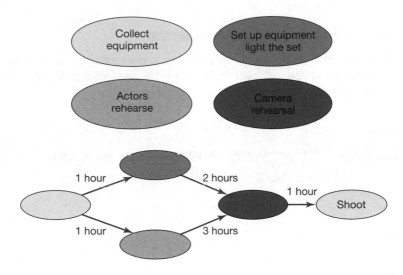

Figure 4.10 A network chart

ACTIVITY 4.8 Time planning – project development

Individual projects need to be managed to ensure their satisfactory completion. Initial
and continued planning will help you to develop your ideas and work to the full.

Project title			
Development stages	**Estimated time**	**Actual time on completion**	**Notes**
Analysis and development of brief			
Ideas development			
Research – practitioners, contexts, materials and methods			
Development and testing the approach			
Production/writing			
Completion and evaluation			
Deadline			

Transfer this information into a Gantt or network chart. This planning information can be included as part of your submission for assessment.

ACTIVITY 4.9 Time planning – project production

Break down the individual project into stages and monitor the progress you make. As you gain experience you will become better equipped to manage the longer and more demanding projects required later in your degree course.

Project title			
Production stages	Estimated time for completion	Actual time	Notes
Stage 1			
Stage 2			
Stage 3			
Stage 4			
Stage 5			
Time allowed for contingencies			

This planning information can be included as part of your submission for assessment.

5 Practical projects

The basis of much art, design and media teaching is the practical project or assignment. This is intended to provide a stimulus or starting point for your work and to direct your attention to a particular aspect of your subject or course requirements. Projects vary in scope and may be undertaken individually or as part of group work.

In this chapter you will cover:

1. project briefs and what they mean;
2. where and how you work – studio and location;
3. working with people;
4. technical teaching, equipment, materials and workshops;
5. health and safety issues.

1 The practical brief

The briefing for a project may be verbal and you will need to take note of key words, ask questions and share with fellow students, or it may be written with details such as aims, learning outcomes, assessment details and other requirements for submission.

The **format** may provide for:

■ a single idea or theme, such as reflections, deconstruction or structure;
■ or a reinterpretation of an artist's work or style.

Or it may provide detailed specifications:

■ a product design project may require analysis of existing products, target audience, material requirements, ergonomics, environmental impact through to marketing;
■ or an animated film to promote a health issue;
■ or you may be asked to devise the project yourself and for this you may need to present a project proposal or plan.

(See *Writing your brief*, p. 121.)

There will be a **time** requirement:

■ **Short (turbo) project** – this will need to be completed in minutes/hours/a single day. Such projects require quick thinking – immediate exploration of ideas based upon limited research, getting the creative juices going – decisive decision making to arrive at a solution and to demonstrate the process of your thinking.
■ **Medium-/long-term project** – this will have a deadline measured in days or weeks. This will require detailed analysis of the problem, with planning, organisation, sources researched, exploration of ideas, development of alternative concepts, synthesis of information and development of solutions, reasons for making decisions and presentation of the product.

There will be a **deadline**:

It is paramount that you gain experience of working within a time frame and be ready for the 'crit '(critique). If you do not meet the deadline, there may be an assessment penalty.

The **materials/medium** to be used may be:

■ specific, such as photography, resin, paint, twigs, string, fabric;
■ found, what you can find or is available to you;
■ a combination, mixed media;
■ open – you choose.

The **size/number** of pieces may be:

- open; or
- specific, for example a display advertisement that does not have the correct dimensions or proportion will not fit the space on the page.

There may also be limitations placed upon the scope for the project, such as location or studio access.

There will be **presentation** requirements:

- how to present the work and what form your presentation should take.

Will you be able to present the work in person and explain your approach and be able to discuss it with staff and fellow students? This may be an interim 'crit' or formative assessment intended to provide a positive discussion and analysis to assist in the development of the project, or a final 'crit' to present the outcome of the project for summative assessment. It is always advisable to ensure the work is fully documented and self-explanatory.

The **learning outcomes** will require a demonstration of some or all of the following:

- quality of thinking;
- depth of research;
- your process of working;
- how you develop ideas;
- alternatives explored – through mind maps, worksheets with notes and the finished product.

Check the brief to ensure that you follow all the requirements.

For the 'crit' or assessment, you will need to prepare yourself to answer these sort of questions:

- What have you done?
- Why did you do it this way?
- How did you make this?
- What is the context for the project or piece?
- What are the strengths and weaknesses of the project?
- What could you have done/do to improve the project or piece?

(See Chapter 7, Assessments, 'crits', presentations, p. 123.)

ACTIVITY 5.1 Project work requirements

Check the project brief and learning outcomes, note down what is expected of you and how you intend to meet the project requirements.

Checklist	Yes	No	Notes
Project proposal			
Ideas development			
Evidence of research			
Visual development			
Finished artefact/product			
Project evaluation			
Other			

2 Practical projects – where and how you work

Degree programmes in art, design and the media are predominantly practical. The focus is upon developing concepts and ideas and realising them in a design, a painting, a film, a photograph. To achieve this goal the student/practitioner must develop appropriate technical and practical skills. This is the *how* in the equation of *why, when and where*.

The nature of practice is varied and there is a significant difference in terms of materials, equipment and facilities that are required for a location film shoot, making a ceramics piece or a fine-art installation. Universities and colleges offer a wide range of resources – teaching, studio and workshop – to support student work and these are tailored to meet the requirements of the specialist subjects on offer.

(See *Work experience* and *Work placements*, pp. 141–142.)

General studio space

This provides an area where groups can meet for a scheduled activity: it may be a life-drawing studio or where a design group undertakes development and preparation work. A member of staff may circulate, giving advice as required.

Personal workspace

Some courses allocate a permanent workspace within the studios to individuals or small groups of students. This generally will relate to the particular activity where the work produced is in some way bulky and difficult to transport. This space needs to be organised to accommodate your needs and limitations may be placed on what can be undertaken within the space. Issues may include vapour or fumes from certain materials and their use will need to be cleared with staff.

There may also be security issues in relation to tools, equipment and the works that are stored within the space. It is desirable that the studio area does not allow access to outsiders but also that equipment and materials are stored there in appropriate and secure containers. Unfortunately the loss of tools and equipment can slow down the progress of your work and can be costly, but the loss (theft) of work can create significant problems and distress for both you and members of your group. The work can be irreplaceable, so take care.

When you work you may like to organise your space in a particular way. Images and objects that are important to you can be displayed and referred to as you work and you may find this particularly beneficial. You may want a quiet space with no people to distract you or you may find that having people around you provides a stimulus. It is a matter of finding where and when you work best.

Specialist studio spaces

The type of space and equipment provided depends on the nature of the activity – the blackout and specialist lighting equipment of the TV, film or photographic studio; the sculpture studio providing space and access to general cutting and construction equipment, such as welding and casting; the animation facility equipped with high-end-specification computers and specialist software.

Location

Working away from the university may require particular care in planning as you may need special permission for access to a location, such as a railway station, or in the street, or there may be ethical issues in the use of models. There may also be particular risks or dangers to yourself, your subject or your equipment. Being aware of what is required is an important part of your professional development and you must follow procedures as specified first by your university and later by your employer.

Example

RISK ASSESSMENT

Why?
Keeps you safe and healthy – good training and a legal requirement.

Employers' duty – must undertake risk assessment of all work hazards. These must be kept up to date. Required to train staff and set up emergency procedures.

Employees' duties – must inform employer of areas of danger and act responsibly, use protective equipment.

Definitions: hazard can cause harm, risk is a chance someone might be harmed by a hazard.

Steps in risk assessment:

- look for hazards, who might be harmed and how;
- evaluate risk – are existing precautions adequate?
- record findings – review assessment.

Two main areas: activity and area/location.

Factors affecting risk: likelihood and severity.

Types of hazard: lifting, handling, falls, air quality, fire, machinery, vehicle movement, chemical, electrical, cut wounds, animals.

Who might be harmed and how: students, academics, technicians, members of the public.

Think safe – stay safe.

ACTIVITY 5.2 Undertake a risk assessment

Undertaking a risk assessment for certain projects is an essential requirement, while for others it may not be considered necessary. This depends on the nature of the activity and the possible involvement of other people, but undertaking an assessment of risks can provide valuable experience of what is standard practice in some industries.

Please note that your university will require you to complete appropriate forms for this purpose.

A risk assessment form must be signed by the responsible tutor for each project before production is undertaken and any equipment is issued or loaned.	
Project title	Student
	Contact information
Date commenced	Date estimated for completion

Describe the nature of the activity

Describe the location/setting and circumstances in which the project will be undertaken

Equipment and materials to be used

Transport

People working with you (names and contact details)

Your risk assessment	*Risk = Estimate the probability of an accident or injury occurring without any control measure* *Impact = Assess the consequence of an accident ranging from superficial injury to serious injury or death*

Hazard	Describe hazard	Risk: state – low, med, high	Impact	Describe precautions to control hazard
Transport/travel				
Location				
Weather				
Heights				
Water				
Hazards: e.g. chemical				

Hazard	Describe hazard	Risk: state – low, med, high	Impact	Describe precautions to control hazard
Equipment				
Electricity				
Fire				
Animals				
Visibility/night working				
Physical				
Other unspecified hazard				

I confirm that the information supplied is to the best of my knowledge, accurate and complete. If risks prove to be higher than anticipated I will cease the activity and seek advice from the responsible member of staff.

Signed Date

Approved by programme/module tutor/lecturer

Signed Date

3 Technical teaching and workshops

There will be a series of workshops that supports the practical work undertaken within the different media. These workshops will vary, from machine to print shops, darkrooms to jewellery- and paper-making workshops. All will require the development of skills to use the processes on offer and this will be delivered in a number of ways by both teaching and technical staff. Some degrees require students to undertake modules that centre upon specialist use of materials, techniques and processes, and students will not be allowed to use workshops if these modules are not completed satisfactorily. There will also be sessions that cover specific processes linked to particular projects. Teaching staff endeavour to time such sessions as relevant to student work so that having presented new material students are able to use it and integrate it into their practice.

There will be lectures and demonstrations, by teaching, technical and visiting staff as part of the overall programme of study. Technical staff will be present in the studios and workshops on a daily basis and are able to assist students individually if required. It is important that you are competent to use the equipment that is available to you – incorrect use can cause damage and malfunction that can put the equipment out of action. If in doubt, always ask qualified staff for further instruction and help.

You will be instructed about the specific health and safety regulations for the workshops you use and it is in your interests that these are followed at all times. In general these will include requirements for wearing appropriate clothing, eye protection and face masks; safety advice on handling cutting or electrical equipment; use of hazardous chemicals; and conduct in the workshop, including prohibition on the use of mobile phones or personal stereos.

Example

HEALTH AND SAFETY PROCEDURES

Staff and students are expected to comply with health and safety rules and codes of practice at all times. Please refer to the student handbook for further details.

- Move with care in the workshop. Have regard for the safety, of yourself and others.
- Never leave equipment unattended if in use. Turn off all equipment when you have finished. If equipment is hot, allow to cool before putting it away.
- When extension cables are in use, ensure that cables do not trail across the floor.
- Never touch electrical equipment or sockets with wet hands.
- Any electrical equipment brought into the studio must be tested by the technician before use.
- Do not eat or drink in the studio or workshop.
- Do not use personal stereos or mobile phones.
- Do not wear loose clothing that could get caught in machinery.
- Wear stout shoes – no sandals or flip flops.
- Tie back long hair.
- Wear protective clothing as advised. Appropriate clothing is available for loan or purchase.
- Clean up any spillages or breakages as soon as possible using the equipment provided. Report any breakages to staff.
- Clear your workspace when you have finished and store your work as appropriate.

Check the available information on good working practice in the workshops and studios that you will work in. In most cases there will be limited opening hours and you will be expected to book the space or equipment for your session. This is normally undertaken on a first-come-first-served basis and you should make sure that you are present on time and fully prepared with the ideas and materials you require. You may lose your allocated time and space if you do not attend punctually.

You will need to plan the session in advance and may need to ask technical staff to order special materials and prepare them for your use.

ACTIVITY 5.3 Practical session checklist

Preparation is all important when undertaking project work. This includes considering what you wish to achieve (aims), the equipment and materials to be used, and any preliminary work that is needed to make the best use of the work session.

Chapter 5 Practical projects

Project title		Workshop	
Date and time		**Technician**	
Aims for session			
Equipment/machinery booked			
Process(es) to be used			
Materials required			
Materials preparation requested			
Costing			
Outcomes			
Possible developments for next session			

Student Experiences:

Introduction to workshops

'When we started the course we were introduced to a series of processes through workshops and this got us going working on particular projects. I've just attended a felt-making workshop and am applying it to a project on the body.'

Example

PROJECT

A project featuring the use of materials and equipment safely and creatively

A degree from the area of three-dimensional design requires a student to undertake the following module:

Materials Technology Processes

Module aims: an introduction to the working environment, essential technical skills and 'best practice' within the workshop.

The Materials Technology Processes module will introduce you to the basic fundamental skills of constructing…The hand and machine skills practised during this module are broad based and transferable; you will use them across many areas. They are the basic core skills you will require for your coursework.

The areas covered by the module are:

- use and safe operation of machinery;
- basic hand skills and workshops practice;
- health and safety within the workshop.

The following techniques and processes required for your study will be covered…

The module is split into three stages:

1 The workshop

Instruction on the use of specialised machinery such as the lathe, milling machine, band saw, sanding machine, vacuum former. Health and safety issues will be covered during this stage. It is mandatory that you attend these sessions.

2 Project work

There will be four projects for you to complete presenting different design problems. These will be assessed. There will also be short 'how to do' lectures. These will be short demonstrations on 'how to do' certain specialised processes or operations such as…We will try to time these sessions so that they relate to the projects as you are undertaking them.

3 Workshop inductions

You are required to attend a series of lectures on workshop practice to be held in the 3D workshops over two days per week throughout the semester. When you have completed these you will be able to use the workshop without supervision. It is important that you attend every compulsory lecture; otherwise you cannot use machinery. Attendance will be registered.

Competency quiz

There is a quiz on the university intranet and this can be located within the home page for this module. Download the quiz and complete it online and email it to the Technical Officer. Completion of the quiz is compulsory to enable you to use the workshop.

Online resources

A series of tutorials and information sheets on machinery, equipment and processes are available online. Go to the module home page for Materials Technology Processes.

For your final assessment presentation you will need to present:

- your research and design drawings covering the projects;
- your design solutions;
- the online quiz submitted as instructed;
- evidence that you have attended all the workshop induction lectures.

4 Equipment and materials

An important part of your developing expertise as a practitioner is to gain skills and knowledge of using specialist materials and equipment, some of which you will need to purchase; other equipment will be available for loan from the university.

Personal equipment

Different subject areas will require you to have specific items of equipment for personal use. In some cases these will include hand tools through to specialist high-capacity computer storage devices. Before you arrive at the university you may receive an equipment list recommending certain items that you are asked to provide and you should endeavour to obtain these. Ensure that you buy equipment of a satisfactory quality as this may last not only for the duration of your course but well into your professional career. With some items it is better to wait until you arrive at the university as you will need to get advice about compatibility with university systems, such as specific versions of software. Make sure that high-value items are properly insured. If in doubt, wait and take advice from staff.

Items for loan

Specialist items, such as cameras and lighting equipment, are likely to be available for loan on a bookable basis from the technician-run stores. You will need to be introduced to the operation of this equipment and technical staff should be available to give you instruction if required. Make sure you book well in advance and that you collect and return the equipment at the agreed times. You will be responsible for the safety and security of the items, will need to know the procedures related to breakages and should report any problems encountered while you are working with them.

The equipment may be insured on university premises but not on location. It is important that you find out the terms for the loan before taking the equipment.

Materials

There will normally be two sources for the materials you will need: a general shop open to students from all subject areas and stocking items such as paper, sketchbooks, paints, markers, and specialist shops situated within workshop areas where materials used within that area are available. Costs of materials vary widely, but universities endeavour to pass on discounts where possible. Some materials will need to be sourced from outside the university and part of your professional training is to know where these can be obtained.

It is of paramount importance that you use the right materials, of the right quality for the work produced, and this can be expensive.

5 Working with people

There are ethical concerns in relation to working with people – from a professional point of view you should be aware of these general principles. Different professional bodies, such as the National Press Photographers Association, have their own codes of ethics related to the representation of subjects. As appropriate to their subject specialisation, students should become familiar with these and follow the guidance within their own area of practice.

There may be issues of consent in relation to the following:

- Class and individual projects in which information is gathered or images are produced in which individuals are identified – this requires that the subjects concerned are informed about the purpose of the work and have the right to withdraw from the activity at any time.
- When subjects take part in production or distribution of art works, such as performances, modelling, fashion, explicit consent will be required. In photography projects it is generally accepted that where a subject is identifiable in the image, but even though they may not have given consent, that they can be depicted. However, if through context, imagery, manipulation or caption an opinion is expressed, specific consent must be given.
- Specific written permission must be given by the headteacher for any activities undertaken in schools.

Take advice within the university about procedures for your study.

Example

CONSENT RELEASE FORM

Date

I hereby consent and grant(Photographer) the irrevocable right and permission to copyright, use and publish all photographs in which I appear, and that are taken by the photographer for any purpose and in any medium.

Signed

To sum up

- Develop a personal method in undertaking project work.
- Approach practical and academic projects in the same way.
- Both approaches require organisation, planning, research and development of ideas and creative thinking.

6 Academic and written assignments

Your degree will require you to undertake project work that involves research and analysis of ideas, theories, techniques and contexts for art, design and media artefacts and products. The assignments required will be presented in different forms, including essays and reports, and you will find a series of examples and activities in the latter part of this chapter and in the appendix to help you to develop the skills required for this work.

In this chapter you will cover

1. academic writing and appropriate use of language;
2. different forms of writing for note and sketchbooks, essays and reports.

1 Writing: why is it important?

Writing is an important way to deepen your learning and for developing and expressing your ideas. You will gain a clearer understanding and ownership of information if you use both written and visual forms to record your thoughts. As you develop your ideas it is necessary to make notes to clarify and explore your thinking as part of the working process. There are many facets to this, as illustrated in Figure 6.1.

Most academic writing that you undertake will also be assessed or will form part of your project assessment. The notes you provide to accompany the project work will help staff to understand your intentions and provide a context for the work. This then forms part of the submission for assessment. There will be a formal assessment of your writing when you are required to submit essays and written reports as the writing needs to clearly communicate your thinking and enable you to discuss ideas and issues to demonstrate your ability to contextualise your area of activity.

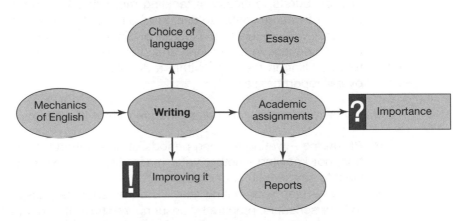

Figure 6.1 Do not underestimate the value of writing in developing your ideas

Student Experiences:

The need to develop writing skills – assessment of practical and academic modules

'The level six modules are marked separately and the grades are awarded. These are then used to establish the level of degree performance and this provides the honours degree classification, 1st, 2.1, 2:2, 3rd, etc. Our degree has a weighting of 75% practical to 25% academic in the form of a long essay, and the performance in the essay makes a significant difference to the degree classification. A student performing at a 2:1 level in practical projects can be reduced to a 2:2 or a 3rd if the essay is of a lower standard. We support and encourage our students to do as much as possible to develop their writing skills before their final year because we have sometimes seen them struggle with the essay and then be disappointed in the final degree award.'

Programme tutor

2 How to improve your writing

Practice

Some students try to avoid writing as far as possible but do not recognise that with practice they will gain confidence, and develop and improve skills. By spending time on it and using study guides, your assessment performance can be improved significantly.

If you have concerns about your writing skills, you should develop a strategy with the aim of improving them. The strategy you adopt will depend on your learning style and also on the problems that you or your assessors have identified and communicated to you through feedback.

You may *write very little*:

- **Problems** – starting, unable to put your thoughts on to paper, writing in short bursts, difficulty in tackling more demanding and extended pieces of writing, unable to decide whether a draft is 'right'.
- **Action** – write regularly in a journal or diary, pay closer attention to the use of language in note taking and sketchbooks, develop your written text by filling in the gaps within a detailed outline of content for the overall report or essay.

You may be required to work on an *extended piece of writing*:

- **Problems** – writing for long periods of time without pause for reflection, not knowing whether your 'mass' of words expresses what you want to say, writing under pressure.
- **Action** – plan your writing time – start as soon as possible and keep to your schedule; prepare by ensuring you have thought through what you wish to say, have made adequate notes to support it; build in breaks for thought and reflection and dedicate certain periods to the task of writing.

Student Experiences:

Critical and cultural studies tutor

'I get tired of students who, on receiving a low grade, say 'I have never been good at writing essays' and then do very little to address their difficulties. Other students, some of whom have learning difficulties such as dyslexia, realise the importance of writing and academic work and then use all the support available to develop the skills required. They then go on to achieve at the highest level.'

ACTIVITY 6.1 Self-assessment - academic projects

There are a number of requirements in undertaking successful academic work, such as writing essays and reports. Evaluate your personal skills and then work to develop them to achieve your potential. What can you do to improve your performance?

	How important			Your skills			
	Not	Quite	Very	None/low	Moderate	High	Priority
Reports							
Case studies							
Essays							
Reflective writing							
Literature review							
Group work							
Presentations							
Writing							
Grammar							
Punctuation							
Choice of style							
Linked sentences							
Structured paragraphs							
Appropriate vocabulary							
Spelling							
Introductions and conclusions							
Acknowledgement of sources/ referencing							

At the end of this chapter and in the appendix there is a series of example and activity boxes that explores the uses of language within a variety of academic contexts. Try them out as they can make a significant difference to your writing skills.

3 Choice of language

Language is developing continually and there are forms considered appropriate for different purposes, depending on whom we are addressing. There is spoken and written language, language that would be used in a job application or an essay, and language which is used to text a friend. There will be terminology specific to your specialist subject – part of your experience as a student is to learn it and use it.

- **Informal language** – spoken conversation, text or email message, a note or letter to a friend, personal notes.
- **Formal language** – spoken in a lecture or presentation, written as in a business letter, email, or academic for a report or essay.
- **Technical language** – subject- and technical-based terminology.
- **Jargon** – the terms used by a profession or specialist group.

Spelling, grammar, typos and factual errors

Do you lose marks due to errors in the text? In principle, no, but it is expected that your work will be as free from errors as possible and the marker will be affected if they are present in abundance. It is important that you make full use of every aid, such as dictionaries and spelling and grammar checks on word-processing software. The aim is for your writing to have authority and if errors are made through lack of attention to detail, this authority is undermined.

4 Writing for note and sketchbooks

Note and sketchbooks allow an approach to writing with the purpose of recording information and exploring ideas. The prime aim will be to meet your personal requirements and as such your notebooks may not be intended for others to view. This will be your decision, but at times staff may ask to see 'backup' work and your notebooks may form part of this, so it is worth considering this possibility when deciding on this form of writing.

Seminar – note taking

Lecturer: 'What form of writing do you undertake?'

Student 1: 'I have a pocket-sized notebook that I carry around to record thoughts about exhibitions or anything that comes along. It's private because if I get frustrated with anything then I can let it out in there in my own words: it's for my eyes only. When I work on an individual project I prepare my notes so that they can be seen by others.'

Lecturer: 'Are there any occasions when you think staff might want to see your supporting work and how do you think they might use it?'

Student 2: 'Maybe if you have done a lot of work on a project and the final piece of work does not show it, or does not quite come off. It's like when you go to a gallery and you see an artist's work and it is not always clear what has gone into it, then you read an interview with the artist or a review and it becomes clear.'

Student 1: 'Yes, staff might want to see how we reached making a final piece of work, who we looked at for our research, the processes we used...'

Lecturer: 'Yes, backup notes can be a great help in assessment. If you look at the assessment criteria for the project you will see that it is important to demonstrate the process of working as well as the final work. We attach a lot of importance to seeing how you have tackled the project in all its stages, the alternatives you have considered and your method of working.'

5 Academic writing

Academic writing is expected to be both critical and analytical, with limited description.

- Think of **critical** as questioning: looking around the subject, asking why, not making assumptions, testing theoretical ideas to see whether they are appropriate, considering what different experts think and whether this is valid when applied to your area of interest.
- Think of **analytical** as taking something apart – an idea, an artefact, an object – assessing the importance of each component individually and overall.
- Think of **description** being limited to saying what is there and setting the scene for your critical analysis.

To achieve this you need to present your discussion in a dispassionate, impartial, rational and unprejudiced way, make use of appropriate language, within a logical structure, using punctuation and signposting to aid the flow of your essay.

6 Writing a good essay

What is an essay?

Any essay that you are assigned will have a number of requirements, aims and objectives and should contain several elements which are essential to completing a successful piece of academic writing.

It will address a set topic or question

The aim of most essays is to examine a specific topic or idea. This will be formulated to reflect the content of the module's teaching and there may be alternative questions available to give choice. The question will be framed to indicate the aspects you should consider in your discussion and will normally allow you to use examples as appropriate to the topic. Alternatively, at later stages in the degree you may be able to devise your own topic and specify the content for the brief and this can be revised and developed as your research and writing proceed.

(See *Procedure for writing an essay*, p. 105, *Writing your brief*; p. 121).

It will set out an argument or point of view

You will be expected to form judgements about the essay topic and ideas related to it, then develop an argument to support your point of view. This is where you can bring in your ideas on how you address the topic. Students can find it difficult to establish an argument as it involves engaging with the topic and following a process of considering the issues critically, forming an opinion and citing information and examples to support it.

(See *Starting Points – looking at other people's work*, p. 155.)

It will be supported by evidence, examples and illustrations

Having developed a personal point of view, your ideas need to be researched to find support from quality, published critical sources. You may be selective as you assemble your material, but at all times you should remain focused on the question and your answer. Quite often as you research you will find information that is interesting but not strictly relevant and there is always a temptation to include it. Keep your discussion to the point. (You may be able to use this information for another project.) Remember to keep details of all sources you refer to, even though you may not quote from them directly; this will form the basis for your bibliography.

Choose examples and illustrations that support your discussion and illuminate the point you wish to make. You should refer to them and establish their relevance in the writing, with the illustrations fully captioned. There should be only as many illustrations as you need in order to support the argument as generally if you focus on a well-chosen image this creates a depth to your analysis. Avoid trying to include images as decoration to improve the appearance of the essay if they do not add to the discussion.

(See *Information sources and intellectual property*, p. 57; *Evidence, citation, referencing, and plagiarism*, p. 114.)

It should be structured in a logical order

Your material should be presented in a logical order, with earlier discussion providing a context for more detailed analysis. There should be an introduction that states the intended content and approach to the essay, followed by the analysis that forms the main argument and a conclusion that rounds up the discussion and sums up your findings.

It should be completed within the set word limit

There will be a word limit and this provides an important discipline in giving you an indication of what is required. There is normally an acceptable margin of + 5% to – 5% on word count. If in doubt, ask your tutor. Regard this requirement as you might do size limitations on a graphic design project – if the dimensions are not as specified, the work is not acceptable and does not meet the requirements for the brief.

As a guide, if the draft of the essay is too long then you must ask yourself whether all the information you have included is relevant or whether there is any repetition and you will have to edit and reduce the number of words. In most cases this will improve the quality of the work by making it more concise. If you find you are falling short of the required number of words

then in all probability you have not undertaken sufficient thinking, reading and research. However, avoid padding and waffle as the essay marker can detect this immediately and the grade will reflect this.

Marking criteria

A good essay will have all of the qualities described here and the marking criteria will include:

- working to the set brief or question;
- quality of research;
- use of appropriate examples of practitioners and contexts;
- using appropriate theoretical and critical models as applied to visual and media culture and your chosen subject;
- analysis and evaluation;
- using reasoned judgements and arguments;
- demonstrating written communication skills using academic protocols (referencing and bibliography).

ACTIVITY 6.2 Analyse a brief

Understanding the brief is the first step in any project or assignment and this should be done by analysing all sources of information available. Doing this will avoid misunderstandings and can provide a series of questions that you may need to ask and answer.

- When choosing your next essay topic, try following this procedure:
- Questions to ask

 1. Any words you are not sure of? Look them up.

 2. Has there been a lecture or seminar on the subject? Check your notes.

- Check the reading list. Browse in the library and do a word search on the internet – try Google Scholar.

- Think about your opinion at this stage: what is your view? Do some writing to clarify your thoughts.

- What are the factors for or against? List them. Create a mind map. These will start to form the basis of key words for your research and reading.

7 Procedure for writing an essay

Think about the time allowed: what is the deadline? You will need to allocate your time to maximum effect.

(See *Organisation and planning*, p. 75.)

First, clarify the task and make sure you understand what is required.

What is asked for?

- **Examine the title and course notes** – what is required? Ask if you are not sure. Write one line to sum up the question.
- **Organise your thoughts** – this is where a mind map can be used. Write one line to sum up your opinion/argument.
- **Write a half page or list what you know and what you need to find out** – what, how, why and when. Use your notes and mind map to decide on key words.
- **Use the key words** – to undertake your searches, read and make notes: record your sources.
- **Decide on a logical plan/structure** – organise your information through headings and sub-headings to fit this. Add details under each heading.

Student Experience

Essay writing – starting points

Lecturer: 'Are any of you having problems knowing where to start with the essay?'

Student 1: 'I'm not sure, but there are several questions that could be ok for me.'

Lecturer: 'First of all, look at them in detail – do they set off a chain of thoughts that suggests a theme that you could work with? List some key points that relate to each topic. Alternatively, if this does not help, think about your current practical projects and your particular concerns at the moment and consider how you could benefit in your thinking by extending your research into related artists, designers or contexts. Then go back to the essay topics and see if you can use this material and develop an approach to the topic that answers the essay question. For instance, there is a question around gender and identity and artists and/or designers who are working in this area. Could you relate this topic in your work at the moment?'

Student 2: 'I'm doing a project based upon the body and how different cultures have represented the body in their art.'

▶

Lecturer: 'So you could investigate a particular artist, or group of artists, who are representative of a culture or cultures and consider it from the point of view of gender and/or identity. This will bring your practice and theory closer together.'

Student 2: 'Yes, I can see how this could work for me as I am working on designs for accessories that are intended to reflect the identity of the user. I could make an analysis of the factors that affect the way we think about ourselves and how other designers have developed products around this.'

Lecturer: 'One thing that can also be valuable in helping you to decide is to think of some examples – they might be magazine advertisements, a product you use or a particular photographer's work that interests you – and consider them in relation to the essay topics. Can the idea behind the question be applied to your examples? Very often you will find that this works well and allows you to write about something that has engaged your interest and helps you to answer the question.'

If you find it difficult to get started, list your points and your ideas to form an outline of the essay, then convert them into sentences and you are underway.

Example

BRINGING TOGETHER NOTE TAKING, PLANNING AND BIBLIOGRAPHY

You need a method that allows for the recording of the details of your sources as you take your notes. By using your word processor you can organise your notes, record the required quotations, make notes, form them into a planned essay structure and complete your bibliography as part of the same process of working.

Make notes on your word processor in **File A (Notes)** facts – ideas, theories, opinions – quotations.

Make the bibliography with full details of the source within **File B (Bibliographic File)**, number each source, add source number to File A (Notes) plus page number.

Continue to take notes from this source with page and source number and save in File A.

Continue the process for each subsequent source numbered consecutively 2, 3, etc. Continue to enter the bibliographical details.

When note taking is complete, print File A (Notes) on paper.

Cut up each individual entry and arrange in the order required as you develop your essay plan.

Then open Notes File A and duplicate and name **File C (Writing)**.

Drag and drop notes from File C (Writing) and place them in the order required from the essay plan and notes.

Start writing, incorporating your notes and quotations into the discussion.

Apply chosen citation and referencing system. Remove numbering from each entry in the essay.

Place Bibliography in alphabetical order by author's name ready for inclusion in the essay.

EXAMPLE

Book researched – File B (Bibliographic File)

Book Number 1 Johnson B, *Photography Speaks/150 Photographers on their Art*, New York, Aperture Foundation (2004)

Note taken – Saved File A (Notes File)

Book Number 1

Larry Burrows 1926–1971 Worked during the Vietnam war, 'Do I have a right to carry on working (photographing) and leave a man suffering? To my mind no, you have got to help…' This is then incorporated into the File C (Writing).

Planning the essay

Your topic, theme and argument are decided, your key words are established, – your notes made. (*See Bringing together note taking, planning and bibliography*, above). Now, you need a structure. You have to decide on an order in which your carefully researched material is to be presented – a mind map can help you to establish your plan.

A guide on the structure of an essay is to start off in a general way in your **introduction**, then narrow the focus on to your analysis before returning to the more general in your **conclusion**.

Example

ESSAY – STRUCTURE – PLAN

1500, 2000, 2500 words

1. Introduction 200–300–400 words

Any or all of the following:

- analysis of the title;
- summarise issues to be raised;
- reasons for choice of topic;
- reasons for choice of examples (if required);
- relationship to own practice (if required);
- definition of terms.

2. Background/theoretical information 400–700–1000 words

- Theoretical and critical models/method of analysis.
- Influences.
- Context.
- Brief biographical details (if appropriate).
- Evidence – historical facts, products, exhibitions, sources.
- Literature review (if required).

▶

3. Discussion/analysis 400–700–1000 words

- Presentation of the argument/point of view.
- Discussion of issues.
- Critical and personal opinion.

All supported by evidence, critical review, examples and fully referenced.

When making an analysis and comparing and/or contrasting examples:

Describe example A.
Describe example B.
Compare and contrast.

OR

When using a critical theory/method of analysis, describe it and then apply it to the examples:

Critical theory/method of analysis 1 – example A example B
Critical theory/method of analysis 2 – example A example B
Critical theory/method of analysis 3 – example A example B

4. Conclusion 200–300–400 words

Summary relating discussion back to title and introduction. Sum up each main point from the paragraphs/sections of the essay.

Bibliography

- All books, journals, websites viewed.
- List of illustrations with captions.

Full referencing of all sources used is essential; these include facts, ideas, direct quotations, paraphrased information and places where further information may be obtained. You will get credit for doing this, but failure to do so will result in lower grades or failure.

ACTIVITY 6.3 Essay planning

Thinking through your approach to the essay topic and planning its content will ensure that you make best use of the time available.

Undertake this activity when preparing your next essay project and refer to Essay – plan – structure, and Tackling an essay project brief.

Essay title

Key requirements in the brief – the essay title in your own words

Your argument/point of view

Introduction

Your interpretation of the topic

How you are going to approach it

Background/theoretical information

Theoretical/critical models to be used

1

2

What, where, when – these are the key points

1

2

3

4

Discussion/analysis

Why? Importance of key ideas/points in your argument?

1

2

3

4

How will you use your examples/illustrations to support your discussion?

Conclusion

Refer to the introduction, the topic and the points you have made in each chapter as you develop the discussion to provide an overall view of the issues.

Bibliography

List of illustrations

Example

ACADEMIC WRITING – WORD CHOICE

Writing for essays is expected to be formal, in clear and plain English and in a **passive form**, which appears objective, giving an impartial discussion of the topic. This is sometimes called the **third person** (he, she, they and it) as opposed to first person (I and we) or second person (you), which gives the impression of being subjective.

An example of the passive form or third person:

This essay will provide an analysis of the work of… This will include a discussion of…

And not:

In this essay I will discuss the work of…and you will find a discussion of…

The first person can be used in **reflective writing** when you are asked to reflect on your experience during a project

▶

Example:

In the process of undertaking the project I initially found difficulty understanding what was required but following a discussion with my tutor I located the right sources and ...

In your writing:

1. Do not make generalisation or assertions:

- The work of ...is very popular.
- Everyone likes action films.

You could write:

- Brown (2009) provides evidence that the work of... has proven to be popular, as evidenced by the sales of the designs.
- Audience figures show that action films are popular...Smith (2010).

2. Avoid the following:

- Research shows...
- Many artists use...

without evidence to support your statement.

3. Avoid clichés – these are phrases used in everyday speech that have become too familiar and are best avoided in academic writing. For example:

- up front
- over the top
- at the end of the day
- all things being equal
- in your face

4. Avoid non-inclusive language: this may exclude people and cause offence:

- A textile designer should use fabrics so that she can ...

You could write:

- Textile designers should use fabrics so that they can...

5. Do not use slang or abbreviations:

- The character in the film was stressed out...
- The ad included a sexist image...

You could write:

- The character depicted in the film showed evidence of stress...
- The advertisement conveyed a sexist representation...

6. Avoid abbreviations:

- it's – should be **it is**
- don't – should be **do not**
- etc. – give the full list
- e.g. – should be **for example**
- i.e. – should be **in other words**
- ICA – should be Institute of Contemporary Arts (on first mention).

Drafting the essay

No essay can be completed in one session or draft – when planning the project you need to allow time for a number of drafts. You may find it beneficial to print with $1\frac{1}{2}$ or double line spacing so that you have room to make corrections.

- **Draft 1** – write to get your ideas down, use your plan, check that you keep to the topic at all times. Do you have enough information? As you go, check spelling and grammar.
- **Draft 2** – check the structure and that information is grouped in the right places and in paragraphs. Is your argument clear and to the point? Are the sentences and paragraphs linked? As you go, check spelling and grammar.
- **Draft 3** – check the style and flow. Read out loud or use a screen reader. Fill in gaps as required. Check word count, spelling and grammar.

Make sure you check the brief:

- **Word count** – if you have too much information, make sure that everything you use contributes to the argument – this is the time to edit out anything that is not relevant. There should never be any doubt in the reader's mind as to why something is included.
- **Presentation** – check that you meet the presentation requirements, especially fonts to be used or avoided, type size to be used, margins required to allow for binding.

ACTIVITY 6.4 Use of language – word choice

The type of language expected in academic writing is specific and formal and its use will provide for a greater authority to your work. Be objective and allow enough time to check that your work expresses your ideas within the accepted form.

As part of checking your written draft, first read through the section on academic writing – choice of words, and use them as a checklist when making corrections.

- Is the language third person, inclusive?
- Are there generalisations or assertions, clichés, slang or abbreviations?

Example

PUNCTUATION AND FLOW

A student writing of Oliviero Toscani 'Breastfeeding' United Colours of Benetton advertising campaign 1989

It is obvious that with this photograph Toscani was making a political statement on racial equality by referring back to the slavery of black people under white oppression, one of the purposes of the photograph evokes feelings in the viewer whether guilt or anger and achieving this suggests this is a piece of successful photography, however the context was that this picture was being used as an advertisement for a clothing company and Benetton dared to publish this advertisement knowing that it would be controversial and gained world wide recognition of the brand name, it could therefore be argued that it was successful advertising.

Year 1 Photography student

It has long sentences and makes overall sense, but with little space available for the reader to pause and reflect on its meaning. When the sentences are shortened there are points of emphasis but the writing does not flow.

It is obvious that with this photograph Toscani was making a political statement on racial equality. It refers back to the slavery of black people under white oppression. One of the purposes of the photograph evokes feelings in the viewer. Guilt or anger was achieved and this suggests this is a piece of successful photography. However, the context was that this picture was being used as an advertisement for a clothing company. Benetton dared to publish this advertisement knowing that it would be controversial and gained worldwide recognition of the brand name. It could therefore be argued that it was successful advertising.

But with punctuation the flow of the writing can make for easier reading.

It is obvious that with this photograph Toscani was making a political statement on racial equality by referring back to the slavery of black people under white oppression. One of the purposes of the photograph is to evoke feelings in the viewer of guilt or anger, and achieving this suggests this is a piece of successful photography. However, the context was that this picture was being used as an advertisement for a clothing company, and Benetton dared to publish this advertisement knowing that it would be controversial and gained worldwide recognition of the brand name. It could therefore be argued that it was successful advertising.

ACTIVITY 6.5 Punctuation

Correct and appropriate punctuation leads to clarity of expression and a flow resulting in ease of reading. Think of the marker reading the work, who will expect these qualities in assessing your essay.

Read through the section on punctuation within Correct English – the mechanics of language before you start. (*See Appendix*)

Select a paragraph written by you as a draft for a current or past project and read through in detail, looking for punctuation and the flow of the writing.

Are the sentences too long or too short? Modify them by use of punctuation and linking words with the aim of aiding the flow. Look in particular for use of commas, semi-colons, colons, apostrophes, quotation marks.

Example

LINKING AND SIGNPOSTING TO AID THE FLOW OF THE WRITING

In your introduction

At first the discussion will … and this will be followed by…and finally…

First and foremost, primarily, at the outset, in addition.

As you develop your argument

It is important to describe the chosen theoretical model before starting the discussion…

Alternatively, when discussing other possibilities…

However, in discussing different approaches…

In addition, the following further points can be made…

Adding to the discussion – moreover, furthermore, in reality, similarly, correspondingly, equally, in the same way.

A different point – with this in mind, others argue that, an alternative perspective on this is…

Introducing examples and illustrations – for example, namely, as follows, for instance, including, such as, … provides insight into, …seen within the context of…

Showing the results of something – therefore, as a result of, for this reason, it is evident, it can be deduced that, it can be inferred that, the consequence is…

In the conclusion

To summarise, the designer has…

In conclusion, this investigation has revealed…

In brief, in the final analysis, on the whole, to sum up briefly…

ACTIVITY 6.6 Essays and paragraphs

Linking and signposting

To aid the flow and continuity of your written work, look for linking and signposting at the draft stage. This technique involves the linking of material and indicating its relationship to the overall argument and its development. The purpose is to provide coherence to the writing and help make your argument clear to your reader by stressing it throughout the discussion.

Select an essay you have written in the past or the draft for a current assignment and read through in detail, looking for its content, structure and links to other paragraphs and sentences within it.

- Look first at each paragraph in detail.
- Does the paragraph explore one topic or aspect of your discussion?
- Does the first sentence introduce the topic and link to the previous paragraph?
- Do the second and third sentences explain, explore and place in context ideas related to the topic?
- Do subsequent sentences provide relevant examples illustrating the topic?
- Does the final sentence sum up and introduce a link to the next paragraph?
- Are there linking words between sentences?

Then look at the essay as a whole.

- Are there signposts from one paragraph to the next?
- As you develop your argument?
- As you discuss your examples and illustrations?
- Linking your discussion at all stages from introduction to the conclusion?

8 Evidence, citation, referencing, plagiarism

Many students experience difficulty with how to use expert writers to support their argument. If this is done correctly then you will demonstrate important evidence of your reading and research and you will be credited in the mark you achieve for your essay. If you do not cite your sources you will be accused of **plagiarism** (that is, taking other people's ideas or research and using them as your own). This will usually result in failure for your work if you do not state where the information has come from by referencing the sources used. For most students, any plagiarism that occurs is a result of not understanding academic practice, which stresses the importance of crediting others' work and enabling other academics to access the specific material.

When written text has been copied, there is a range of software available for tracing plagiarism, so for this reason students are usually required to submit their work in both paper and electronic form.

When do you reference?

You reference when you:

- provide factual information, such as dates, places, techniques;
- quote an author's words;
- refer to ideas or concepts gathered or paraphrased from a particular source;
- indicate further information could be located at a particular source.

If you follow these rules you will avoid plagiarism.

You will need to provide the following information: who wrote the work, when was it written, the name of the work and where the particular piece of information can be found. There are a number of different methods of doing this and it is most important that you use the one which is approved by your university. Systems should not be mixed. Look at the description here of two systems: the Harvard system and the British Standard or Numeric Bibliography Footnote system. The information required is the same but its presentation is different.

Example

CITATION AND REFERENCING

The Harvard referencing system

This book uses the Harvard referencing system and many universities have adopted this system as standard. Harvard is an author–date system – in-text citation with a final list of references. This should not be mixed with a footnote system.

Books

Author's name and initials
Year of publication, in brackets
Title of the book, in *italics*
Edition, if other than the first
Place of publication
Publisher
In-text citation

'Whichever system you choose, you must use it consistently, accurately and follow the rules.' Price & Maier (2007:309) (Author(s), date, page number), more than two authors would be Price *et al*. (2007:309).

Reference

Price, G. and Maier, P. (2007) *Effective Study Skills; unlock your potential*, Harlow, England, Pearson Education.

Chapter from an edited book

Name and initials of the author of the chapter
Year of publication in brackets
Title of the chapter
Title of the book, in *italics*
Editor(s) name(s) and initial(s)
Title of the book
Edition, if other than first
Place of publication
Publisher
Page number or chapter

Journals

Author's name and initials
Year of publication, in brackets
Title of the article (not in italics)
Title of the journal in *italics*
Volume number and part number
Page number(s)

For example, In-text citation:

Meadway (2008) observes that 'Most investors and governments are searching for a green "silver bullet" – some new technology that will reduce carbon emissions…'

Reference:

Meadway, J. (2008) 'Community spirit: innovation against climate change'
New Design. 60(1) pp. 36–39.

Electronic sources

There are many sources of information available electronically and the principle is the same in that you must provide enough information to allow someone else to find it.

Internet pages (uniform resource locators or URLs)
Articles in electronic or internet journals
Electronic books
Online newspaper articles

Provide as much of this information as you can

Author's name and initials
Year of publication, in brackets; if no date, square brackets [n.d.]
Title of the websites in italics followed by [online]
Publisher if available
Available from: URL [date accessed]

In-text citation:

Dr Jane Fitzpatrick (2003) of the University of the West of England points out that 'Plagiarism in academic work carries stiff penalties'.

Fitzpatrick, J. (2003) Studying and learning: plagiarism. *HERO* (*Higher Education Research Opportunities*) [online] Viewed 24.01.2009. Available at www.hero.ac.uk/studying/guidance_and_support/studying_and_learning/plagirism.cfm

British Standard or Numeric system

When the British Standard or Numeric Bibliographic system is used, a number is placed within the body of the text and the full details of the source are placed as a footnote or endnote.

'The key purpose of any citation and its corresponding reference is to enable you, or someone else who is reading your work, to identify and locate the original text'[1]

Price, G. and Maier, P. (2007) *Effective Study Skills; unlock your potential*, Harlow, England, Pearson Education, p. 309.

Other than this the presentation of information is similar for both Harvard and British Standard systems.

Photographs and images (see Information sources and intellectual property, p. 57.)

Illustrations that you use should be captioned, indicating details of the work reproduced and a reference to where you located the image. This may be from the internet, books or journals. Each illustration should be preceded by Figure 1, Fig. 2, etc. and should be placed at the point in the text where the image is discussed or in a list of illustrations at the end of the essay or report.

Figure 1. Sylvie Fleury, *Bedroom ensemble*, 1997, Artificial felt, wood construction. [No dimensions] Installation view. Courtesy Mehdi Chouakri, Berlin, 1997. Riemschneider, B. and Grosenick, U. (Editors), (2000) Art at the turn of the millennium, Koln, Taschen Colour plate p155.

Figure number, artist/designer's/photographer's name, title of work (*italics*), date, dimensions of the original, medium, location (gallery, museum, private collection) and the bibliographic British Standard or Numeric details of the publication or website where you sourced the image.

Films

Title (italics), date, director.

TV programmes

Title of programme, channel, time and date of transmission.

Example

REFERENCING

Quotations and paraphrasing

Note the use of quotation marks '…' where a **key phrase** expresses something better than you could:

Sylvester Stallone films include as many 'signifier(s) of masculinity' as is possible creating a 'grotesque masquerade of manhood' Moore (1988:53).

A **longer quotation** (20–30 words) should be introduced as follows:

Suzanne Moore (1988) observes that 'Explicitly sexual representation of men has always troubled dominant ideas of masculinity, because male power is so tied to looking rather than to being looked at'.

If longer it should be indented.

To **paraphrase** or not: an alternative to direct quotation is the paraphrase, where the same content is put into your own words. This can be valuable because there is less interruption to the flow of the sentence.

Moore (1988) comments in *The Female Gaze* that the ideas of dominant male roles are challenged when graphic sexual images of men are presented to be looked at as this results in them appearing to be passive.

The idea must still be referenced to provide an indication of your sources and your range of reading.

Three **full stops** are used to indicate that something has been left out of a quotation …

Moore (1988) concludes that 'The striking thing about contemporary images of men…The feel is softer, their gaze unthreatening'.

Alternatives:

> Moore (1988) suggests that…
> Moore (1988) argues that…
> Moore (1988) states that…

Reference at the end of the essay or report.

Moore, S. Here's looking at you, kid! Gamman, L. and Marshment, M. (Eds) *the Female Gaze: women as viewers of popular culture*, (1988) London, The Women's Press.

(Author of the essay or article, title of essay, editors of the book, title of the book, date of publication, place of publication, publishers)

9 Bibliography

The bibliography is where you record all the relevant sources that you have used in exploring the topic, even if you have not quoted them all directly in your written text. This provides a demonstration of what you have researched and also allows the reader to see the range of material you have accessed. Keep a careful note of content and sources for your personal reference.

The bibliography should be presented in alphabetical order by author's name. The following table illustrates the information required.

	Author	Year of publication	Title	Title article/ chapter	Issue	Place	Publisher	Edition	Page no.	Date accessed
Book	/	/	/				/	/		
Chapter in book	/	/	/	/			/	/	/	
Journal article	/	/	/	/	/				/	
Internet	/	/	/						/	/

Material on citation adapted from Price and Maier (2007) and online guidance notes, University of Hertfordshire Business School: Academic Support Unit, and Skills Handbook University of Hertfordshire School of Creative Arts.

(See *Note taking*, p. 46.)

10 Writing reports

A report is designed to provide an account of an investigation and an evaluation of a process, a project or work placement. Evaluation gives you an opportunity to assess the value of something and to demonstrate what you have learned.

The project may require a *log book* in which you record your day-to-day observations as you experience the placement or undertake the process. It is difficult to remember important details if you attempt this after the event.

Your report will require the following:

1. introduction describing the aims and purpose of the report, including the methods used in preparing the report;
2. sources of information and theories used;
3. your observations on the results produced;
4. samples and illustrations where necessary;
5. your learning;
6. conclusion.

ACTIVITY 6.7 Report writing

There are specific requirements in writing a report and this should be approached differently to working on an essay. Before starting, check the information that is required. Keep careful records of your observations and this will facilitate the task.

Title/subject	Deadline
Aims	
Log book	
Method of preparation	
Information sources See referencing	
Theories applied See referencing	
Description of process/company	
Your observations	
Your learning	
Samples/illustrations	
Conclusion	

The order presented here could form the structure or plan for the report.

11 Writing your brief

You will need to provide:

- a title that includes the area of the study, theme or idea for investigation;
- the purpose of the project.

The proposal will need to state your aims and intentions, together with a description of the theme, area of investigation or design problem to be solved. It should also include sources for research, such as library and internet, practitioners to be investigated, critical analysis and literature review; industrial contacts/sponsorship; techniques, materials and media to be used; planning stages, process of ongoing evaluation and presentation of intended outcomes.

Example

INSTRUCTIONAL WORDS IN THE BRIEF

Analysis – describe key ideas in depth, show relation to each other and their overall importance
Compare – similarities and differences
Contrast – show differences
Criticise – make judgements on merits of ideas/artefacts; backed by evidence
Define – specific meaning
Describe – account of what is there in detail
Discuss – reasons for and against; implications
Evaluate – look for strengths and weaknesses; judgement of value
Illustrate – use examples/illustrations to explain something
Review – make a survey of something.

ACTIVITY 6.8 Writing your own brief

When writing your own brief, make sure you clearly set out your intentions as your assessment may well be related to the quality of the proposal itself and to you achieving your intended outcomes.

Checklist

Project title	Deadline
Theme/area of investigation/design problem	
Personal aims	

Project title	Deadline
Outcomes/what you will produce	
Materials/media/techniques	
Sources for research	
Industrial contacts	
Funding/sponsorship	
Planning stages	
Evaluation stages	
Presentation	

To sum up

- Writing is a very important part of your studies.
- For most students there are new skills and techniques to learn in order to produce successful academic writing.
- Developing and implementing these skills will significantly improve your performance in assessed written work of all kinds.

References

Price, G. and Maier, P. (2007) *Effective Study Skills; unlock your potential,* Harlow, Pearson Education.

7 Assessment, 'crits', presentations

Assessment of your work is an important part of your studies and there are various stages at which this takes place. There will be both formal and informal opportunities to discuss the work in progress (formative assessment) on both an individual basis and in group tutorials, seminar discussions, presentations, peer assessment and the interim critique. This process allows you to respond to suggestions as you are developing your work through the various stages to its completion. Following this, summative assessment takes place before arriving at a final grade. Your course will have certain learning outcomes that describe what you are expected to achieve in terms of learning, and staff will be working to agreed assessment criteria on which judgements are made and marks and grades are the result.

In this chapter you will cover:

1. different forms of assessment, including self and peer assessment;
2. preparation and presentation of work for assessment;
3. the use of feedback within the assessment process.

1 Stages in the assessment process – formative and summative

The various stages in the assessment process are shown in Figure 7.1.

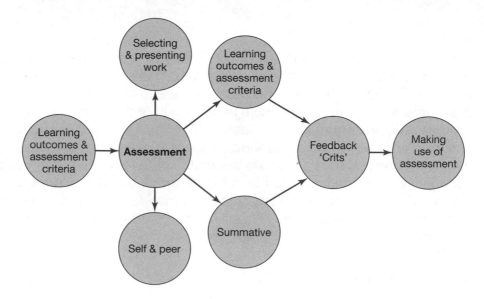

Figure 7.1 Stages in the assessment process

The components and mechanisms of assessment

Once the project brief has been established, you move on to summative and formative assessment, with their various components (see Figure 7.2).

2 Self and peer assessment

There are arguments for involving students in a self and peer assessment process in that it equips them to make judgements about themselves and their work. Students surveyed on graduation stated that it gave them valuable experience of assessing their performance in preparation for the workplace.

Student participation in the process can be undertaken at various stages during a programme of study or in project work. For example:

■ when the project is set, a choice of appropriate learning outcomes is discussed;
■ considering what should be assessed – what is important in the project;
■ and how this should be done;

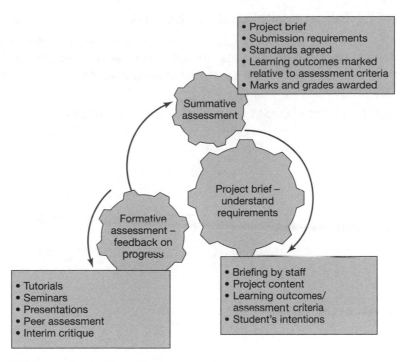

Figure 7.2 Summative and formative assessment

- discussing assessment criteria;
- and setting assessment criteria in consultation with students;
- making self-assessment and peer-assessment feedback comments;
- suggesting self/peer-assessed grades/marks.

It is considered that the more students are involved in this process, the more there will be increased self-awareness and a general improvement in performance.

Students may be asked to undertake marking exercises in which samples of work, both practical and academic, will be available and students will be asked to comment on them, apply the assessment criteria and suggest grades. This can be discussed within the student group and with the tutor's comments taken into account at a later stage. An alternative approach is during the preparation of project work or essay writing when students are divided into pairs and asked to prepare the work in two stages. Initially, the ideas and development stage or first draft of an essay is marked by a colleague, who makes suggestions as to how the project might be improved. These suggestions are then incorporated into the final submission with an account of the suggestions and improvements made. For example, 'I have widened my range of sources as my partner commented that I had relied too heavily on the internet.' 'The comment was made that my conclusion was too long but I do not agree because...'

ACTIVITY 7.1 Self-assessment sheet – project work

As part of the evaluation of your work, and how you have undertaken it, it is worthwhile trying to step back and consider its strengths and weaknesses. You will then be able to discuss the project with colleagues and staff as part of the assessment and self-appraisal process.

This could be undertaken with a friend or on your own initiative.

Strengths of this piece of work
Weaknesses of this piece of work
How this work could be improved
The grade it deserves
Why this work deserves better than a … grade
What I would have to do to turn this into a … grade for the project
What I will pay attention to in my next project
What I would like your comments on is…

3 Feedback – 'crits'

Tutorial and seminar discussion provides an informal opportunity to discuss work in progress. Also, on completion of the project you may have direct personal feedback on your performance from members of staff.

During the 'crit' you will be expected to present your work and ideas to staff and fellow students. This process is intended to provide a positive discussion and analysis to assist in the development of the project (interim 'crit' or formative assessment) or to present the final outcome of the project (summative assessment).

You will need to prepare yourself to answer these questions:

- What have you done?
- What alternatives did you explore?
- Why did you do it this way?
- How did you make it?
- What is the context?
- What are your strengths and weaknesses?
- How could you make improvements?

There will be comments and suggestions in relation to your work. It would be helpful if one of your colleagues could make notes of these so that you can consider them after the event. Be objective – this is a discussion of your work, not you personally. Some comments may well be contradictory and you should be prepared for this. You have to assess the value of the criticism, learn from it and in so doing take ownership of it, then make constructive use of it in progressing your studies.

ACTIVITY 7.2 Preparing for critiques

The criticism of your work is an important stage in your development. You may be nervous about speaking in front of staff and fellow students to explain your intentions, but by considering the following questions you will be better prepared for the critique experience.

What have you done? What is your interpretation of the brief? How did you approach the problem/brief? Personal aims?
Why did you do it this way? Reasons for your choice of the solution presented?

What alternatives did you explore? Describe the ideas you considered and reasons for not developing them
How did you make it? Materials, techniques, experiments, reasons for choice?
Research undertaken – context, relevant practitioners and their work?
Strengths and weaknesses?
Improvements?
Other comments

Student Experiences:

Formative assessment

Notes of discussion at 'crit' – live project – animation for an advertising website.

The context: the client is a model maker. The brief is to produce advertising to demonstrate the use of models in advertising – models of barges within town and country settings.

Need to consider the content of the advertising narrative – looking at current forms – the themes used in different animations. Possible ideas: *Thomas the Tank Engine* but using canal barges, a murder mystery on the canal, a spoof of the *Titanic*, or an adventure as in *Dora the Explorer* – there is a need to develop the story line. Experimenting with Flash movie at this stage using stop frame animation with long shots, close-up, lighting – and possible use of jerkiness of stop frame to develop humour. Developing the technique, need to work on the advertising concept and content in producing the story board.

4 Selecting work for assessment

Check the brief to ensure that you have followed all instructions. Does your work demonstrate all the requirements for submission, such as:

- technical folder (research, experimentation);
- project/design proposal;
- concept design/ideas development;
- presentation and visualisation;
- models or maquettes;
- identification of market and user;
- material specification;
- report of group-based work;
- evaluation?

Can you identify and demonstrate evidence in the work that relates to the learning outcomes and assessment criteria? Select work on the following basis:

- Will you make the presentation of the work in person or will the work be assessed by staff without your presence?
- If making a presentation to students and staff, how many?
- How much time have you been allocated?
- What display facilities are available – wall space, projection facilities?
- Decide what is essential to show and tell the story of your approach. In what order should the work be presented?
 - Look at the work in this order and consider what you wish to say
 - Does it present a logical progression without comment?
 - Should there be notes/labels to explain your intentions?
- If making the presentation in person, amplify the notes and rehearse – allow time for questions.
- In preparing an exhibition space consider:
 - How much wall space is available, is it in good condition? If not, can you improve it/paint it?
 - Does your work need to be mounted? Is this appropriate depending on the nature of the presentation – interim 'crit', final degree presentation?
 - Make sure that you meet normal professional requirements within your subject area. For instance, are the mounts clean and trimmed square as appropriate for design presentations?
 - Are captions needed?
- Work not included should be considered as backup, be placed in appropriate folders and arranged for ease of access, with a clear and logical presentation of your ideas and outcomes.
- Be objective – consider the person who is viewing your submission and remove work that does not support the story you wish to tell of how you have undertaken the project.

5 Learning outcomes and assessment criteria

A system has been developed based upon learning outcomes and assessment criteria. The learning outcomes are intended to provide clear information to students as to what they are expected to learn – what they should be able to do and understand, the abilities and skills they are expected to demonstrate – and to encourage them to recognise that creativity and commitment to a deep approach to learning will be rewarded in the assessment process.

Intended learning outcomes would normally include students having to demonstrate knowledge and understanding of:

- subject material; understanding of theoretical perspectives, concepts, issues; application of knowledge in different contexts; analysis of problems and possible solutions;
- abilities and skills;
- teamwork, communication, time management, resources management, workshop skills, information technology.

The intended learning outcomes presented to the student will be more detailed in providing information specific to the particular subject requirements, such as knowledge of working methods or design processes, technical and research requirements. These should be read in relation to the assessment criteria.

It should be noted that there may be unintended learning outcomes where a student has, through a process of personal investigation, considered the 'problem' presented by the brief from a valid but unexpected point of view. Within subject areas where there is no set answer and where creativity is valued, this outcome should be accepted and rewarded in the assessment process.

Assessment criteria are designed to provide a measure of student learning to an agreed set of standards when applied to the stated outcomes. A successful student will be able to demonstrate some or all of the following:

- knowledge and understanding of current work by practitioners within the discipline;
- visual language, materials and techniques;
- ideas development;
- conceptual development;
- creative design process, analysis, selection;
- exploration of techniques and materials;
- range of alternative solutions presented;
- realisation;
- production of final product, artefact for various professional/audience requirements;
- **aesthetic** and functional judgements in realisation of outcome.

Transferable skills will include taking personal responsibility and showing initiative in the management of one's own learning.

On submission, students will be expected to provide:

- evidence of ideas/design development;
- application of a range of appropriate media, methods and materials.

As this set of assessment criteria shows, there is a series of requirements and through the brief the lecturer can specify what evidence is required to demonstrate what the student needs to submit to meet these requirements. These may include a proposal for the work, evidence of research of practitioners/markets/users, material and technical information, initial concept and its development, alternative approaches considered, final artefact, report on group-based activity and a project and personal evaluation. This enables the staff to make judgements on the totality of the work produced and the method of working that has been undertaken. It provides for a student who may venture into new and unknown areas, and in doing so has significant learning experience but may have difficulty in fully resolving the final product for the project. The demonstration of the process of working in approaching the problem forms important evidence and is taken into account along with the final artefact when an assessment is made.

The assessment standards are agreed within the staff team and universities will have different ways of doing this. There may be a system of standardisation through discussion of work from similar projects, marking individually and then discussion of the grades or marks produced, or team marking in staff groups. The decisions made should be based upon collective professional judgements and monitored by external examiners or moderators.

6 Levels of learning

Within education there has been established a taxonomy or classification of levels of learning distinguished by increased complexity in attainment:

- No evidence of anything learned.
- One correct and relevant element is present.
- Several relevant elements are present but in an unrelated way.
- Relevant elements are brought together and related to each other within a structure.
- The structure of elements is related to other areas of knowledge; answers are relevant to the question but not bound by it.

These levels of learning will be translated into marks and/or grades, which may be percentages and /or numerical and/or alphabetical grades. Familiarise yourself with the system employed at your university.

7 Making use of the assessment process

The assessment process is summarised in Figure 7.3.

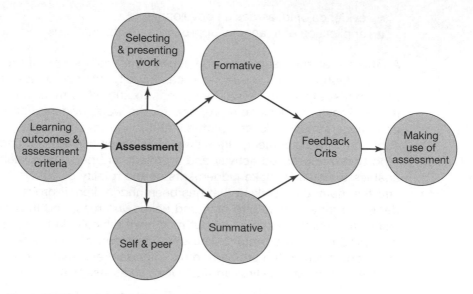

Figure 7.3 The assessment process informs your understanding of your performance

Source: Adapted from Jackson, B., 'Assessment practices in art and design: a contribution to student learning?' Reproduced from Gibbs, G. (ed.) (1995) *Improving Student Learning – Through Assessment and Evaluation*. Oxford, Oxford Centre for Staff Development. Source: www.londonmet.ac.uk/deliberations/ocsid-publications/islass-jackson.cfm viewed 21/04/2009.

Preparing for assessment provides a stimulus to get things done and helps to focus your thinking on what is required. As preparation for the workplace it is an important component in giving you experience of working within a time frame and of your work being scrutinised and judged as it will be when you work in industry. The assessment process should inform your understanding of your performance as part of your learning and education.

If you do not understand the process or the reasons why a grade has been awarded for your work, you should ask your lecturers to explain.

Example

THEORIES RELATED TO ASSESSMENT AND LEARNING

As a student you undertake a wide range of activities, from workshops to presentations, essays to personal project work, and some of these culminate in assessment in one form or another. Universities and the wider public see this as an important task as it maintains the 'standards' for the subject area and the qualification awarded. It is designed to provide a measure of the student's learning and their achievement.

What is the thinking behind current practices and their relationship to studying Art, Design and Media? Certain past assessment practices are considered to have been inadequate in that they tended to emphasise what had been taught and did not centre on the student learning experience, and these are not the same. Within current practice it is intended that students should know what is expected of them and what they need to do to achieve to a high level. It is recognised that course and syllabus descriptions do not provide this information. The overall aims within art, design and media education is to provide activities/projects that recognise the importance of problem solving in various forms and that this requires creativity, imagination, originality and understanding. Creativity is defined here as 'imaginative activity fashioned so as to produce outcomes that are original and of value' (Davis, A. ADC – LTSN Learning and Teaching Fund Project: Effective Assessment in Art and Design: Writing Learning Outcomes and Assessment Criteria in Art and Design. www.arts.ac.uk/docs/clatd learningoutcomes 21/04/2009.

To do this the student must be encouraged to adopt a 'deep approach' to learning that allows them to view the subject, field of activity and immediate task in the round, and 'take risks and challenge orthodoxy' in solving the 'problem'. Tasks should be set so that the student is encouraged towards divergent thinking, such as a graphic design project brief that asks a student to consider the marketing of products from a third world country and the contribution they can make as a designer in this process. This provides an opportunity to engage with a topic of current relevance, for the student to take ownership of it, and to consider and generate alternatives. A project that requires a student to design packaging for a wind-up torch for the third world requires a limited, closed and convergent process of thought. This can result in a 'surface approach' to learning where a student may be encouraged by the teaching and assessment system to seek to determine what achieves good grades, and produces highly finished work at the expense of depth of research, developed from a single concept and is superficially focused on a predictable solution.

Through a teaching ethos and the use of learning outcomes that provide clear information to students as to what they are expected to learn, what they should be able to do and understand, the abilities and skills they are expected to demonstrate, students will be encouraged to recognise that the deep approach will be rewarded through the assessment process.

To sum up

- You need to understand how assessment is undertaken for your course.
- You will need to prepare your work for submission in such a way that it is clear to the assessor how you have approached the project.
- You need to regard assessment as part of your learning experience.

8 Preparing for the future – work experience and careers

Your programme of study will be designed to prepare you for the future and to enable you to use your experience in higher education to help meet your long-term aspirations and the development of your career prospects. Your course will have sought to equip you with the thinking and practical skills and experience of working practices to enable you to start and develop a long-term creative and satisfying working life.

Art, Design and Media courses place emphasis on doing and making within the chosen medium and from the outset of your degree you can and should focus on professional requirements.

In this chapter you will cover:

1. linking your degree studies to career development;
2. preparation for work experience and placements;
3. ideas of how to market yourself and prepare for your professional life.

USING THIS CHAPTER			
If you want to dip into this chapter	Page	If you want to try the activities	Page
2 In-course professional development	138	8.1 My aims for the final year/level 6	136
3 Graduate employment	140	8.2 An action plan for the final year/ level 6	138
5 Work experience	141		
6 Work placements	142	8.3 Work placement approval form	143
7 Marketing yourself	144	8.4 Your CV – checklist	148
9 Job applications and interviews	149		

1 Your degree programme and the future

At the beginning of your degree you can take an active and forward-looking approach to the planning of your studies by appraising and developing your skills, keeping a record of your experience and progress with planning for personal development tools (universities should have courses and software to help you do this) and developing your CV. In considering your future it is useful to consult your university careers service, which will have expertise in employment prospects for graduates. These elements will enable you to be active in your decision making. Figure 8.1 illustrates the various approaches you can take to your career.

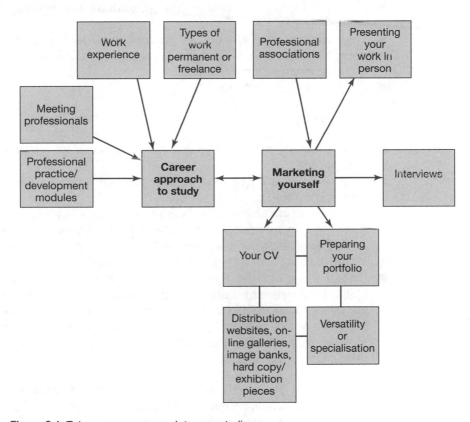

Figure 8.1 Take a career approach to your studies

In taking a career-based approach to each year, consider the following:

Year 1 – Level 4:

- Establish skills – develop thinking, practical and subject skills.
- Undertake any freelance work that is available.

- Aim to broaden your experience and consider any additional activities you can undertake, such as participation in societies, volunteering or paid part-time work. Being active while you are at university will demonstrate elements of initiative, enterprise, independence and the capacity for hard work – qualities potential employers are looking for.
- Establish your CV.
- And enjoy yourself!

Year 2 – Level 5:

- Consolidate your skills – aim to orientate your interests and practice towards professional outcomes.
- Continue freelance work, including working on university projects when available.
- Take advantage of any and all contacts to extend your work experience. Participate in projects that relate to the outside world, such as commissions and competitions.
- Continue to develop your CV.

Year 3 – Level 6:

- At an early stage review your CV and consider where this could be strengthened.
- Look at what is required of you for the year ahead, make an action plan and work to it.
- Focus your practice in developing your experience towards the area that you wish to work in and continue to develop your portfolio. Take advice, evaluate your strengths; is there a need for work that demonstrates versatility or a degree of specialisation?
- One of the problems that final-year students face is that pressure builds and there is an understandable concentration on the immediate course work requirements: completion of the dissertation and the development of practical project work towards final assessment and the degree show. This means that preparation for the next step after graduation – getting a job – tends to be of lower priority.

It is difficult to get the emphasis right, but remember that during your final year the workload will increase significantly and so organisation and time management become increasingly important.

ACTIVITY 8.1 My aims for final year/level 6

You are beginning the final stages of your degree, time has gone quickly and you will have much to do. Consider the following factors so that this culmination of your studies is as productive as possible and takes into account preparation for life after university.

I am considering my career choices and these are:
I have sought careers advice and the advice is:
I have decided to emphasise:
My reasons for this are:
I will be undertaking the following research on this area of employment:
I am hoping to gain experience in the following work-related areas: My contacts are:
To build towards this goal I am developing the following project(s):
I have drawn up an action plan for my year's study:
My CV The main strengths are: I need to work on the following: The design of the CV will feature:

ACTIVITY 8.2 An action plan for final year/level 6

Having looked at the areas you need to work on during the final year, it is valuable to map out what is required and create an action plan for each project you need to undertake.

Title/details of requirements	Semester	Date set	Deadline
Project 1			
Project 2			
Project 3			
Project 4			
Project 5			
Other			

2 In-course professional development

Many degree programmes include professional practice and development modules that are designed to direct students towards a career orientation. These usually take place within the second year of the programme and require the student to consider their practice and interests in relation to work-related outcomes. This will be provided in a number of ways within your programme:

- lectures by visiting professionals;
- research into possible career opportunities and student evaluation of personal skills relative to job requirements;
- projects working with visiting industry professionals;
- student membership of professional associations;
- live projects working for clients within the university, outside individuals and organisations;
- responding to competition briefs;
- collaboration with external individuals or organisations;
- work experience directly within industry;
- reporting to staff and students on work experience undertaken;
- continuing to develop personal skills, speaking in seminars and presenting work.

You should remember that the more you do relative to the workplace, the more confidence you will have that you can perform as required when you graduate.

Example

PROFESSIONAL ASSOCIATIONS

There are a number of subject-based associations, such as the Society of Illustrators, Artists and Designers (SIAD), Broadcasting Entertainment Cinematograph and Theatre Union (BECTU), and the Association of Photographers, whose role is to promote excellence within their media field through encouragement of professional standards and recommending business practices for members. Services vary but may include advice on areas such as contracts, pricing and marketing; they also provide a forum for discussion of key issues within the profession, a showcase for members' work and a particular interest in education and training.

There are different membership grades, which include student and graduate membership. A student member while studying can make contact with the profession through access to lectures, events, publications, portfolio surgeries/criticism and circulation of student CVs to full members, with the possibility of work experience.

On the completion of a higher education qualification, there is the opportunity for graduate membership through to fellowships after qualifying periods of working within the industry. There are normally membership fees, but the information and possible contacts can be invaluable.

Example

TYPES OF WORK

Permanent or freelance

During different stages of your career there will be options regarding the type of employment you undertake and this may vary in relation to your subject discipline, the structure of the industry and your inclinations. There are advantages and disadvantages to both.

Permanent employment offers stability, a degree of permanence, a career structure, working in a team, on-the-job training, guidance and experience of business practice. However, there is the possibility of getting stuck in a limited area of work, having others making decisions for you and about you, not being in control of where and when you work and becoming involved in company politics.

Freelance work offers lack of stability with varying day-to-day demands – if you have work you are often close to being overwhelmed, if there is little work you have to endeavour to find it – freedom to make decisions for yourself about the type of work and where and when you work. But you need to take control of creative and business aspects such as marketing, pricing, invoicing, managing finances and taxes.

Different areas of the industry use people in different ways. Freelance designers and media workers may be taken on on temporary contracts to augment permanent staff on major projects, while other work may be commissioned on a job-by-job basis. Within the media industries there is a practice of taking on freelance 'runners' who assist in a variety of ways, from office work and cleaning to control of extras on a film shoot. It is a way of entering and learning about the industry as a first stage but may have long and irregular hours, and is low paid.

3 Graduate employment

During your degree, try to explore a variety of relevant fields, with the aim of focusing on what is right for you. Do some research into your intended specialist area or industry. You may not be able to get the 'ideal' job, but you are in a better position having shown initiative and established personal goals so that you can go on to apply for something closer towards reaching your aspirations.

- Use free and low-cost sources to gain information – internet, libraries, etc.
- Sign up with employment agencies that provide a wide range of valuable advice and information, including notification of job opportunities posted to you by email.
- Check advertisements from all sources, including local papers.
- Look out for graduate fairs.
- Keep active – if you do not have a job, establish a daily routine to give yourself a structure to keep you going. This can be difficult if you have too much time.

Student Experiences:

Graduate employment

'My first job was to work in the office, answering the phone, doing paperwork, and my opportunity came when there was a problem on a fashion shoot and I was able to prove that I had the skills to help solve it. Now I am assisting regularly in the studio and on location.'

4 Real-life projects for outside organisations

Participation in projects for outside organisations, including other university departments, can provide an opportunity to work within a familiar environment in terms of facilities and materials, yet you may need to meet the requirements of a client who may not understand the processes or limitations of working within a particular specialist medium. You will experience the reality of negotiating and clarifying the brief to ensure your understanding of what is required is the same as that of your clients. You will present your ideas and solutions, meet deadlines and present yourself and your work in a professional way. And with these projects you will have the benefit of discussing your work in progress with course staff.

You may be asked to undertake work through personal contacts and it is worthwhile talking to teaching staff about this. Provided the nature of the work fits within the curriculum for your course, their advice will be beneficial in conducting this work in a business-like manner.

5 Work experience

Universities organise work experience in different ways and its availability may be a determining factor in you choosing a particular degree programme. This may form part of:

- a module or be a dedicated work-related module (possibly optional);
- work during the summer vacation;
- a specific additional and credited year of study in industry or abroad.

This can be of significant benefit to you in building your experience for the future and may help you establish useful contacts that may serve you well in seeking to obtain your first job.

Student Experiences:

My work experience

'I did a work experience during my second year and found it very interesting. The company produced fashion patterns for the industry. These were graded and were produced for retail manufacturers and I was in quality control. It was quite technical and I had to check that the information and data on the computer were correct and complete using Gerber technology as it went into the system. Two weeks later they rang me up and offered me a job during the summer holiday.'

'My work experience that was planned for two weeks ended up in three or four months' work and they offered me a permanent job. This was tempting, but I decided that if I took it I would not get my degree and this was important to me. The company said I should be in touch next year. I was working for Models and when I first started I was nervous that I knew too little, but I found that I was equipped to do the work. The work that the company do is high-end, very detailed models of buildings which would be used for display purposes. For instance, one that was made was displayed in the marketing suite at Canary Wharf in London. The work required lots of planning and there was auto cad used to check the order in which things should be done and to check that the plans were correctly to scale. There is a need to choose the right materials to get the effect you want within the budget and how finished the model needs to be. The cad software controls laser cutting and the cc mill to produce the parts to correct sizes. These are then assembled. Though it was not my strongest subject, I did maths at A level and the way of thinking has helped me to do precise work.'

Staff may make arrangements for work experience, but in many cases you will need to take the initiative, with their help. There will be procedures to be followed and if the work experience is expected to coincide with teaching periods, you will need to obtain approval. You may be required to attend certain sessions back at the university, such as tutorials.

Take any opportunities you can.

6 Work placements

The university will have a set of procedures designed to ensure that you benefit to the full, are safe in the workplace, are properly treated in terms of employment and equal opportunities legislation, and are properly supported when you are there.

You will be expected to:

- meet with the organisation in setting up the placement;
- take responsibility to ensure that appropriate employers' liability insurance is in place by the organisation;
- obtain approval and provide the required details to the university administration;
- conduct yourself professionally;
- follow all procedures, including ethical, confidentiality and health and safety requirements for the organisation;
- undertake a risk assessment as required by university procedures;
- manage your own learning as required within your programme;
- record your experience and learning – this may be in the form of a reflective journal and/or formal placement report and may include a presentation to fellow students;
- inform lecturing staff if you experience problems.

Lecturing staff will be responsible for:

- briefing and preparing you for the placement;
- approving the nature and content of the work and arranging assessment as required;
- ensuring personal contact is maintained with you and your employer;
- making arrangements for your return to the university.

ACTIVITY 8.3 Work placement approval form

When undertaking a work placement, these details will need to be placed on record.

Complete the following:	
Degree programme	Date
Organisation	Name of student
Contact name and position	Contact details – address, phone number(s) and details

Nature of work to be undertaken	
Starting date	
Finishing date	

Assessment details

Learning outcomes to be met

To be submitted

Record of work undertaken

(photographs if permitted)

Reflective journal

Placement report

Requirements

Presentation (format, number of words)

Deadline for submission

Approved by representative of host organisation	Lecturer responsible for placements
Position	Signed
Signed	Date
Date	

Student

Signed

Date

7 Marketing yourself

Marketing yourself is in effect conducting an advertising campaign designed around you, your work and your future. The key factors are to:

- focus on your strengths and abilities;
- focus on the organisation, position, job or funding body you are applying to – an application for an office job or in retail will be different to a designer seeking a start-up grant for a small business;
- find a concept for design and delivery that will gain attention.

How to get attention

There are various ways to get yourself noticed:

- **The degree show** – let people know that it is happening, issue invitations to all your contacts as well as friends and family. Make sure you are there during private views and the show itself – do not wander off and talk to friends. If you cannot be there during the period that the show is open, make sure you have well-designed and plentiful business cards, CVs and a visitors' book, and respond immediately to any contacts made.
- **Your portfolio** – this should show both a degree of specialisation around your particular interests and elements of versatility. It should be adaptable depending on how it is to be used. Take advice – use the academic staff, visitors and professional associations. Get used to presenting your portfolio – the more practice you have, the more prepared you will be for that all-important job interview. Take notice of any advice given and continue to develop your portfolio.
- **Your CV** – this may be the first point of contact and would normally include personal details, education and qualifications, experience and employment details, a personal profile and your key skills. There is no single format that is appropriate – it will need to be adaptable depending on its purpose, such as an application for employment, a bursary, a commission, a placement. There is a case for a unity of design and presentation of CV, letter head, and business card with a visual style that reflects your media style and personality. Impress with your creativity and professionalism.

You need to establish your target audience for your marketing campaign to reach potential employers. This will come initially from your personal contacts, employment agencies, job advertisements and professional associations. You may not get an immediate response, but persistence is everything. You may need only one opportunity and it may not be in the specific area that you want to work in, 'but a foot in the door gives you a chance'.

Alternative formats and methods of delivery

You will need to consider all of these:

- on paper;
- an electronic format allowing your marketing package, including a selected portfolio and CV, to be circulated by email;
- websites, including portfolio online galleries, student portfolio show-cases.

Student Experiences:

My career so far

'I used a contact to get an occasional job as a runner for a company making low-budget pop music videos. Using this I progressed to be a runner for a multinational film company, which led to becoming art director, then creative director. I have now started my own company– taking in my old employer as my first client.'

Student Experiences:

Graduate freelance

'I had started freelancing, working around illustrative typography and promoting myself through sending emails to various art directors and publications, including a number of samples of my work. I was getting some work, but it was only just enough to keep me going. When I had some spare time I experimented with a change of style and when I sent this out I hoped it would improve things. My first commission was from a national newspaper to produce seven double-page spreads for their colour supplement. The deadline was three and a half days – with no sleep! But I did it and since then I have continued to have commissions based on this style, including a national advertising campaign. It has changed my life.'

8 Your creative CV – information required

Regard creating your CV as an opportunity to make a personal and individual statement. You will need to provide a resumé of your interests and qualifications, but it needs to be presented with imaginative design, working to a professional standard (including, for example, high standards of photography of your work) that will attract attention.

There is no set format for a CV and you will have to make decisions where information should go, but it needs to:

- reflect your particular interests;
- relate to your work and therefore your subject specialism;
- be targeted to the industry, showing that you have researched the application.

The content needs to demonstrate the use of appropriate English (incorrect spelling or grammar is a disaster: you should check it and get someone else to check it) and the design is as important as the content. It should be no longer than two pages, with key information on the first page. Space is therefore precious, so the content needs to be concise and easily read. See the example below.

The standard information required in a CV

Name	Address	Other personal details such as age, gender, ethnicity, single or married, or disability do not need to be included
Home phone number	Mobile phone number	
Email address	Web address	
Personal profile (optional) 'Product design graduate with experience in industry and project work demonstrating ability to innovate with materials applied to consumer products, able to work in creative teams with particular interest in developing engineering solutions towards manufacture…'		Can be placed at the beginning and will be read first and should be directed towards the subject of the application. Brief statement of your attitudes, skills and experience. Statements made need to be supported by the rest of the CV
Education and qualifications Latest qualifications first: degree, A levels… University, college and school where you studied, with dates You could describe an emphasis on your practice, particular skills gained, such as processes and software used, and the topic for the final dissertation		Think carefully about what to include. It will be assumed that if you have an A level in a subject you will have a GCSE in that subject. It may be important to include subjects such as IT, business or languages that might relate to a job. You do not need to include grades for your initial qualifications
Employment history Most recent within creative industries, name of company, job done, skills gained – try to relate to subject of application 'I assisted in the finishing department mounting large photographs for display panels' Write in positive terms: Designed…photographed…organised…attended…developed…worked with…supported…planned… Other employment listed chronologically		Not all work that does not relate to the application needs to be listed but you should seek to demonstrate that you have the required skills, such as organisation, teamwork, initiative, reliability, motivation… Remember that if you have worked as a receptionist this will demonstrate the ability to meet people in a business-like manner, or as a silver service waiter shows the ability to work under pressure

Key skills (optional) This is an area where you can draw attention to your particular skills: technical, creative, IT, personal. A CV might read as: Contributed as a team member by using practical common sense to solve problems Able to take direction and use initiative to achieve what is required Flexible in approach and determined to succeed in my chosen career	You may not have direct experience of the industry that you are applying for but this provides an opportunity to relate what you have done in terms of common or transferable skills that would be required
Interests (optional) Information of other activities not mentioned elsewhere: societies, positions held; your approach and philosophy to your medium, key themes/influences in your work; understanding of the industry 'Match secretary for the university……..society responsible for arranging fixtures' 'Personal illustration style drawn from a long-term interest in…'	This is an opportunity to provide something extra. You may have an interest in an aspect of architecture, theatre, a sport, potholing… An employer will be able to deduce something of your personality and how 'rounded' a person you are from this, and with luck might have a parallel interest. Remember, you will need to be able to answer questions on this if you meet them so do not over-elaborate. This may or may not be relevant to an application for funding of a project
Design/presentation A professional layout, with unity of style between CV, covering letter and business cards For creative posts it can be valuable in demonstrating the nature of your work; alternatively images of your work can be presented separately in addition to the main CV	This forms part of the overall design of the CV, so make sure it relates to the subject or job applied for and does not obscure the text supplying important information. Do not over-elaborate and remember the cost of production and postage
References (2 or 3) Name, position, address, contact details: university work related personal You don't have to include this unless asked for but a statement that 'References are available on request' will suffice	Always ask the referee first. It is better not to duplicate, say, using two of your lecturers. If possible, they should be as recent a contact as possible and provide different aspects of you and your experience
Declaring a disability Nature of disability and special requirements expressed in positive terms. 'I am dyslexic and have used the following software… in writing my dissertation and have achieved an A/B grade' You will need to decide on the timing of your declaration (on application, at interview, when starting the job), but you are not required to inform your employer, though it may be advisable to do so, in order for any arrangements to be made	Legislation requires employers of more than 15 people to make 'reasonable' adjustment for the employment of people with disabilities. Contact Skill (The National Bureau for Students with Disabilities www.skill.org.uk) which provides detailed advice on the law, job applications, access to work and other aspects of your education

ACTIVITY 8.4 Your CV: checklist

Use this checklist to ensure that you have the information you need and which is appropriate for any application that you may be making. Do this in advance and you will be better prepared.

Name	Address	Checklist for your CV
Home phone number	Mobile phone number	Remember to find out about the employer, the job and the skills required
Email address	Web address	
Personal profile (optional)		Focus on the job and yourself – is it clear, concise, is the information relevant? Are your strong points emphasised early on? Is the order of presentation logical?
Education and qualifications		Is the style of language right for the purpose – job or application for funding? Are the spelling and grammer correct? At least two people should check it for you.
Employment history		Do the design and layout provide for easy reading? Is there any repetition? Will it photocopy clearly? If emailed, can the format be opened on both a PC and a Mac?
Other employment listed chronologically		Will the design attract attention from others? Show your CV to others – ask whether it is effective.
Key skills (optional)		
Interests (optional)		
Visuals		
References (two or three)		
Other information		

9 Job applications and interviews

As part of your research you have located a possible job opportunity that interests you. You decide to apply. What do you do next?

When making a job application ensure your English is clear, concise and correct. It is normal to include a covering letter – this will be read first and needs to lead the employer to look at any other material. It should state the job reference number and specification as a headline and first paragraph, why you meet the requirements, and demonstrate knowledge of the company. Use your own letter heading if you have one, with a straightforward 12–14-point type with 1.5-line spacing on good quality paper. Where other documents are included, state at the base of the page Enclosed – CV, application form, etc.

Interviews

Your marketing plan has worked, the CV has attracted attention and you have been invited for a personal interview. Some of the same factors apply as for the preparation of your CV and the application form:

- Know the company, look at its website, find out how they approach their marketing, what is their style.
- Know the job – read all the information available to you.
- Prepare your portfolio – assume you have 15–20 minutes, so ensure the work is relevant and presented professionally.
- Think about who might be interviewing you – in a small cutting-edge company the panel will probably be creative people, whereas in a larger organisation it will probably include personnel staff plus creatives. This may affect the way you dress – be yourself: a suit and tie may be right or not, but dress smartly.
- Rehearse showing your work – think about what you would like to say about each piece and overall. Do not be put off if they look at your work very quickly – professionals can assess work as they will know what they are looking for.
- Think of questions you can ask.
- Arrive in good time.

To sum up:

- Think 'career' throughout your course.
- Plan and prepare for the future.
- Be professional.

3 An introduction to critical, cultural and contextual studies

An important aspect of art, design and the media is a component that requires you to study ideas of the role of the artefact, object, animation, garment, photograph, product, double-page spread, film within contemporary society. You will look at how these communicate, where, when and what influenced their making, and their importance within different cultures. These ideas and theories can be complex. The following chapters introduce some of them to enable you to start to inform and enrich your practice through understanding them in considering your work and the work of others.

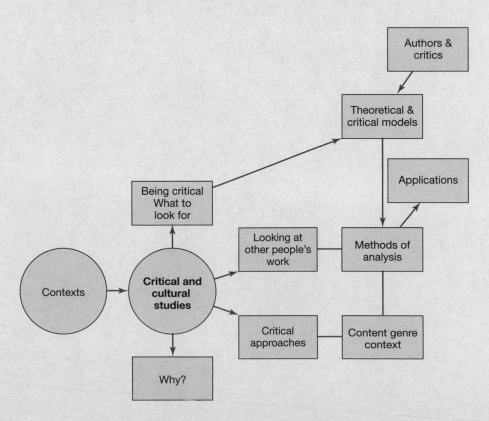

9 Critical, cultural and contextual studies

Critical, cultural and contextual studies provides the theoretical and academic component of Art, Design and Media degrees. Students approach this area of their studies from different viewpoints: there are those who have the ambition to work in the creative industries because they have a predominant interest in making, and find the more theoretical and abstract thinking of the philosophy of visual and design culture difficult; there are others who find that the concepts and arguments concerning the role of media and cultural theory stimulate their thinking and practice. Within higher education it is recognised that the graduate practitioner should be informed of contemporary ideas and therefore this content forms part of practice-based degrees.

This chapter is designed to provide you with strategies to enable you to approach this area of study, which is likely to be new to you and can at first appear to be demanding in terms of the language and ideas involved. This introduction discusses the reasons for the inclusion of critical and cultural studies within degree-level work and then, in a series of stages, describes ways of approaching art, design and media work within the context of the thinking of important academics, writers and critics.

In this chapter you will cover:

1. discussion of the purposes of this area of study;
2. looking at other people's work;
3. concepts, theories and contexts explained and applied.

USING THIS CHAPTER			
If you want to dip into this chapter	**Page**	**If you want to try the activities**	**Page**
2 Starting points – looking at other people's work	155	9.1 Looking at other people's work	157
		9.2 Identify modernist and postmodernist thinking	165
3 Key ideas and thinkers	158		
4 Modernism and postmodernism	163		

1 Why critical, cultural and contextual studies?

The purpose of critical, contextual and cultural studies is to provide insight into a number of key concepts to enable you to apply them to your work and gain greater understanding of your area of practice.

- Critical means to explore a subject area, its practitioners and practices, and to question the ideas, methods and approaches.
- Cultural means the ideas and thinking commonly held about the subject area and medium, its conventions and purpose.
- Contextual means to consider the time and context or setting in which a work is made, be it a film, painting or design.

There may be an historical element in this study but in the main the focus is on contemporary work.

Your theoretical programme of study should inform your studio practice, help you to develop personal working methods and widen your range of skills. These include the ability to locate and analyse information, to evaluate theories and arguments, and to present your findings in a clear and communicative form. Most courses require you to incorporate the outcomes of your research into the preparation work within practical projects, where you might investigate the themes and ideas used by an artist or designer, or a particular style or genre. You will be expected to provide a reasoned argument for your judgements and phrases such as 'I liked it' or 'I didn't like it' will not be accepted. You will be asked to undertake analysis, which means to break down into consistent and important features and to establish their significance and relationships. This involves choice of appropriate examples, to be objective, questioning and critical, and this is the most important skill required for critical and cultural studies and in your practice. Many degree programmes include the critical, cultural and contextual studies component as separate modules or courses.

Assessment for these modules is usually in the form of an essay. The academic essay provides a form in which you can explore and present your thinking about a specified subject. There are rules about how it should be presented. You will be expected to provide your findings based upon reading and research through the use of footnotes, referencing and a bibliography. You will be expected to make your argument with clear and logical use of language, offering evidence supporting a point of view from authors that you have located and researched on the subject. The ability to present such information in a professional and attractive form is a skill that may be required during your working life.

Within some degree courses there is the possibility of offering alternatives to the academic essay that allow you to demonstrate all of the above. This might be a PowerPoint presentation, story board or production, but you need to remember that the criteria for marking will centre upon the quality of analysis and content. Academic staff may advise you that significant time spent on the form and presentation of any alternative would be better spent on research. It is also rewarding to achieve well in an area that you are not so familiar with and a good piece of written work may well be of value in your portfolio.

The language used in writing about visual and media culture can be difficult, but once you understand the meaning of these ideas, and as you grow in confidence, you will find there is much to be gained in relation to your practical work.

Student Experience

Academic work

'I have always been nervous of the academic side, but the tutor has been very helpful and I have been able to build up my confidence. I have discovered it is so interesting and important to know something of the history of graphic design.'

'There was a lot new to me when we started the theory and essay writing, such as the ideas and footnoting and everything. What I have found out is that it is your interpretation of what you see but you have to find out what others think. You have to prove you have done the reading and research to support your opinion.'

(See *Approaches to project work*, p. 62 and *Academic and written assignments*, p. 96)

2 Starting points – looking at other people's work

A starting point in undertaking the more academic aspect of your study is to look at other people's work and to ask and answer a series of questions:

- What? Where? When?
- How? Why? Whose interests?
- What meanings are generated?

See Figure 9.1.

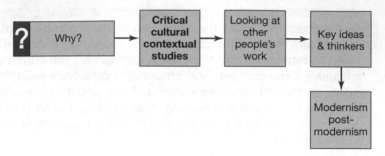

Figure 9.1 Looking at other people's work

These questions form the basis for investigation and analysis and can be used to contextualise your research in support of both practical and written projects. Consider the following example.

Describe the artefact (object, design, art work, film)

- **What is it? What does it look like?** Begin by looking at what is there and describe it as precisely as possible. This is a form of denotation.
- **Where was it made? When was it made?** This provides the context of production. An object made 100 years ago in Europe will be different to an object made in Japan in 2011. How does this influence the nature of the object itself? Always make a record of where the information came from – you may need it again in the future.
- **Who made it?** Was the artefact made by an individual artist or designer, or made by a production team as in a film? What are their backgrounds, influences? What further research do you need to undertake to answer this?
- **How was it made?** What are the materials and techniques of production – small scale or mass production?
- **Why was it made?** What are the makers' motivations? For example, there is a difference between the making of an experimental animation and some information graphics. Is it made as a personal project or is it designed for small-scale or mass production? What evidence do you have for this?
- **Whose interest does it serve?** Who benefits from this being made and in what way? Does its production support an *ideological* position? This may be explicit, forming part of a propaganda campaign that is pro green, or implicit in supporting the consumption of products, as in advertising or reviews of consumer products within lifestyle media coverage. What evidence do you have of this?
- **What meanings are generated?** This is an important area in that the conclusion of analysis is to consider the mechanisms of communication and how artefacts are designed to communicate and generate connotations and meanings, whether intended or not.

Starting points – looking at other people's work

> **Ideology** – the system of values and beliefs which an individual, group or society holds to be true or important. The media is one agent that perpetuates these within a society, as are the government, the church, the education system and others. (2006) *Dictionary of Media Studies,* London, A & C Black, p. 114.

How the audience will receive information is also determined by their experience. Those who are familiar with a particular medium will have different expectations and react differently to those who have no experience of it. The expertise of creative professionals is to recognise this and consider the nature of the intended audience. From this we can gain understanding of motivations, influences and meanings and this can stimulate us in our own work and give us understanding of the medium we are working in.

(See *The theory of the sign*, p. 174, *Semiotic analysis*, p. 176)

Use this as a starting point. Undertake some reading to clarify and expand your knowledge.

ACTIVITY 9.1 Looking at other people's work

A first step in the study of your area of practice is to look in a systematic way at the work of existing practitioners and consider what, where, how and why it was made.

This study can be used to support academic and practical projects.

Select an artefact, such as an object, design, artwork or film, that relates to your interests and analyse and research it under the following headings.

Describe what it is
What does it look like?
Make written and visual notes
Where and when was it made? Place, date
Were there particular ideas, or art, design, media or cultural influences? Name them, describe them and collect examples. Were there people working at that time who may have influenced the work?

Who made it?
Name(s)
Background – influences
How was it made?
Materials, techniques
Why was it made?
What is the purpose and motivation for making this?
Whose interest does it serve?
Can an underlying set of ideas be seen that the work supports?
And above all, what meanings are generated?
How do you interpret this artefact? Is there evidence of other people's interpretations?
Make sure that you record details of all your sources so that you can find them again if you need to.

(See *Gathering information*; p. 45)

3 Key ideas and thinkers

All artefacts are produced within the world, with all its history, variety and complexity. Our ideas of making sense of them are based upon our knowledge and beliefs incorporating our understanding of how people think and live, and factors such as science, economics, politics, religion, collective and personal 'society', and the arts, design and media.

Ideas about the human mind and how it works, economic life and production, the organisation of society and the effects of the media on our sense of the world all have a bearing on our thinking about, and our understanding of, art, design and the media. A series of ideas and theories has been developed over time to help explain and make sense of our society and culture: these ideas and theories are continually being reassessed, developed and debated by critics, academics, philosophers and practitioners.

Ideas about the human mind and how it works

Sigmund Freud (1856–1939)	Theory of psychoanalysis based on treatment of 'neurosis' and the 'unconscious' mental processes. The psychology of our mental processes and how we think forms the basis for further interpretations or readings.
Jacques Lacan (1901–1981)	Rereading of Freud (psychoanalysis from 'biological' to 'cultural'), world represented through symbols, signs and images.
Laura Mulvey (1941–)	The pleasure of looking.
Julia Kristeva (1941–)	Gender and identity.

Critical thinking has been informed by theories of psychoanalysis (Freud) that were developed in relation to neurosis, where issues are resolved through talk, with the aim of achieving a self-revelation. Popular ideas relate to notions of child sexual development and the consequent drives, including the Oedipus (love of mother, rivalry with father) and **castration complex** (loss of the penis or phallus as a symbol of power), phallic symbols and the Freudian slip (where a statement is made unintentionally that reveals an unconscious concern). Interpretation can be both subtle and complex and comes from dreams where the unconscious is symbolised. Art works are seen as a text (in which there is nothing accidental) being equivalent to a dream in which the artist's repressed desires are revealed. Surrealism is the best-known art movement exploring this, allowing an audience to experience the revelations of this process with the 'pleasure' of a voyeur or viewer.

Considerable importance has centred on theories of child development and the **mirror stage** (Lacan) and our entrance into an awareness of self and of language (which is based on the symbolic, at first in the form of speech, then words and letters). Lacan argues that during this process of human development a sense of lack or loss is felt related to our early experience when the mother or 'provider' met all needs, and as greater independence is achieved there is a desire to compensate for this in the use of substitutes (**fetish**) to satisfy this sense of loss. The more common understanding of this is the use of sexualised fetish objects, such as high-heel shoes, leather and rubber wear, and in pornography the display of female genitalia. This idea of human beings searching for pleasure through images as a form of substitute can be applied across the arts and media. We also talk of shopping therapy or commodity fetish, in which we gain satisfaction from buying goods.

Writing from a **feminist** perspective, Mulvey critically examines the concept of the pleasure of looking (scopophilia) in connection with cinema audiences and the people on the screen. Her argument is that the hero (male) controls the action and the more passive heroine (female) is there to be looked at under this male **gaze** and this confirms women as stereotypical sexual objects. These representations of people, and the way they are looked at,

is believed to reveal power structures within Western society. Alan Jones explores aspects of fetish, some say sexism, in his painting and sculpture, and Cindy Sherman explores aspects of the passive female observed.

Within feminist criticism, developing as part of the women's movement in the 1960s, there is consideration of the relationship between sexual (biological) and gender (culturally formed) roles within society and the formation of **identity** (Kristeva). This centred on debate over what is natural and formed biologically, and roles and behaviour that have been learned within a given culture. **Post-colonial theory,** gay, lesbian and queer theory, developing in the 1990s, can be related to feminist ideas in that it concerns identifiable groups which are seeking recognition and acknowledgement within society as a whole.

Economic life and production

Karl Marx (1818–1883)	Overthrow of 19th-century capitalism, Marxist theory – ownership of the means of production. Underpins thinking of some current theories.
Louis Althusser (1918–1990)	The role of the artist.
Walter Benjamin (1892–1940)	Mass reproduction of works of art, film and photography.

There have been 'two' rival economic systems, one of capitalism, private ownership through investment for profit, and the other designated as public ownership of the means of production and distribution (Marx). **Marxist theory** was 'interpreted' and applied as communism, that is state ownership of resources, industry and transport. During the twentieth century these ideologies were coupled in national, global, political and cold war rivalry with, latterly, an ascendancy of capitalism and 'free democracy' and markets. Ideas behind these economic systems are important as they affect our understanding of the function of the artist (Althusser), design and media within these systems, and how they are regarded and supported. Recently, significant consideration has been given to the production of commodities, consumer culture and conservation within all areas of society through the application of **ecological design**. The need to develop appropriate technologies and use of resources has become paramount within economic and design practice.

Arts and media activity takes place in an economic context and there are differences between design and production teams contributing to the manufacture of consumer products or film making, and an individual making jewellery or a painting. The number of people involved and scale of finance are different, although artists such as Damien Hirst work with a number of assistants, with the sale of his works amounting to significant sums. The status of the work of art (Benjamin) has changed from individual works

enjoyed and owned by the privileged few to mass production of art, such as prints which can be enjoyed by many people, along with the design and media industries making products for global consumption.

The word **institution** has two meanings, both of which can be applied to art, design and media and their production, distribution and consumption. In one sense institution can be applied to organisations such as arts funding bodies or galleries, film production companies and cinema owners, or industrial companies that clearly have considerable effect on the cultural and economic climate. Within media studies there is a different use of institution and this refers to the conventions, both cultural and political, under which the media product is produced and distributed. These are self or externally regulated conventions of what is 'acceptable' in society, and artists who accept the consequent adverse criticism and publicity challenge these conventions.

Organisation of society

Michel Foucault (1926–1984)	Power of institutions and use of knowledge to support existing ideas and structures. Linked to post-structuralism.
Edward Said (1935–)	Western societies' view of 'colonial' peoples, particularly from the East (Orientalism). Post-colonial theory.
Simone de Beauvoir (1908–1986)	Sets feminist agenda.
John Berger (1926–) and Germaine Greer (1939–)	Women's bodies represented as objects of desire.
Guerrilla Girls (1985–)	Sexual politics and the arts.

An element of contemporary understanding of society is based upon discourse about how power and knowledge of the use of language (Foucault) – with specialised language used in specific areas of activity such as the law, medicine and the arts – establishes a power relationship between those who have mastery of the language and those who do not. Foucault also challenged thinking on the power of institutions in relation to madness as a culturally defined condition, aspects of sexuality, prisons, punishment and surveillance (Storey, 2006). He developed ideas of the **panopticon** (that is, being seen and visible at all times), where, due to continuous surveillance of our actions, we become self-regulating in our behaviour. This constitutes a power relationship between the observer and the observed which is particularly relevant in modern societies where we are continuously under observation by security cameras.

Within the modern world there are power relationships between different countries and continents based upon earlier colonialism and current eco-

nomic power. The theory of **post colonialism** (Said) provides a critique in which the Orient (a fiction representing the 'mysterious' East) has been created by the West (the colonialising power) as the '*other*' on which stereotypical ideas and sexualised fantasies can be projected.

During the 1940s and 1950s, ideas leading to the development of feminism emerged (de Beauvoir), in which the expectation that women should be feminine whilst confined by their role in a male-dominated society was challenged. Further critiques of the representation of women's bodies as objects of possession and desire, both historic and contemporary ((Berger and Greer), were made. This movement has been developed by activists around sexual politics and in recent years towards a recognition of the dominance of the 'canon' present within the history of art, with it appearing that only male artists produced works worthy of recognition and inclusion (Guerrilla Girls).

Discourse – the development and dissemination of a set of ideas.

Canon – the inclusion of particular art and artists who are accepted as having been important in the development of any medium and whose works are included in histories or collected by national galleries. Who should be included is open to dispute, for example questions are asked as to why there are so few women artists represented up until the mid to late twentieth century.

The effect of the media and the internet on our sense of the world

Marshal McLuhan (1911–1980) Media as an extension of human experience.

Jean Baudrillard (1929–2007) Theory of 'simulation', the process of images or constructions substituting for a 'normal, lived' experience. Disneyland and 'reality' television.

In less than a generation our experience has altered fundamentally through the development of the **media technologies** (McLuhan): 50 years ago communication was limited to landlines and radio across distances, with information in books and libraries; now we have mobiles for all ages and instant electronic communication in speech and information access via the world wide web. It appears that in the space of a childhood this has become the norm for our existence. A significant element of our experience has come through the technology of the media, with its virtual constructions or simulacra of the world, where the **hyper real** seems more real than the 'real world' (Baudrillard). Philosophers and thinkers have been fascinated by these developments and seek to understand their consequences.

4 Modernism and postmodernism

The development of the thinking about the arts, design and media is taking place within the context of the past and a present that is rapidly changing. We need to consider where the practice of our particular specialist medium is coming from historically and to consider aspects of what is broadly categorised as **modernism** (covering a period roughly from the 1900s to the 1970s) and **postmodernism** (up to the present).

Modernism

'The over-arching concern of the Modern Movement was to break down barriers between aesthetics, technics and society, in order that an appropriate design of the highest visual and practical quality could be produced for the mass of the population.'

Greenhalgh (1990)

'Modernism has a long and varied usage as a designation of a period, a style, and a theoretical stance. ...Typically modernist art was concerned with the new, using unconventional materials, novel means of construction and experimentation with new ways of depicting the subject.'

Meecham and Sheldon (2000)

Modernism:

- is of the modern and industrial – rejecting the traditions and methods of the past, with an emphasis on progress and a distinction between high and low culture;
- reflects the period of production – elitist and distant from ordinary people – remembering that much that was produced in the past was challenging to people at the time of making but is now generally accepted and appreciated as it has become familiar;
- is the age of the hero but at times with racist and sexist undertones.

Postmodernism

'Post-modernism designates a set of attitudes towards the nature of knowledge – how we know things and how we know what we know is influenced by what we believe. It is for the most part based upon the idea that the world does not function according to rational laws and that the most challenging of human issues are beyond the grasp of scientific approaches.'

Marsen (2006)

Chapter 9 Critical, cultural and contextual studies

Architectural theorist Charles Jencks (1939–) 'is a notable critic of modernist brutalism (and) claims that architecture should be able to work on several levels simultaneously, appealing to the general public no less than to the architectural profession.'

Sim, and Van Loon (2001)

'Postmodernism. An overused catch-all...The downside of postmodernism's lack of fixed principles and standards is a melancholic schizophrenia, in which the lack of boundaries becomes itself restrictive and even repressive...'

Meecham and Sheldon (2000)

Postmodernism:

- is of the electronic and virtual age – collapse of ideas of history and certainty – with global communication systems and endless production, reproduction, circulation and exchange of signs and images, and the questioning of the 'real';
- focuses on issues and ideas around the 'death of the author', blurring the distinction between original and copy. Mixture of media used. Different combinations of materials – plastic with steel, surface pattern;
- takes on experimental and playful approach – limited concern for function and ergonomics. Eclectic influences: egyptian art, kitsch, punk, science fiction;
- reflects the period produced, exploring issues of appropriation, representation, gender and identity, reality, racism and colonialism.

Distinctions between high and low culture or media are not recognised within postmodernism, and all forms of visual and media culture are seen as of value and worthy of study. One area that has developed is the combination of different media and materials into **hybrid** forms, such as combinations of photography and video within sculptural installations.

Both modernism and postmodernism are all-embracing terms which can be applied to all arts, from literature to architecture, and which embrace many concepts within art history and critical theory.

Contrasting modernist and postmodernist thinking

Design/logic	Chance/chaos
Anti-history	Retro
Meaning	**Deconstruction**
Truth	Irony
Harmony	Discord
Restrained/appropriate	Eccentric/anarchic/inappropriate
Coherence	Collage/**montage**
Monochrome	Colourful
Permanence	**Ephemeral**
Serious	Trivial/playful
Abstraction	Representation

ACTIVITY 9.2 Identify modernist and postmodernist thinking

Modernism and postmodernism are concepts that embrace much art, design and media activity from now and the recent past, and can provide a useful initial point for analysis.

Select images, designed objects, buildings, films, and consider the characteristics of your chosen examples. Can you identify them as modernist or postmodern in concept?

To sum up

- Looking at other people's work is a good starting point.
- Ideas about the human mind and how it works have a bearing on our understanding of art, media and design.
- Look at ideas and theories of:
 - how things are made within economic systems;
 - people and society, our ways of thinking and attitudes to each other;
 - the media and how the world is represented;
 - the historical and contemporary context of modernism and postmodernism.
- These all have a bearing on our thinking and understanding of art, design and media.

References

Greenhalgh, P. (ed.) (1990) *Modernism in Design*. London, Reaktion Books, p. 9.

Marsen, S. (2006) *Communication Studies*. Basingstoke, Palgrave Macmillan, p. 29.

Meecham, P. and Sheldon, J. (2000) *Modern Art: a Critical Introduction.* London and New York, Routledge, pp. 220–222.

Sim, S. and Van Loon, B. (2001) *Introducing Critical Theory*, Royston, Icon Books, pp. 115–116.

Storey, J. (2006) *Cultural Theory and Popular Culture: an introduction,* 4th Edition, Harlow, Prentice Hall, pp. 101–103.

10 Critical approaches

The area of critical analysis can appear complex and requires an approach that takes students into areas of thinking and terminology that may be unfamiliar to them. Providing a series of brief explanations of the concepts and language of visual and media culture will enable them to understand the ideas behind critical and cultural studies. This chapter will describe how these critical approaches can be applied and gives an indication of key writers and critics who will figure in your further research.

The chapter is designed to introduce critical approaches (theoretical/critical models and methods of analysis) that can relate directly to your course projects and assignments. You will find this a valuable starting point in understanding critical analysis within visual and media culture and will centre on the concepts of structuralism and post-structuralism.

In this chapter you will cover:

1. theoretical and critical models – structuralism and post-structuralism;
2. key applications, authors and critics.

1 Structuralism and post-structuralism

There are various critical approaches you can adopt in your studies (Figure 10.1).

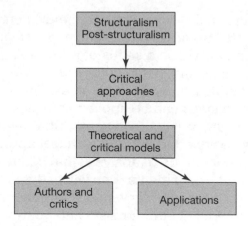

Figure 10.1 Critical approaches

Structuralist and **post-structuralist** thinking on ways of looking at the objects and artefacts that we use and enjoy has proven to be of real significance and concerns means by which communication in all forms takes place.

Structuralism

'An approach to critical analysis which emphasises universal structures underlying the surface differences and apparent randomness of cultures, stories, media texts, etc...'

Branston and Stafford (2003)

'Aims at revealing how we understand each other by... (following) conventional rules – how we 'signify' to each other.'

Sim and Van Loon (2001)

'Language organises and constructs our sense of reality – different languages in effect produce different mappings of the real.'

Storey (2006)

Ferdinand de Saussure (1857–1913) was the founder of modern linguistics and structuralism, who divided language into *langue*, rules and conventions by which language is organised, and *parole*, individual statements or use of

language. Structuralism concerns the structures and conventions by which meaning is communicated. These structures are learned within languages in all forms, spoken, written and visual. If these languages are not understood then the message is partially or not communicated.

Post-structuralism

Post-structuralism is based upon a rejection of the idea that meaning and knowledge are formed systematically and with a fixed method of analysis of text. Meanings are looked for below the surface or 'hidden', as are multiple meanings. There is also an intention to demonstrate inconsistencies in the text.

Comparison of structuralist and post-structuralist analysis

The structuralist seeks:

- parallels/echoes;
- balances;
- patterns;
- reflections/repetitions;
- symmetry;
- contrasts.

The post-structuralist seeks:

- contradictions/paradoxes;
- shifts/breaks in time, viewpoint, tense, attitude;
- aporia (doubt or difficulty);
- conflicts;
- absences/omissions;
- linguistic quirks.

The effect is that the structuralist seeks to 'show textual unity and coherence' and the post-structuralist to 'show textual disunity' (adapted from Barry (2002)).

2 Theoretical and critical models

We have discussed the what, why, when, how and where response. This approach can be developed further by understanding the application of a series of critical and theoretical models or methods of analysis (in practice these can be considered to be interchangeable terms) that provides a structure for discussion of the work of others.

- Theory – system of ideas explaining something.
- Critical – a discriminating judgement.
- Model – simplified description of a system.
- Analysis – detailed examination.

Theories are developed over a period and are tested and sometimes discarded as different ideas are developed. You need to select the ideas, theories, critical model and method of analysis that is appropriate to the particular medium, art form or image.

The main theories to consider initially are shown in Figure 10.2.

Structuralism
Hidden structures/social functions studied within cultures, kinship systems, legends myths sign systems
Semiotics: study of communication through signs within society; signs may stand for that which exists or may be fictions
Binary oppositions or divide: meanings from opposite values
Intertextuality: images relating to previous art or media works

Content analysis
Measurement of quantity (column space/time) devoted to topics within mass media.
Objective, precise, verifiable.
Decisions made about topics/categories.
No indication about quality

Content said to determine form

Content
Image relative to subject – sources in real events, scenes people or imagination, fiction stories

Post-structuralism
Deconstruction: questioning of established modes of thought and academic disciplines

Representational work of art synthesis of form and content

Form
Materials, colours, lines, lighting, tonal values, forms and shapes, textures, techniques, composition. Changes with time and social change/ technological change. Mass media equivalent **production values**

Process model of communication
Based upon transmission of information from a source using a '*coded*' signal via a medium to an audience.
Any interference inhibiting understanding described as 'noise'. Some models include concept of 'feedback'. Indication of efficiency of communication system. All media can be said to have 'codes' specific to them

Genre
Grouping of artworks – share elements, themes, stylistic conventions. Emerges, evolves over time. Open to parody. Film sets up expectation of audience. Architecture and design equivalence is **type**

Style
How something is put together rather than the communication. Cuts across all media. Artefacts/ architecture grouped together.
Arts movement
Group of artists with similar concepts/ approach

Hermeneutics
Meaning and significance of works of art based on intended meaning, parts of work related to the whole, prejudices and expectations of the viewer. Questions 'universal' /stable interpretations, works experienced at different points in history

Physical context
Different meanings related to context of viewing

Figure 10.2 The main theories and concepts you should consider in your studies

Having gained an understanding of the terminology, keep reading and expanding your knowledge.

3 Theoretical and critical models – applications

As practitioners, having gained understanding of the meaning of the terminology, there is a need to decide on appropriate applications of the theory and critical models and to embed this into our thinking about our area of practice (Figure 10.3).

Structuralism *All media related to narrative, esp. film* Semiotics *All media, esp. photography, advertising* Binary oppositions or divide
All media, esp. film
Intertextuality *All media*

Post-structuralism
Deconstruction *Artists, architects, fashion, graphic designers, 1980s*

Content analysis
Mass media

Process models of communication
Remote methods of communication, *mass media, advertising*

Content and form
All media

Style and movement
All art and media forms

Hermeneutics
All media, ancient works Iconology *myth, bible, classical history, Renaissance* Iconography Art history, film critics

Genre
Painting, photography, film
Type
Architecture, design

Physical context Sculpture, site-specific art. Media outlet, newspapers

Figure 10.3 Applications of the theory and critical models

(see *Content, genre, physical context*, pp. 189–195.)

4 Theoretical and critical models – authors and critics to research

When searching for material to support your research you will encounter the names of many contributors to the debates around visual and media culture. Figure 10.4 is not a definitive list but a starting point and can form a basis to your gaining understanding.

This offers a guide as to who you will encounter as you embark upon your reading. Some of their original writing is very demanding, with complex language, but many of the ideas behind their thinking are in essence straightforward and of real value to the practitioner. Do not be put off.

Go to the source that will describe the idea in simpler terms and on the basis of this understanding, go deeper as you need to, engage with the thinking, locate further material and make it your own.

Structuralism De Saussure, Levi-Strauss, Althusser, Jacobson, Metz *Semiotics* Peirce, Barthes, Eco *Narrative* Propp, Wright, Todorov, *Intertextuality* Kristeva, **Post-structuralism** Foucault *Deconstruction* Lyotard, Derrida	**Form and content** Various sources
	Content analysis Various sources – media studies, advertising
Process model of communication Shannon and Weaver, Gerbner, Jacobson	**Genre and style** Various sources
Hermeneutics Gadamer *Iconology and Iconography* Various sources – Panofsky, Heidegger, Gombrich	**Physical** Various sources, context of viewing

Figure 10.4 Starting point for your people research

To sum up

■ The use of critical approaches will enhance your work.

■ A knowledge of the key thinkers will aid your research.

References

Barry, P. (2002) *Beginning Theory: an introduction to literary and cultural theory*, 2nd Edition. Manchester, Manchester University Press, pp. 72–73.

Branston, G. and Stafford, R. (2003) *The Media Students Book*, 3rd Edition. London, Routledge, p. 508.

Sim, S. and Van Loon, B. (2001) *Introducing Critical Theory*. Royston, Icon Books, p. 63.

Storey, J. (2006) *Cultural Theory and Popular Culture: an introduction*, 4th Edition. Harlow, Prentice Hall, p. 88.

11 Theories and methods of analysis

In this chapter a number of theories, critical models and methods of analysis are presented, largely centred upon a structuralist framework. These theories, critical models and methods can form a basis for analysis of a variety of visual and media artefacts. They are of particular value in giving access to critical thinking for predominantly practice-based students.

With the aid of description and visual examples, these key concepts are introduced and explained. Work through the content of the chapter, try the activities as you build your understanding and engage with critical thinking.

In this chapter you will cover:

1. theories of the sign, codes and semiotic analysis;
2. concepts of myth, intertextuality, narrative and content analysis.

1 The theory of the sign

Figure 11.1 shows the various critical models and methods of analysis we are exploring here. The sign is the initial and basic unit of the communication of meaning. Different writers use subtle differences in terminology as they seek to distinguish between different forms of the sign but with the fundamental concept of the sign being straightforward.

A **sign** is 'any physical entity to which a community gives meaning. Words, clothes, gestures, possessions, pictures, colours'. Morgan and Welton (1992). In everyday life we learn to absorb meanings from many things, such as objects, images, fashion, colours, gestures. These are signs and we learn to read them on the basis of our personal experience, but we need to recognise that other people may interpret them differently. You as a student are working in art, design and media practice to convey your message in a form that engages/challenges and also communicates as you intend.

> **Text** – within cultural analysis, the totality that is studied – images, words, sounds.

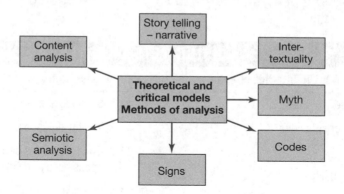

Figure 11.1 Theories at the foundation of your studies

The sign in different forms

Swiss linguist Ferdinand de Saussure introduced the term *signifier* as the physical form of the sign. It may be a pair of shoes, a road sign, an animal; it may be a word, spoken or written.

There are additional signs present in the tone of voice – calm or fearful – or in the choice of layout, typeface or colour.

Signified is the mental concept the sign stands for, i.e. concepts of what a lion represents (see Figure 11.2), while the 'real-world' object to which the sign refers is described as the *referent*.

Figure 11.2 Signs can convey all sorts of different meanings

Charles Sanders Peirce (1839–1914), developed the concept further by classifying the sign in the following ways:

- **Arbitrary signifier** – language, spoken or written, no necessary resemblance to what they signify: lion, leon (Spanish), jalopeura (Finnish), shishi + (Japanese characters).
- **Iconic signifier** – resembles the sign: a physical resemblance to the referent (Figure 11.3) in a detailed drawing, photograph or film – apparent record of real world but 'constructed' or 'fabricated' as a written or verbal (arbitrary) description.

Figure 11.3 The sign bears a physical resemblance to the referent

- **Indexical signifier** – acts as evidence of an event. A burnt-out building like the one in Figure 11.4 represents fire. The cranes *could* represent renewal; another example would be sweat for effort.
- **Symbolic signs** – visual signs arbitrarily linked to referents. For instance, a crown represents monarchy.

Figure 11.4 Indexical signifier

2 Semiotic analysis

'Semiotics is an approach to text analysis that studies the nature of signs and their importance in the ways we make sense of the world...Signs never really tell the truth in a direct and objective form: they mediate reality by allowing us to select aspects of the perceptible world and create stories with them.'

Marsen (2006)

Semiotic analysis (or semiology) provides a method for the study of signs and symbols in language and communication systems and the meanings that are generated for any given audience. This forms a method of analysis that is of particular value in the analysis of art, design and media products.

Roland Barthes (1915–1980) suggested a starting point in making semiotic analysis by following this procedure:

- **First level of signification: denotation** – the definition of the word in the dictionary. Literal or primary description, this can be applied to visual images or artefacts in identifying signifiers and describing what is present. Denotation of a speed camera is that which appears in the law and legal regulation describing its use or in the dictionary.
- **Second level of signification: connotation** – recollections evoked by the sign or signs. They vary with the individual and are dependent on personal knowledge and culture, and tend to be subjective. Connotation of speed cameras depends on whether you have been fined for speeding or are concerned about child safety because of speeding near a school.

Barthes was interested in the way that signs become specific to particular cultures and become increasingly complex in the messages they can convey within that culture.

(See *Myth*, p. 183.)

Images are rarely seen without words, such as a title or caption (a further layer of signification), and may *anchor* the reading to restrict interpretation – variations in the words used may change meaning. For example, see Figure 11.5: Centre Georges Pompidou (constructed 1971–1977), 'a postmodern high-tech building that revolutionised architecture', or alternatively, Centre Georges Pompidou is 'an eyesore alien in the historic Beaubourg area of Paris that represents a brutal disrespect by city planners for the surrounding city'.

The caption may also *relay* meaning by which it is designed to extend possible readings.

Figure 11.5 The Georges Pompidou Centre in Paris

Example

A SEMIOTIC ANALYSIS

Denotation: a photograph of a line of trees, with grey/white bark, carved initials, names and hearts ringed in black through age, a wall and cobbled path lead along the river bank, with a bridge and buildings in the distance.

Photographic: a monochrome image with emphasis upon perspective, a depth of sharpness (field), a low contrast lighting with predominance of mid tones. A 'city landscape'.

Connotations: as a photograph the implication is that this image represents an observed, 'real' scene, a record of a particular place but at an indeterminate time. The carved initials indicate that this is a place for romance, where many couples have wanted to record and declare their love with their names entwined among the symbolic hearts. It is a romantic place of legend, the left bank of the River Seine in Paris, a place for lovers to come together during the nighttime summer hours. This, though, is a cold image in a wintry morning light that leads to questions about how many of these romances will endure.

ACTIVITY 11.1 Semiotic analysis

Semiotic analysis is considered to be of significant value when approaching a variety of artefacts. Try it and you will find that semiotics provides a form and structure to use for the study, and therefore the understanding, of the work of others.

Select an image or object.
Undertake denotation: describe it.
What are the connotations – your interpretation?
What factors in your experience influence your interpretation?
Are there words to anchor or relay meaning?

3 The theory of codes

A **code** is a set of signs or symbols *organised* into a system of communication, as in Figure 11.6. The basis of this theory was the Process Model of Communication formulated by Shannon and Weaver in 1949 in relation to telecommunications, which is of particular value in analysis of communication over a distance.

> **Noise** – the term given to anything that interferes with the understanding of the coded communication.

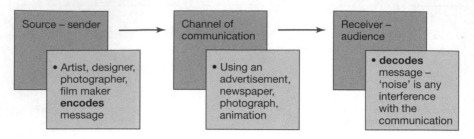

Figure 11.6 System of communication

Within the art, design and media environment a particular set of signs forms a code that is characteristic of a particular medium or object, such as a garment where the signs may convey a meaning such as evening wear and luxury, a style such as 'grunge' or the set of signs that conveys a particular style or genre of a painting or film.

Codes can be broken down into:

- **cultural** – including genre and style, and context of viewing;
- **technical** – choice of materials and method of making;
- **aesthetic** – style, treatment and visual content;
- **intertextuality** – relation to other artefacts.

Example

THEORY OF CODES

In design and media terms the Process Model of Communication can be applied in this way:

A designer (as source or sender) produces and takes to manufacture (as source or sender) a range of jewellery and encodes a message (that the product is intended to be fun, for the teenage market, good value and fashionable) by using shiny, primary-coloured plastics shaped into cartoon-like figures (coded signs). The jewellery is presented through photographs of models wearing it in advertising and placed in teenage magazines (channel) where it is offered by mail order for purchase. The receiver or possible purchaser decodes the message and decides to purchase or not to purchase the product.

Questions posed:

- Possible noise that may interrupt understanding of the message?
- Is this a message that will attract young people concerned with teenage fashion?
- Do the materials and form of the jewellery used convey the intended message?
- Is the intended message conveyed to the potential purchaser via the medium and channel used?

The message intended is that this jewellery is fashionable, fun and good value, but to some purchasers it may be considered outdated, attractive to the very young (not teenagers) and cheap looking.

Feedback in this case would be direct if the sales of the product are as predicted, but it may be more difficult to find out what aspect of the process has been unsuccessful other than by conducting detailed market research (survey or focus group) with the intended target audience.

ACTIVITY 11.2 Identifying codes

Used in conjunction with semiotics, the theory of codes can provide an additional layer of understanding to your analysis.

This activity could be applied to your own or to another person's work.

Specialist medium
Source/sender
Describe possible aims for the work
Coded message
Describe related codes
Cultural, including genre, and context of viewing
Technical – choice of materials and method of making
Aesthetic – style treatment and content
Intertextuality – relation to other artefacts

Channel medium
How does it reach an audience?
Decoded message
Receiver
The viewer or receiver needs to be familiar with the codes used in order to understand the message communicated
Noise
What are the potential factors that could interfere with communication?
Feedback
How will you obtain information and feedback?
How can this feed into future work?

4 Myth

Myth: 'ideas and practices...promoting values and interests of dominant groups in society (that) defend the prevailing structures of power. Dependent on ideas that signs may have multiple meanings (polysemic).'

Storey (2006)

'Myths are stories we tell ourselves as a culture in order to banish contradictions, and make our world understandable and therefore habitable; they attempt to put us at peace with ourselves and our existence.'

Storey (2006)

The idea of '**myth**', as used by a number of authors, is that the signs we experience as they are presented to us in a variety of forms, and as they represent the world, provide us with an implied set of values for how we should live. We learn to read these groups of signs demonstrating a particular lifestyle and this in turn presents a particular organisation of society. It is argued that this ever-present influence *supporting things as they are* tends to lead to a fundamental lack of questioning of the consequences of our way of life. The concept of 'myth' encourages us to question the status quo and provides the basis for investigating what is implicit or behind the material that is presented to us.

Social anthropologist Claude Levi-Strauss used 'myth' as having similar meanings to **ideology**, that is our perception of the world including power relationships and how these may be considered 'natural, and how myths become meaningful through structures of language and its rules. Through the study of myths and kinship systems, Levi-Strauss argued that all systems that generated meaning were structured through sets of '*opposite values*' or '*binary oppositions*' or '*divide*' – human beings tend to think in terms of these oppositions, such as nature/culture, hot/cold, hero/villain, boy/girl, black/white. Within feminist or postcolonial criticism it is argued that this form of classification can be used to imply a hierarchy or order of importance.

ACTIVITY 11.3 Opposite values or binary oppositions or divide

Are these values and oppositions detectable in the analysis of the work that you are studying? What meanings do they convey?

Select an image or images from the media, magazines, newspapers, TV news or a short film sequence. Identify where there are examples of oppositions. Is there evidence that one element is presented as more or less important than others?

5 Intertextuality

Julia Kristeva developed concepts of intertextuality within postmodern thinking, with the recognition that no practitioner in the making of works of art, design or media is isolated and therefore draws on experience of other works of art, design and media. In the terminology of visual and media culture this indicates referral, implicitly or explicitly, to other texts that may come from any source. An example of intertextuality would be in the look portraying mental pain or madness originating in Edvard Munch's painting *The Scream* (1890s) being recognisable as the reaction of terror in many horror films; or the pose derived from the depiction in Renaissance paintings of the gods and used in Goya's *Maja Desnuda (Nude Maja)* 1797–1798; and in countless pin-up photographs. A reference to an earlier visual form or concept requires originality in its reinterpretation and presentation in a new work. Film makers, for example, take particular delight in referring to scenes from earlier movies. This may be respectful, playful or a parody, but has tended to be knowingly aware of the process of referencing to other artefacts and ironic in its form.

ACTIVITY 11.4 Intertextuality

An understanding of intertextuality can enrich your response to the artefacts you study and it can be fun to find the references to other works that artists, designers, photographers, film or media artists have made. They will be there!

Select a particular artefact from within your chosen medium and research possible references to other works.

6 Story telling and narrative

Story telling is a fundamental and natural human activity and covers all aspects of our lives. A story has a beginning, a middle and an end, but not always told in that order. It may be fictional or describing an actual event, as in news or a documentary. A story may be told as a *closed* **narrative**, which will normally provide a form of conclusion as in most feature films, or as an *open narrative*, for instance in soap operas where the lives of the characters are explored continuously. When the story is told in fragments not relating to any timescale it is described as a *discontinuous narrative*. The story is the totality of information that is revealed to the viewer, whilst the plot is the parts used to present the narrative through both image and sound. **Narratology** concerns itself with the relationship between the organisation of the content in telling the story and who is telling the story: this may be one of the characters presenting their point of view or a person who is not involved in the story as a character.

Vladimir Propp (1895–1970) studied fairytales or 'wonder tales' and found that though the stories have varied content, characters can be identified as having consistent roles or 'spheres of action' that *perform a narrative function*. These include a villain, a hero, a donor (who provides 'an object with a magic property'), the helper, the princess (a reward for the hero), her father, the despatcher (who sends the hero away) and a false hero. The narrative function of these is to move the action forward and they provide insight in relation to the analysis of common themes, such as good against evil or people coming of age, in all forms of story telling within different media from comics to film. We are familiar with these 'constructed characters' and the success of the film will be in how they are used and how their roles are presented in a different and entertaining way.

ACTIVITY 11.5 Character and narrative function

Propp's ideas can form a starting point for analysis of narrative within art, design and media work. Are these ideas important in an analysis of the work you are studying?

Consider a favourite story, computer game or film and test the validity of Propp's ideas on character and narrative. Some roles may be combined into one 'character' and interchanged to create interest and suspense.

Who is the	villain(s)
	hero(s)
	helper(s)
	donor(s)
	princess
	false hero(s)
	despatcher
How do they progress the narrative?	

Chapter 11 Theories and methods of analysis

Tzvetan Todorov (1939–) presented the idea that actions within a narrative are based upon a logic and that a number of different critical models can be used in analysis. He also proposed that a character's state of mind might constitute the action. Narrative structure starts from a point of *normality* or equilibrium, which he called plenitude, a force *disrupts* this calm and the *equilibrium* can be restored only by an opposing force (Figure 11.7).

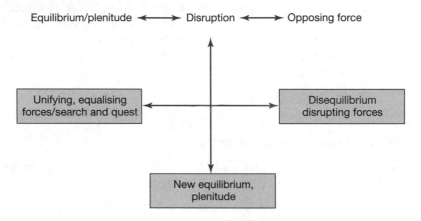

Figure 11.7 The narrative process

Source: Adapted from Turner (1993), p. 77. Reproduced with permission.

ACTIVITY 11.6 Narrative and structure

Todorov's ideas on narrative structure can form a basis for analysis and help us to place the artefacts we see and enjoy into a different critical perspective.

Select a story from any source, such as a film or comic, and analyse it in relation to Todorov's ideas on narrative structure.

Describe the equilibrium or plenitude of the narrative. When is this established?
What is the form of the disruption? Who provides this?
How is equilibrium achieved? Who achieves this?
Is the narrative structure as described in Todorov's model? If different, account for this.

Are there any differences that make the story more or less interesting?
Can you identify an underlying theme or message?

Will Wright argued that **binary opposition** and narrative function should be related in analysis. This concept can be applied to a variety of media artefacts. In the analysis of the Western Wright indicates that through oppositions there is revealed a 'symbolically simple ... but deep conceptualisation of American social beliefs' (Storey, 2006).

Inside society	Outside society
Good	Bad
Strong	Weak
Civilisation	Wilderness

7 Content analysis

Content analysis is a widely used research tool that can be applied to a range of artefacts, from literary works to the mass media. The aim is to establish a frequency in which something occurs within a given text. Decisions have to be made as to the particular area and scope for research: it may be to investigate the differences in content of news coverage of a particular event by TV news channels; the frequency of which men and women of different ethnic groups appear undertaking different 'roles' within certain forms of advertising; or the occurrence and type of violence in a computer game or animation. The outcome is quantitative – that is based upon a count of, say, the number of times something appears, the number of column inches or air time devoted to the topic – and should produce statistical and verifiable results. To achieve a degree of qualitative interpretation in an analysis there may be a requirement to place relative values on the different categories, such as the 'role' of business or sports people, musicians or celebrities; or the nature of violence, be it gun or knife, domestic or armies at war, 'realistic' or stylised in presentation.

ACTIVITY 11.7 Content analysis

This method of analysis can make a valuable contribution to our thinking as media products are studied and can reveal important aspects of which we may have been unaware previously.

Select a mass media product or products where you have an impression that there may be a bias of some kind, such as those given above. It may be celebrity magazines, a TV channel or programmes, an arts magazine or galleries.

Undertake a content analysis and state the area for research, define the problem for investigation and give your hypothesis.

Select the subject for study – the text. What is the size of the sample? What is the context?

Select the categories to be studied.

Check that the categories are sufficiently different and refer back to the research question.

Collect data and make an analysis. Decide on presentation of data – table or chart.

Conclusions. Has your question been answered and your hypothesis proven to be correct? Are your results valid? What message is conveyed and to what audience? Do further questions arise that would be of value for further research?

References

Marsen, S. (2006) *Communication Studies*. Basingstoke, Palgrave Macmillan, p. 54.

Morgan, J. and Welton, P. (1992) *See What I Mean: an introduction to visual communication*, 2nd Edition. London, Edward Arnold, p. 41.

Storey, J. (2006) *Cultural Theory and Popular Culture: an introduction*, 4th Edition. Harlow, Prentice Hall, pp. 90–93.

Turner, G. (1990) *British Cultural Studies: an introduction*. Boston, Unwin Hyman, p. 77.

Turner, G. (1993) *Film as Social Practice*. London, Routledge, p. 77.

12 Content, genre, physical context

While certain methods of analysis look towards structural meanings related to aspects of society and the effects on our thinking on the arts, design and media, other classifications may consider the content, form, style, type or place that the artefact is viewed.

It needs to be recognised that there are different ways of looking at artefacts. In this chapter there is a discussion of some aspects that can be brought into the analysis that can be undertaken.

In this chapter you will cover:

1. ideas around content and form; styles, movement and genre;
2. the physical context in which the artefact is viewed.

1 Content and form

In the analysis of artefacts the terms content and form are linked (Figure 12.1) and can form a useful approach in considering any product of the arts, design and media.

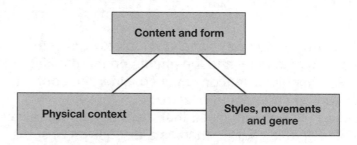

Figure 12.1 Content and form are linked

When viewing any image or production we say it has **content**, it contains something, a representation of ideas, people, objects or things. These may be real or invented. The content can be described in words in a descriptive list and Barthes' denotation forms a part of this as a first level of significa- tion. Subject is used as an alternative to content, with the difference being that the subject, or what the artefact is of or about, is collectively presented through the content. For example, a subject such as congestion may be lit- erally represented by a content, including stationary vehicles in a traffic jam, or crowded and overlapping typography. There are limitations in the general use of terms such as content or subject in that analysis should go beyond description and incorporate ideas within sign systems, semiotics, conno- tations and meanings generated. There are alternative uses of the term content, including a more comprehensive inclusion of factors such as the artist's intention and the viewer's interpretation.

Form is also used as a term to describe all the formal visual elements, such as colour, line, tonal values, shape, composition, medium and techniques. We consider these as the tools of the practitioner. The way they are used varies with the area of practice, development of technology and experimen- tation, and changing social attitudes to aspects of craft skills, for instance. A more specific additional use of the word form in art or design indicates that an object is three dimensional and is used in sculpture or ceramics. This would be termed shape if the image were two dimensional.

The art critic Clive Bell in 1914 proposed the idea of 'significant form', by which visual qualities affected the 'aesthetic emotions', which provided the distinctive characteristic of any art work (Walker and Chaplain, 1997). This thinking was influential but was disputed by artists and philosophers when the status of what constituted an art work was challenged by the exhibition of a urinal entitled *Fountain* by Marcel Duchamp in 1917, and the develop- ing structuralist thinking of art as a meaning producing process.

Form and content are linked within all the arts, design and media – they cannot be separated. As practitioners, we search for both content and a means of expressing that content. Content that is valid and interesting can be compromised if it is not expressed in an appropriate form; minimal content expressed with the assured use of formal elements with an immaculate technique can produce work of little interest. In theoretical language we can consider these visual elements as signs within a system of communication that generate meaning within a coded message.

A further dimension is the concept of *form following function* in design and architecture, established in the 1930s within the Bauhaus movement. The idea is that the form of the object should indicate its purpose, be it an industrial product or a poster. This concept reflected a design aesthetic relating to 'modern' (1914 onwards) construction techniques and materials that emphasised simple, pure lines, with an absence of decoration in buildings and everyday objects. An approach that was frequently 'far more symbolic than material' (Woodham, 1997) comes from a modernist viewpoint that has been challenged in contemporary post-modern design with its playful disregard of function in the object's appearance – think of intertextual references in designs such as Mickey Mouse telephones and Alessi lemon squeezers.

Aesthetic – comes from philosophy that distinguishes factors of taste affecting beauty. Recent ideas indicate that differentiation is variable according to the culture and experience of the viewer. Also used for specific visual qualities concerning particular specialist media.

Medium – within the arts 'the physical material or form used by the artist' (oil paint, clay, etc.), 'a means of communication' *Oxford Compact Dictionary and Thesaurus* p. 465.

Media – plural of medium. As in mass media: collective term for newspapers, radio, TV.

Within the mass media an equivalent term of **production values** has developed, which relates to the time and investment put into use of materials, technical quality, and costumes and sets. There is a difference in approach between making a daytime soap production and a feature film, for instance.

2 Styles, movements, genre

Within the areas of critical analysis and art history there are differences of approach in the sense that critical analysis *tends* to approach more contemporary concerns while within art history the thinking and theories extend to artefacts from the whole area of human activity deep into the past. However, there are clear crossovers, and style, movements and genre are of concern within both academic disciplines.

Style indicates the following:

- a recognisable artistic school or period;
- how the visual or formal elements are used, a recognisable use of a set of visual codes;
- 'house style' – a set of rules for presentation, such as spelling and grammar for a publication;
- 'Lifestyle' – commonly used in relation to the way people live and the kind of consumer goods that support this.

Stylist – provides advice and selection of properties and accessories for the content of scenes for advertisements and fashion shoots.

Movement – group of people with similar aims and ideas

Genre – grouping of artworks that share elements, themes, and stylistic conventions

Style, movements and genre are commonly used terms with overlapping meanings used within the arts and media. It is worthwhile looking at the subtleties in the uses of these words and trying to understand the different interpretations and uses. This is an example of Foucault's ideas in relation to knowledge of specialist language within the arts, design and media where in some cases the professional is distinguished by the use and understanding of specific terminology.

Style relates to the manner in which an artefact is put together through the use of materials available within a medium, for example painting, photography, film or architecture. This is also applied to a group of artists where there is a common and distinctive approach to technique or to an individual artist to the extent of being able to distinguish between different stages in their career.

To the art historian, style is used in a particular sense to mean 'a specific period of history and is defined by those common characteristics (physical, technical and theoretical) which are to be found during that particular period' (Richardson and Stangos, 1974). However, it should be understood that artistic work will have developed over a period at a particular time and place and it is subsequent to this that art historians will place a categorisation or label such as a style or movement. The more common use of style is less specific and indicates a particular use of visual elements that can generally be recognised as similar. This might include, for instance, a particular cut or use of materials in fashion or a spray-painting technique. It may also refer to arts movements where, though rooted in a particular period, such as Gothic or Art Nouveau, the elements may be reworked and recycled into a new interpretation. At best this results in a contemporary reinterpretation of the style, but it may also result in an imitation or pastiche of the original. In theoretical terms style is a contentious term and should be used with understanding and caution.

ACTIVITY 12.1 Identify different styles

This form of analysis will require research into the qualities which contribute to a recognisable style and involves looking at a variety of artefacts. Could this influence the way you make your own work?

Describe how an artefact has been put together and the common characteristics of the style.

For example, naturalistic, film noir, high key – low key.

Genre is based upon the French word for variety or type and is used within the arts and media to describe a work being made using a set of conventions. Within film the term genre is used in two ways: one is in the application of a particular style of production, such as film noir, in which light is used to create deep shadows and a sense of darkness and menace as in gangster films, and the other is an approach to particular topics or themes. An action film will lead to a certain expectation in the audience that there will be a fast-moving plot with heroic figures and special effects, while a romantic comedy will be expected to provide humour underpinning a love story. These can be described as gendered in approach – the action film will be expected to attract young people, predominantly male, and the romantic comedy to attract an audience of women. The creative key to a familiar genre is how the topic is presented in a new way, with changes that surprise us and engage our interest. A film described as a particular genre will set up expectation in the audience and this is important to its financial success. Within the film world creative references are made to different styles and genre (intertextuality) and part of the interest and pleasure in the study of film is to detect these references to other works.

In painting and photography, genre may relate to the subject matter, such as portraiture or landscape. These categories have their own histories and conventions that the artist can draw on and use as a creative reference point. There is also genre painting in which scenes from everyday life were depicted, such as conversation pieces, tavern and morality scenes – Hogarth to Sickert and the Glasgow School.

ACTIVITY 12.2 Identify different genres

This form of analysis will require research into the qualities that contribute to a recognisable genre and involves looking at a variety of artefacts. How does this influence your thinking about your own work?

Identify the genre(s) of a film, painting or photograph.

List the characteristics (signs) that make up the genre(s).

3 Physical context

The context in which the arts and media are viewed has a particular effect on the way they are valued and considered. Works that are exhibited in a prestigious gallery in a capital city will provide different connotations to those exhibited in a student assessment show – one will be reported in the national arts press while a local audience will see the other.

Some artefacts are made to be seen in a particular space and the location can be seen as integral to the work. An example of this would be Antony Gormley's standing figures entitled *Another Place* (1997), which stand in the sea off Crosby Beach near Liverpool (see Figure 12.2).

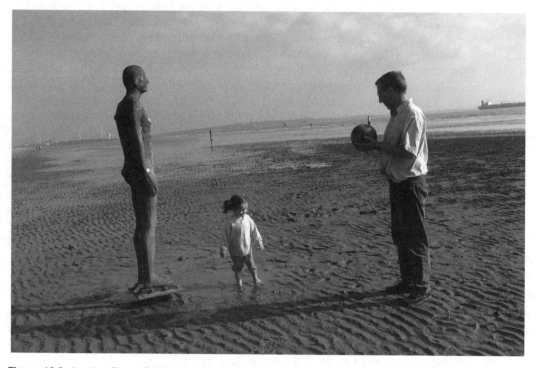

Figure 12.2 *Another Place*, Crosby Beach near Liverpool

ACTIVITY 12.3 Physical context

Where a work is placed and seen can be very important as to how it is perceived. Do you consider this in relation to your own work?

Select an artefact from a named source, consider its location and describe:

- the artefact and the context in which it is viewed;
- how the connotations would be or are altered if viewed in a different setting.

References

Richardson, T. and Stangos, N. (1974) *Concepts of Modern Art*. Harmondsworth, Penguin Books, Preface p ix.

Walker, J. and Chaplain, S. (1997) *Visual Culture: an introduction*. Manchester, Manchester University Press, p. 155.

Woodham, J. (1997) *Twentieth Century Design*. Oxford, Oxford University Press, p. 35.

13 Being critical – what to look for

It needs to be remembered that all theory represents a point of view. This may be based upon a philosophical belief or social and economic issues. It is possible to approach criticism with a view to highlighting particular ideas, any of which can be applied singly or in different combinations to visual and media work. Consider different approaches and what may be appropriate for your area of practice. Take ownership of them and let them inform your thinking.

In this chapter you will cover:

1. a range of critical approaches to visual and media artefacts.

USING THIS CHAPTER			
If you want to dip into this chapter	**Page**	**If you want to try the activities**	**Page**
1 A summary of the ideas that critics and academics seek to apply	197	13.1 Taking an approach to criticism	200

1 A summary of the ideas that critics and academics seek to apply

Figure 13.1 sums up being critical.

Figure 13.1 A summary of being critical

Application of **modernist** concepts includes looking for:

- evidence of the modern and industrial age, and a hierarchy of media;
- reflection of the period produced, at times with racist and sexist undertones;
- distinction between high and low culture;
- experimentation in the arts;
- exploration of qualities of specific media;
- application of form reflecting function.

Application of **post-modernist** concepts includes looking for:

- evidence of the electronic and virtual age, and global communication systems;
- evidence of the collapse of ideas of history and certainty;
- a reflection of the period in which the work is produced and possibly exploring issues such as appropriation, representation, gender and identity, reality, racism and colonialism;
- evidence of the reproduction and circulation of signs and images, and blurring of distinctions between original and copy;
- questions as to the nature of the 'real' and its simulation;
- use of a mixture of media with combinations of different materials;
- an experimental and playful approach with possible eclectic influences from many cultures;
- minimal concern for function and ergonomics.

Application of **structuralist** concepts includes looking for:

- evidence of structures within the text such as genre, narrative structure, intertextual references and applying sign systems within semiotic analysis to all aspects of Western culture, from ancient Greek sculpture to cosmetics advertising.

Application of **post-structuralist** concepts includes looking for:

- evidence of difference between the 'underlying meaning' of text and 'surface meanings', inconsistencies and possible multiple meanings within text.

Application of **psychoanalytical** concepts:

Freudian psychoanalytical critics look for:

- distinction between the conscious and the unconscious mind;
- intended content (conscious) and unintended content (unconscious) in text, with the unintended being emphasised as the key meaning. They look for this in the 'motives and feelings' of the author and any characters;
- psychoanalytical principles/stages in child development, emphasising the importance of psychological factors over social factors.

Lacanian psychoanalytical critics look for:

- unconscious motivations and emotions underlying the conscious text;
- the Lacanian stages in child development, evidence of 'desire' and 'lack', and the dominance of the unconscious.

Application of **feminist** concepts includes looking for:

- evidence that demonstrates that society is male dominated and that this power relationship is not 'natural';
- differences between men and women, which are largely culturally formed and only partially biological;

and challenges the:

- canon of practitioners and researchers to rediscover women practitioners;
- representations of women as 'other' or lack;
- representations of the power relationships between women and men as natural;
- ideas of the death of the author in that it may be important that the author's experience may be significant as being gay, black or female.

A summary of the ideas that critics and academics seek to apply

Application of lesbian and gay concepts includes looking:

- for evidence of a canon of 'classic' lesbian and gay artists and practitioners;
- to identify and foreground gay and lesbian themes within all media;
- to expose homophobia in mainstream practice, including the media.

Application of **post-colonial theory** includes:

- the representation of different cultures and seeks to show that the Western canon within the arts is not universal and does not recognise ethnic and cultural contributions and differences;
- showing that the effects of colonisation and imperialism are not acknowledged;
- a celebration of diversity and the bringing together of cultures, and that 'otherness' is a source for positive activity and achievement.

Application of **Marxist** concepts includes looking:

- to relate the context of the work to the social class of the practitioner, who may not be aware of what is revealed in the text;
- for an explanation of the work in relation to the social period that produced it, and for Marxist themes such as class struggle and stages of transition of societies, such as feudalism to industrialisation;
- to demonstrate that works from all media are determined by political circumstances.

Application of **ecological** concepts includes:

- particular attention to and ethical responsibility for the natural world, use of energy and resources, questioning ideas of economic growth, and emphasising the need for sustainability.

Application of McLuhan's concepts includes looking for:

- the use of the 'medium' to extend human experience;
- evidence of the effects of the global access to wide ranges of information and entertainment.

Application of Baudrillard's concepts includes looking for:

- evidence of the representations of the 'real' world and the differences between the constructions or simulations of the world;
- the effects of symbolic acts and the news coverage that accompanies them.

Adapted from Barry (2002).

ACTIVITY 13.1 Taking an approach to criticism

Different critical and theoretical models can be applied in different ways. What is your thinking on the most interesting and revealing approach to the works you study?

Select a practitioner, designer, photographer or film maker whose work interests you and who may relate to your personal practice. Consider examples of their work. Select at least three different critical models and apply them to the work. Reflect on their suitability and consider how they may assist you in understanding the work.

References and bibliography

Barry, P. (2002) *Beginning Theory: an introduction to literary and cultural theory*, 2nd Edition. Manchester, Manchester University Press.

Berger, J. (1972) *Ways of Seeing*. London, Penguin Books.

Branston, G. and Stafford, R. (2003) *The Media Students Book*, 3rd Edition. London, Routledge.

Costello, D. and Vickery, J. (eds) (2007) *Art: key contemporary thinkers*, Oxford, Berg.

Evans, J. and Hall, S. (eds) (1999) 'The other question: the stereotype and colonial discourse', *Visual Culture: the Reader*. London, Sage Publications.

Frosh, S. (1991) *Identity Crisis: modernity, psychoanalysis, and the self*. Basingstoke, Macmillan.

Hatt, M. and Klonk, C. (2006) *Art History: a critical introduction to its methods*. Manchester, Manchester University Press.

Greenhalgh, P. (ed.) (1990) *Modernism in Design*. London, Reaktion Books.

Jobling, P. and Crowley, D. (1996) *Graphic Design: reproduction and representation since 1800.* Manchester, Manchester University Press.

Kress, G. and Leuwen, T. (1996) *Reading: the grammar of visual design*. London, Routledge.

Lechte, J. (1994) *Fifty Key Contemporary Thinkers*. London, Routledge.

Lusted, D. (ed.) (1991) 'Representation', *The Media Studies Book*. London, Routledge.

Marsen, S. (2006) *Communication Studies*. Basingstoke, Palgrave Macmillan.

McLuhan, M. (1964) *Understanding Media*. London, Routledge Classics.

McLuhan, M. (1967) *The Gutenberg Galaxy: the making of typographic man*. London, Routledge, Keegan Paul.

McLuhan, M. (2008) *The Medium is the Massage*, London, Penguin Classic.

Meecham, P. and Sheldon, J. (2000) *Modern Art: a critical introduction.* London and New York, Routledge.

Morgan, J. and Welton, P. (1992) *See What I Mean: an introduction to visual communication*, 2nd Edition. London, Edward Arnold.

Mulvey, L. (ed.) (1989) 'Visual pleasure and narrative cinema', *visual and other pleasures*, Basingstoke, Macmillan.

Richardson, T. and Stangos, N. (1974) *Concepts of Modern Art*. Harmondsworth, Penguin Books.

Rosenblum, N. (1997) *A World History of Photography*, Third Edition. New York, Abbeville Publishers.

Sim, S. and Van Loon, B. (2001) *Introducing Critical Theory*. Royston, Icon Books.

Storey, J. (2006) *Cultural Theory and Popular Culture: an introduction*. 4th Edition. Harlow, Prentice Hall.

Turner, G. (1990) *British Cultural Studies: an introduction*. Boston, Unwin Hyman.

Walker, J. and Chaplain, S. (1997) *Visual Culture: an introduction*. Manchester, Manchester University Press.

Wells, L. (ed.) (2003) 'Extracts from the work of art in the age of reproduction', *The Photography Reader*. London, Routledge.

Wells, L. (ed.) (2004) *Photography: a critical introduction*, 3rd Edition. London, Routledge.

Woodham, J. (1997) *Twentieth Century Design*. Oxford, Oxford University Press.

Woodward, K. (ed.) (1997) *Identity and Difference*. London, Sage Publications.

4 Specialist media

The specialist media that students work with are different in technology, requiring differences in emphasis of approach and thinking. In the following chapters, key media ideas and concepts are discussed, industry, education practices and teaching sessions described, and students speak about their experiences of how they work.

art, design and media contemporary applied arts fashion fine art

graphic design and illustration interior and spatial design media

TV and film production media studies animation

computer games/arts photography product industrial

14 Art, design and media – meanings and differences

applied art	design	fine arts	media industries

Art, design and media encompass a wide range of activities, with each having its own character but with a central element of creativity. These specialisms utilise different materials, technologies, skills and outcomes but also varied ways of thinking. Educators and practitioners label these as specialist subjects, media or disciplines, with some seen as distinct and others applied within different specialist contexts. Photography, for example, is a medium practised in its own right but is also used within fine art and design.

In this chapter you will cover:

1. discussion of the range of specialist media, their characteristics and applications.

USING THIS CHAPTER			
If you want to dip into this chapter	**Page**	**If you want to try the activities**	**Page**
1 Ideas, theories and applications	206	14.1 Where do your interests lie?	208

1 Ideas, theories and applications

Within the arts, design and media various distinctions are made.

Fine arts describes works intended to stimulate and challenge the viewer. **Applied art** as a term is used when *design* and *aesthetics* are applied to functional objects that we use every day, such as a lamp post, a toaster, a necklace. The fields of industrial design, graphic design, fashion design, interior design, decorative art and functional art are described as applied arts. In a creative context the fields of architecture and photography are also described as applied arts.

In 1893 Candace Wheeler wrote of the importance of art to the individual in the following terms: 'Decorative and applied art are of the utmost importance to mankind, since the one contributes to those monuments which excite the loftiest and most supreme satisfaction, and the other surrounds, or may surround, the individual with endless sources of pleasure and content' (Gorman, 2003).

The term **contemporary applied art** is used in relation to courses that group media such as ceramics, jewellery and textiles, where the emphasis is upon an exploration of craft and experimentation with materials and processes in making artefacts which are functional and decorative. The objects may stem from outside commissions but will also be conceptually self-initiated by the maker.

Design activity in contemporary terms tends to have a different starting point and involves the application of a creative process, taking into account aesthetics and function in working to solve a 'problem' instigated from an outside source or client. The 'problem' may be one of communication, as in graphic design, utility, the user and sustainability, as in product design, or a fresh style, as in fashion design – or a combination of communication, function and style, as applied to any subject discipline. There are different philosophies for design being applied within the arts, media, engineering and production.

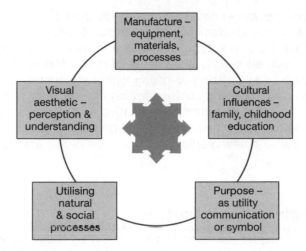

This diagram draws upon the influential analysis by Victor Papanek relating to the functional aspects of design and taking into account the Yin-Yang, 'the soft-hard, feeling thinking, intuitive-intellectual mix'. This dichotomy of 'evaluative criteria' can be applied to many art, design and media artefacts.

There is an increasing concern for design and sustainability. Birkeland presents 'a new vision for design'. These concerns include the following:

- responsible – goals around needs, social/eco equity and justice;
- synergetic – positive synergies: involving systems change;
- contextual – design conventions and concepts directed towards social transformation;
- holistic – aims for a life cycle to ensure low-impact, low-cost, multi-functional outcomes;
- empowering – use of human potential, self-reliance towards ecological understanding;
- restorative – integrates the social and natural world; encourages 'a sense of wonder';
- eco-efficient – to actively increase the economy of energy, materials and costs;
- creative – going beyond boundaries of thinking, to transform and 'leapfrog';
- visionary – focuses on visions and outcomes and provides methods, tools and processes to deliver them.

Adapted from Birkeland, J. in Bharma and Lofthouse (2007)

There can be no doubt that the media industries form an increasingly important part of modern society in terms of mass communication of news and information, as entertainment, as a former of opinion and cultural influence. The area encompasses a range of media forms, from print, broadcast and online to advertising. Working within the media falls into two areas: production of content, such as writing or journalism, and delivery of the media product that includes both creative and technical expertise. These cover areas such as cinema (traditional and digital film), TV and video production (digital) and new media, which includes digital animation and games art.

ACTIVITY 14.1 Where do your interests lie?

Having read the chapter that defines meanings, describes media characteristics and applications, you may wish to evaluate your subject and media interests as part of a self-assessment.

........................ interests me because ...

I am suited to working in this area of study because ...

References

Bharma, T. and Lofthouse, V. (2007) *Design for Sustainability*, Aldershot, Gower Publications, p. 5.

Gorman. C. (2003) *The Industrial Design Reader*. New York, Allworth Press, p. 44.

Papanek, V. (2004) *Design for the Real World: human ecology and social change*, 2nd Edition. London, Thames & Hudson, p. 7.

15 Contemporary applied arts

ceramics – earthenware porcelain stoneware tiles figurines
glass – jewellery – metalwork silversmithing
textiles – embroidery knitting lace linen painted textiles
patchwork & quilting printed textiles resist dyeing rugs &
carpets silk tapestry wool woven textiles
furniture – CHAIRS tables

In this chapter you will cover:

1. discussion of the ideas, concepts and practices within contemporary applied arts;
2. students talking about their backgrounds and experiences.

USING THIS CHAPTER				
If you want to dip into this chapter	Page	If you want to try the activities	Page	
1 Ideas, theories and contexts	210	15.1 Considering your interests	214	
2 Contemporary applied arts practice	211			
3 Contemporary applied arts education	212			

1 Ideas, theories and contexts

'In today's world the concept of craft and applied art is in a period of change and rapid development. This development sets new demands upon the craftsman...Previously the idea of craftsmanship has been associated with a specific material or technique and a physical form bound by convention or tradition. Our current understanding of applied art has given rise to new forms of expression...stimulates new possibilities and supports cross-disciplinary projects.'

Extract from course outline, HDK School of Applied Art Gothenberg
Sweden **http://www.hdk.gu.se/**

'Those of us who have spent time in the field are at a stage, I am sure, at which earnest definitions and descriptions of craft as something which is (or is not) art, is (or is not) design, as technophobia, as an anthropological signifier, as a protector of apparent traditions, as old (or new) age lifestyle, as patriarchy, as airport trinket, as ethnic iconography, as communist Utopia, as eco protest, as redundant technology, as aromatherapy, and most emphatically as victim in an unloving world, have ground us all down... Craft is presented in this book [can be argued] as a fluid set of practices, propositions and positions that shift and develop...a confident striding out of a vital part of visual culture.'

Greenhalgh (2002)

'The philosophy of the School of Applied Art is to encourage students, through their various subject specific interests, to challenge and reinterpret the artefacts of applied art – their role and purpose – as things that are closely linked to daily life. As applied artists who operate in the context of developing ideas through materials, through making and through the consideration of display, we offer attitudes and views on issues across craft, design and art...(it) encompasses scientific exploration of material, the development and use of new technology, the cross-fertilisation of old and new technologies, and the possibility of new forms...a critical and historical approach to artefacts and discourses about them – a critical language for the applied arts – and the exploration of themes and questions through the making of an object...The current buoyancy of the applied arts as an art and design practice is the result of the re-inclusion in art and design of the decorative, the domestic, the sensual, the ethnic and vernacular, narratives of time and the past; and the result of interest in process and the origin of form, the meanings of personal and collective identities, and the materiality of everyday life in a digital age.'

Extract from course outline, The Royal College of Art (http://www.rca.ac.uk/)

2 Contemporary applied arts practice

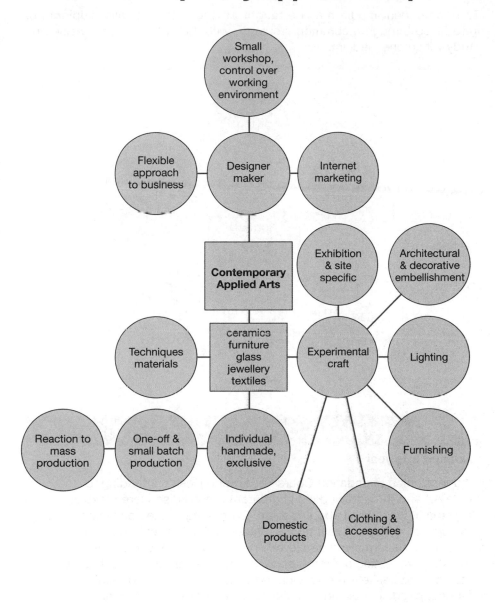

Small workshop, control over working environment

Flexible approach to business

Designer maker

Internet marketing

Contemporary Applied Arts

Exhibition & site specific

Architectural & decorative embellishment

Techniques materials

ceramics furniture glass jewellery textiles

Experimental craft

Lighting

Reaction to mass production

One-off & small batch production

Individual handmade, exclusive

Furnishing

Domestic products

Clothing & accessories

3 Contemporary applied arts education

The component media may be taught as separate specialist subjects or introduced through a common first year, with the option to emphasise and study within one medium.

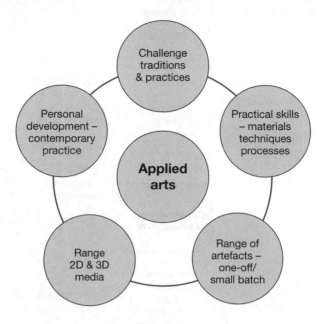

<div style="background:black;color:white;">

Student Experiences:

</div>

Applied arts year 1

'I undertook a Foundation Course in Art and Design intending to do Fine Art and through working in different areas I discovered textiles, and that it was not all about fashion. Everything clicked as I wanted to carry on doing different things. I have particularly enjoyed working in textiles, papermaking and jewellery, and we have workshops with the staff presenting different techniques and approaches such as felt making and basket making, working with metals, printing techniques on fabrics, padding, quilting and stitch. I have a skin condition and wanted to challenge perceptions of it for my interpretation of the body project, and developed embroidered fabrics based upon the patterns created on the skin.'

Student Experiences:

Applied arts year 3

'I became interested in applied art when I saw some dresses made out of paper and I thought of the other possibilities there are if you can do that. Applied art is rather like fine art but you are more likely to be able to make a living, or get a job!

'I had fun in my first year, and did enough to get through, but was not sure what medium I wanted to work in. The course allowed me to play and explore textiles, ceramics and jewellery. Working to given briefs such as 'multiples' allowing us to interpret it as we wished. I developed a working method using note books, sketchbooks and worksheets. In year two I developed an interest in printing and textiles and undertook contextual studies related to photography.

'In my third year for my major project I started collecting objects that are tactile such as lace and photographs, photo albums – something I have always done. I developed an interest in albums as they are nostalgic. Some had images partly torn in being removed, there was the texture of the glues, they were discarded and often the people were unknown. Part of this was that my grandmother died recently and that meant we had to go through her things, including the albums. I researched artists who use photographs in different ways.

'I keep an exhibitions note book and collect material on visits, then start to work in sketchbooks forming ideas. I am also experimenting with processes and keep a technical folder in which I record details of my experiments with different printing and image transfer processes. This includes a description of the processes and the results. As I have developed the work I can go back and know exactly what I have done and can repeat it if I need to.

'I have had a series of tutorials. An early one helped me to consider an emphasis on the found photograph, and the most recent suggested that I consider the way to apply my ideas towards a contemporary application. Staff provide a series of alternatives and you have to decide what you feel is the most valuable to develop. I am casting a reinforced paper fabric on to large oval shapes with inlaid printed images including photographs and letters, and I particularly like them when they are lit from behind. I am also interested in drawing into the images to emphasise something of the lives of the people depicted. The pieces are 3D and include narratives based upon this material. This one is on the theme of weddings. I have found the form and the processes I want to work with and it is now three months to go before my degree show and I need to finalise the content of the pieces.

'The dissertation has to be related to your main area of work but provide a theoretical context. I started early as I am dyslexic and this means things take longer for me. I was able to do the research and writing over part of the week and keep the practical work going at the same time. I know some of the others felt they had to concentrate on the writing and found it difficult to keep the practical going. I could not believe it that some delayed and delayed starting it. I could not have done that.'

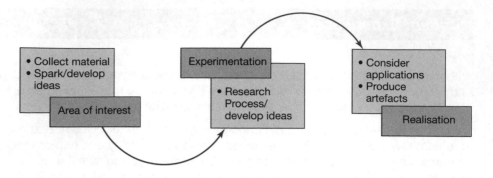

ACTIVITY 15.1 Considering your interests

Having read the chapter on contemporary and applied arts you may be engaged by the characteristics and requirements in working in these areas of practice. You may wish to evaluate your subject and media interests as part of a self-assessment.

Contemporary and applied arts interest me because…

I am suited to working in this area of study because…

Reference

Greenhalgh, P. (ed.) (2002) *The Persistence of Craft*. London, A&C Black Publishers, p. 1.

16 Fashion design

innovation		Sports knit outer wear footware accessories
Seasons autumn/winter spring/summer	*women's girl's men's teenage bridal*	haute couture ready-to-wear mass market
high **fashion** street **fashion** ethnic **fashion** punk **fashion** day evening wear	lifestyle	**trends**

In this chapter you will cover:

1. discussion of the ideas, concepts and practices within fashion design;
2. students talking about their backgrounds and experiences.

1 Ideas, theories and contexts

'For me, fashion, the healthy kind, the kind that interests me, represents contemporaneity, feeling in harmony with the moment in which one lives; this is what I struggle for – to understand my time through costume.'

Interview with Ennio Capasa (fashion designer) in Miglietti (2006)

'Shirin Guild believes that certain styles of dress possess a time-honoured functionality and enduring beauty and thus her collections subtly evolve from season to season…Function and comfort are a priority…her clothes appeal to and flatter women of various ages, shapes and sizes…a judicious variation in textiles and yarns can render garments of similar cut ideal for specific purposes and occasions.'

Amy De la Haye, in White and Griffiths (2000)

'Contemporary fashion both appals and appeals. This fuels the dynamism of fashion and fulfils our desire'

Martin (1997)

'Innovators respond early to the sensory appeal of new silhouettes, details and style combinations, and have the confidence to wear them ahead of others in their group.'

Brannon (2005)

Fashion culture

'…functions of dress: utility, modesty, immodesty (sexual attraction) and adornment…George Sproles suggested four additional functions: symbolic differentiation, social affiliation, psychological self-enhancement and modernism.'

Fashion and self

- social and psychological – fitting in and standing out

Fashion and popular culture

- frivolous fads, superficial

Fashion and change

- anything may be in or out of fashion – from kitchens to trainers, processes of transformation, planned obsolescence

Fashion and communication

- take up of ideas and trends – reaching the consumer

Fashion and the international

- influence and interpretation of national and cultural styles

Fashion and commerce

- international industry, retail, area of economic activity

Fashion and gender

- lifestyle, economic and social, clothes or 'uniforms' for work – the man's suit, colourful, restrictive, attention-seeking – women's status

Source: Based on Jenkyn Jones (2002).

How fashion changes

Trickle-down effect

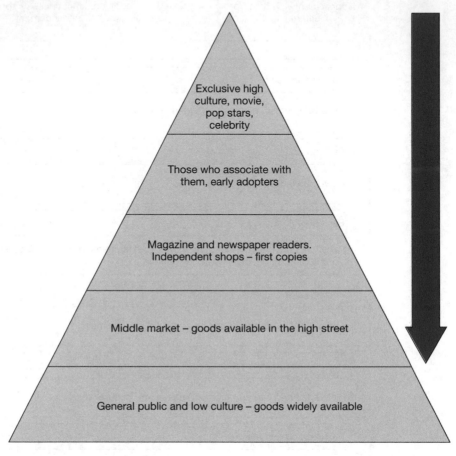

Exclusive high culture, movie, pop stars, celebrity

Those who associate with them, early adopters

Magazine and newspaper readers. Independent shops – first copies

Middle market – goods available in the high street

General public and low culture – goods widely available

Source: Based on Jenkyn Jones (2002).

Bubble up

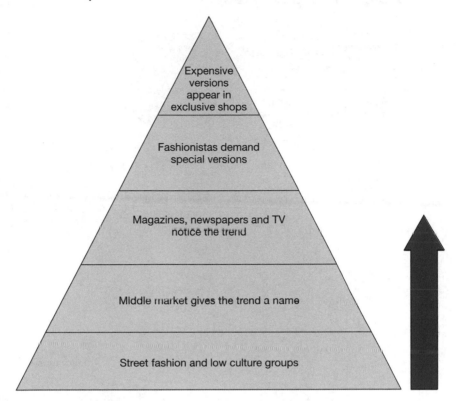

Source: Based on Jenkyn Jones (2002).

2 **Fashion practice**

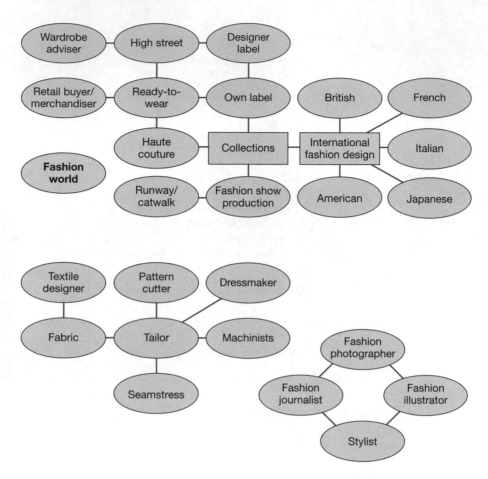

3 Fashion education

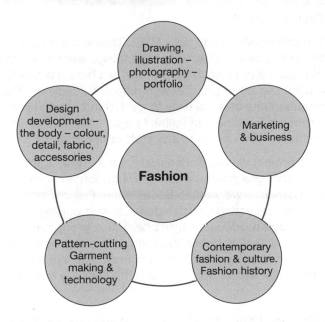

Fashion year 1

'I did an Art foundation course and was open minded when I started with the idea of textiles and then went on to fashion. The course required me to change and present work in a much more neat and tidy way as on foundation I had tended to work with a messy sketchbook. My difficulty was that I had a scribbly drawing technique and in fashion illustration it has to be neat and show detail. There are introductory workshops on techniques for making clothes, but I had no experience of dressmaking before I came and have a lot to catch up on to others on the course. We have a series of short-term projects which cover different areas of fashion. I am doing Fashion and Marketing and wanted the business aspects as well and I think I may go into buying or fashion journalism as I like writing and reading about fashion. But I still need to know how to make trousers now!'

Student Experiences:

Fashion year 1

'I went to college and did a BTEC Diploma in Fashion and learned about the dressmaking side. At college things were much more relaxed and we did two major projects in the year, but here it is much more intense, with a whole series of projects with different deadlines. They have particular requirements and it is easy to get behind – then I panic. I can remember it most of the time, but I think I might need to plan ahead more carefully in future. I like doing the arty stuff rather than the essay writing.

'The project we are working on is for summer garments. We were divided into small groups and went up to London and collected material from everywhere – we went to Buckingham Palace, art galleries, railway stations collecting visual material, taking photographs of people who stood out, produced a style board as a group and then produced an individual design board. We then took on someone else's design board and had to produce our designs from that. We are finishing the making of the blouse and bottom now and the staff are helping us to do it.'

Student Experiences:

Fashion year 3

'At school I did A level Art, Drama, English and a foundation course in Art and Design. Initially I considered illustration, then fine art interested me, but I decided on fashion.

'During year 1 and year 2 we were required to take in lots of information, and staff were important in organising the experience. You need to work with a real purpose – with day sessions taking in a lot, become used to working to a tight deadline, and need to manage your time very carefully. I have worked from eight in the morning till four the following morning to get things done. They do push hard on the course. It is so difficult to estimate how long it will take to make a jacket collar – you think it will take an hour and it takes three. If I go on too long I make mistakes, so I need to take a break and come back better for it. Some people in my group who did not get going on the project have been known to work for 48 hours non-stop by keeping awake on caffeine – not a good thing.

'I am now at the final stages of working on my collection and this afternoon have had a critique of the final seven garments. Each one of them had to be modelled by members of the group. It went well and staff have suggested minor changes, such as shortening a skirt. Others have much more to do. We hand in next week, then there is the degree show.

'We have been working on this for the whole year – last summer we were required to come back with ideas for a theme for the collection, something we had a passion for. I am interested in music and sing and write my own songs, so I came up with 'the structure of sound'. It is based upon musical instruments and the 'colour of sound', with experiments around different colours as a basis. We undertook in-depth research around the theme and I worked upon around 200 designs during October and November, producing toils for the chosen designs garment (a prototype in basic fabric to check that the garment is working) to show that you can raise your arms and so on. I went on to develop 60 garments and have to present seven of the most exciting for assessment. In addition, we have to present an A3 folio prepared as for interview, including fashion illustrations, an editorial photo shoot (I did this in Scotland where the colour of the landscape provided the right atmosphere, and modelled the garments myself) – and a 'look' book where the details of the garments are photographed. We have to do a lot – design, make, direct photo shoots.

'I have tended to go against certain trends as I am interested in a tailored look. Some tutors tend to encourage the weird and the wacky – I am not into that and I have developed a style that is wearable and sellable.'

Student Experiences:

Fashion year 3

'During our second year we are given time to attend London Fashion Week and I really enjoy going to the shows. The art is to get into them and when you do get into them it's great! You need to have the right look and the right attitude – dropping a name or two helps – but the key is which names and where – that is a trade secret. When you do get in you see what is going to happen at the next season.

'For the fashion degree show you don't get to see your own clothes being modelled – you have to wait until you see the video of it afterwards. The students are behind the scenes dressing the models for us all. The clothes are in order on the rails and when your collection comes up you get to tweak the detail.'

ACTIVITY 16.1 Considering your interests

Having read the chapter on fashion design you may be engaged by the characteristics and requirements in working in this area of design. You may wish to evaluate your subject and media interests as part of a self-assessment.

Fashion design interests me because...

I am suited to working in this area of study because...

References

Brannon, E.L. (2005) *Fashion Forecasting*, 2nd Edition. New York, Fairchild Publications, Inc. p. 50.

Jenkyn Jones, S. (2002) *Fashion Design*. London, Laurence King Publishing, p. 17.

Martin, R. (1997) 'A note: a charismatic art: the balance of ingratiation and outrage in contemporary fashion', *Fashion Theory: The Journal of Dress, Body & Culture*, 1 (1), pp. 91–104.

Miglietti, F.A. (2006) *Fashion Statements: interviews with fashion designers*. Milan, Skira Editore, p. 126.

White, N. and Griffiths, I. (eds) (2000) *The Fashion Business*. Oxford, Berg, p. 57.

17 Fine art

painting	**installation**	Performance	object making
photography	Photographic & autographic lithography	relief printing	Line & woodcut
screen process	monoprint collograph	etching itaglio	wood construction metalwork
modelling carving	mould making and casting	digital arts	sound and video
	drawing		

In this chapter you will cover:

1. discussion of the ideas, concepts and practices within fine art;
2. students talking about their backgrounds and experiences.

USING THIS CHAPTER			
If you want to dip into this chapter	Page	If you want to try the activities	Page
1 Ideas, theories and contexts	226	17.1 Considering your interests	232
2 Fine art practice	227		
3 Fine art education	228		

1 Ideas, theories and contexts

Fine art is created for purely aesthetic expression, communication or contemplation. Painting and sculpture are the best-known fine arts.

www.bluemoonwebdesign.com/art-glossary.asp

A term used to distinguish artworks considered to have rare and refined quality, often considered – by those who make such judgements – to be more worthy of preservation and study than 'popular' or 'low' art.

www.shimer.edu/greatbooks_greatart/Glossary.cfm

'The power of art is the power of unsettling surprise…beyond the delivery of beauty…disruption of the banal…an alternative kind of vision: a dramatised kind of seeing…we get shocked.'

Schama (2006)

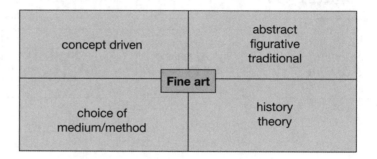

2 Fine art practice

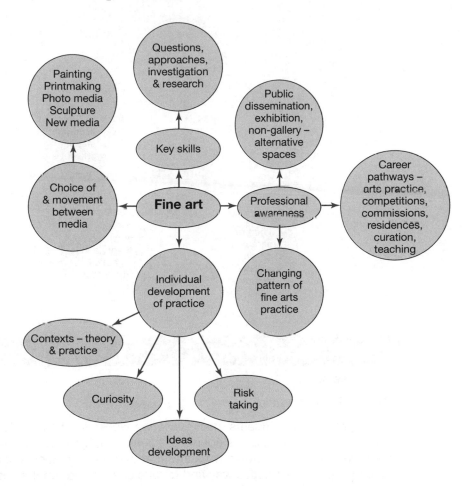

3 Fine art education

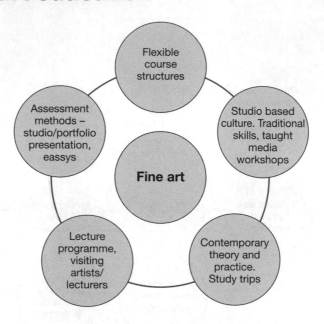

Student Experiences:

Year 1 seminar

Setting: Fine art studio

Same group of six students meet every two weeks for the day. Aim of the seminar: to encourage students to speak about their work – articulate their ideas around their own work and that of others – in a critical, objective and constructive way and to take charge and run the session themselves without a staff presence, encouraging mutual support. This has led to self-sustaining groups that have continued after student graduation.

Lecturer's briefing: 'We are asking students to make a decision before the seminar to select a particular piece of work, but not bring it to the session initially, and to describe it in detail to the group. This would include visual areas like scale, medium, colour, surface (such as texture in detail, not just rough but perhaps with granulation made of fibres or saw cuts). Do not say what you intend to be the meaning of the work or any associations. The group without seeing the work should make a drawing of what is described. One of the group should also act as a scribe and note down the conversation as it develops.'

Student 1: 'I want to describe a sculpture that I am working on. It is based on a cut body shape made with a band saw. It is made from wood, has no additional colour, the surface is smooth, a narrow waist that is cut off at the hips and there is no head. It is quite flat as I am interested in Egyptian images. It has arms that are made from separate pieces and are longer than the body.'

Student 2: 'Is it a boy or girl?'

Student 1: 'A boy.'

The work is brought into the group and displayed.

Lecturer: 'What are the associations that members of the group can see?'

Student 3: 'Reminds me of some Greek sculptures that are in pieces.'

This leads to a discussion of the origins of Greek sculpture that has reached us as fragments of parts of the body, how it was painted originally and represented an ideal of the human form.

Lecturer: 'This process of making becomes very interesting, how at various stages during the process of making we sense that this is a point where it may be valid to stop and not go for a look that tries to be close to a form of reality.'

Student 4: 'It reminds me of toys such as action figures. Doll figures are worrying at times. My sister has a number, and when I throw them on top of her pile of toys I feel I am in some way abusing them.'

Various associations by group members – of robots, Pinocchio, an armour chest plate. Angel of the North, Antony Gormley, Schnabel, Giacometti, Ron Merks.

Lecturer: 'Can a work be abstract and figurative?'

Student 3: 'The artist may have particular intentions, ideas in your head, experiences and associations that they have but are not known to the person viewing the work...who will also have experiences and associations coming from the work. In talking about this we are bringing those out.'

Lecturer: 'How might this work be developed?'

Discussions centred around changes of scale, perhaps photographing the sculpture and placing it in different settings/backgrounds, duplicating the figure, making it very small, asking what story was to be told around the work, working in a different medium or on canvas...and further reading on mythology and Egyptian art.

A session in which, through collective discussion, references were made across a wide range of historical and contemporary issues plus possible artists and areas for the student to research. There is so much that comes from sessions such as this that it may be confusing. There is a need for reflection by the student and an establishing of an emphasis and direction as to how to select material that is valid for the individual.

Student Experiences:

Fine art year 3

'I did an Art foundation course and moved to fine art having considered textiles. I was talking to some graphics and animation students and realised we are the only degree where we do not get detailed project briefs. We have to come up with the idea, then do it and talk to staff about it. I find seminars the most useful – it's good to hear what other people are doing with different ideas, media and ways of doing things.

'My current work centres upon my interest in writing and the making of art as a form of personal therapy. When I was angry and stressed I found writing it down to get it out there was right for me and not (intended) to communicate specifically to people looking at it. I wanted it to be ambiguous and I discovered I could write backwards and that is what I have been doing (working on a large canvas, with columns of handwritten text with letters and sentences backwards). People have commented that it represents different things to them about symbols and language, and because of the small size of letters it draws people in close. My big decision now is whether to leave the canvas on the wall for the degree show or to put it on a stretcher – my lecturer says I should in case I get an opportunity to show it later.'

Student Experiences:

Fine art year 3

'At school there was always an interest in my art work. It was displayed from primary school onwards. My teacher at secondary school recognised my abilities as a painter and always wanted me to continue.

'I took a foundation course in Art and Design and it made me realise that I was in something of a box and this helped me to look at other things. I considered textiles but decided to go ahead with fine art for my degree.

'At the beginning we had a series of workshops looking at different ways of doing things. Generally we did not have briefs or projects but did benefit occasionally from a different starting point… and a structure to work into or against. I learned how important theory was early on and became engaged in it. We also had seminars in which we had to present work in progress and I learned a lot about how to talk about my ideas.'

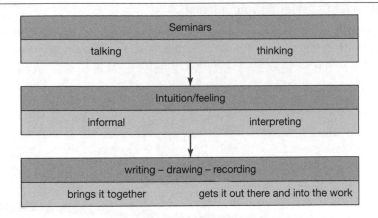

'So far I have moved into photography and animation as I like to do things using different media. Tutors have encouraged this. I used to paint from photographs and this was a step back to the medium itself. I have looked at artists who use photography and what I would call the 'poetics' of photography. I see the camera as a tool, as with a brush and a drawing. I still draw regularly and miss the link to certain skills and being physically involved in the act of the painting. I feel I may go back to painting when I have developed this phase of my ideas.

'Critical studies and theory are very important as they allow me to look at things in a different way and tune this into a part of my art, placing what you are trying to do into a historical context and seeing yourself in relation to other people's work. I have really benefited from being able to think differently and from being in a different place.

'An area that has concerned me is how to use tutor's advice. You have to take on board what other people say but cannot base your decisions and rely on it, as sometimes staff give contradictory advice. You have to consider what you think is core to your progress. You have to take parts of their advice and personally assess them. You can think that you will get better grades if you do what they say, but grades are not important. What matters is what you learn.

'I am not sure what will happen when I finish the degree. I do not see myself as a gallery artist, though I will continue with my work. I have been doing freelance work visualising scenes as part of proposals for film projects and could see this as a way to make part of a living.'

ACTIVITY 17.1 Considering your interests

Having read the chapter on fine art you may be engaged by the characteristics and requirements in working in this area of practice. You may wish to evaluate your subject and media interests as part of a self-assessment.

Fine art interests me because…

I am suited to working in this area of study because…

Reference

Schama, S. (2006) *Power of Art*. London, BBC Books, p. 7.

18 Graphic design and illustration

> **Graphic design** – computer graphics information graphics
> Information science visualisation visual perception art direction
> **images** *illustration* **photography** typography interface design logos
> websites **advertisements** book **design**
> brochures **product packaging** *posters* editorial **design** for magazines and
> newspapers **design** for print web **design**
>
> **Illustration** – drawing painting **computer *art* computer *graphics***
> typography **technical illustration** storyboarding *image rendering*
> photography video games movies **animation**
> ADVERTISING publishing

In this chapter you will cover:

1. discussion of the ideas, concepts and practices within graphic design and illustration;
2. students talking about their backgrounds and experiences.

USING THIS CHAPTER

1 Ideas, theories and contexts

'Graphic design is a creative process that combines art and technology to communicate ideas. The designer works with a variety of communication tools in order to convey a message from a client to a particular audience.'

AIGA Career Guide

'Otto Neurath, inventor of international picture signs, suggests (that) a 'model for the graphic designer of the next millennium, the language worker equipped to use design and theory for unearthing new questions and constructing new answers.'

Quoted in Lupton and Abbott Miller

Illustration: artwork that helps make something clear or attractive...a visual representation (a picture or diagram) that is used to make some subject more pleasing or easier to understand.

www.wordnet.princeton.edu/perl/webwn

Illustration in art, an image that purports to make visible, or simply to ornament, the sense or meaning of a text, particularly as an aid to the reader's interest or understanding.

www.shimer.edu/grestbooks_greatest/Glossary.cfm

'Cogent design are a full service graphic design and marketing consultancy...Services include; web, brand and corporate design, b2b business to business marketing, signage, presentations, branding and brand development, marketing communications, brochures and multimedia.'

www.cogent-design.com/services.htm

2 Graphic design and illustration practice

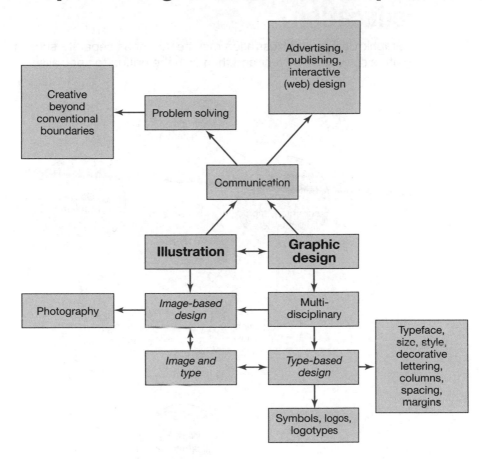

3 Graphic design and illustration education

Graphic design and illustration may be taught as separate subjects or linked with a common first year and then with the option to specialise.

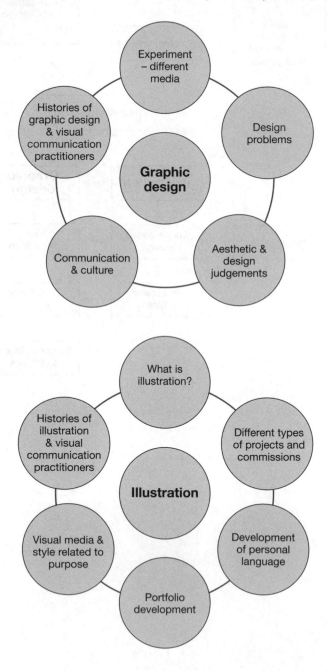

Student Experiences:

Graphic design year 1

'I did a Foundation Course in Art and Design and this confirmed my choice of Graphic Design.

'During the first semester we did quite a lot of group work and were introduced to techniques such as problem solving, typography, photography and computer printing. One kind of project we did was to create ten different images that convey meanings around a single word such as 'cold'. We study different artists and designers. We have been introduced to study skills and I am working on my weaker points in essay writing such as research and referencing.

'I work better under pressure – when I have a deadline.'

Graphic design	• problem • research • develop ideas • develop solution • complete to deadline

Student Experiences:

Graphic Design and Illustration year 3

From Yekaterinburg, Ukraine – studied in Ukraine and Moscow, final year in England.

'I studied architecture and interior design in my own country. My school in Moscow taught graphic design and illustration with an emphasis on using English. Some of the design lecturers were English. I find it difficult to express myself as the gestures and use of language are different and people behave differently. There is a difference in the briefs, so it is a challenge and I make a big effort to understand. Here (in England) people come into the university and there are seminars, crits and tutorials. They talk to each other – sometimes about the work – they interrupt and just chat. This is disturbing if you are trying to work.

'London is very different – people here say sorry when something happens. I like it here and would like to work here.'

Graphic design year 3

'I started my Foundation Course in Art and Design planning to take a degree in model making and special effects for film. Working through different disciplines with two-week projects made me feel that I wanted to work differently. During the graphics block I started to understand what it is and found it was more interesting for me, it was experimental in trying to find ways of expressing meanings. Until then I did not know that graphic design was so exciting, using design to achieve layers of meaning. It was an epiphany, a spontaneous decision.

'On our first day I remember that the programme leader was upset because Alan Fletcher (influential founder designer of the design group Pentagram) had died and we did not know who he was. The course has led me to want to read design books and picture books. I have a sudden thirst for knowledge and want to know about things. The subject requires us to take influences from everywhere: we are told to read good newspapers and know about current affairs as these affect graphic design. When working on my last project I looked at aspects of mythology, Van Dyck, symbolism. Graphic design is about designing knowledge visually.'

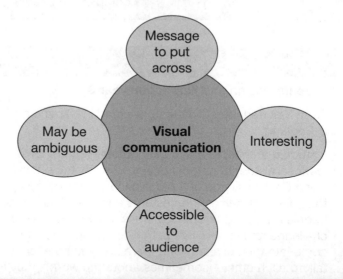

Graphic design year 3

'When I do a project I try to produce as many ideas as possible – to explore alternatives. My way of working is to try to look for a method that I can use. One of my projects has been to design a four-dimensional typeface which has its form based upon animation. I have obtained copyright registration for it.

'Critical and cultural studies is very important to me and provides an interesting perspective on things. I wrote my dissertation on architecture and the use of city spaces. Foucault's ideas on the organisation of space and its relation to power formed a part of it, with ideas around how cyclists use the city, and the culture of skateboarders as an alternative for surfers. Reading changes my ideas.

'I studied in Moscow and this was an amazing experience. It made me look at things very differently as I never knew what to expect. My work experience has worried me. A project in which we would be allowed something like two months at university had to be resolved in two hours. It was very interesting to develop the initial concept with other people, but then I had to work to guidelines for the design. There was real time pressure. I think graphic designers should work with a social responsibility, and while at university I can afford to say it should be more than just selling.'

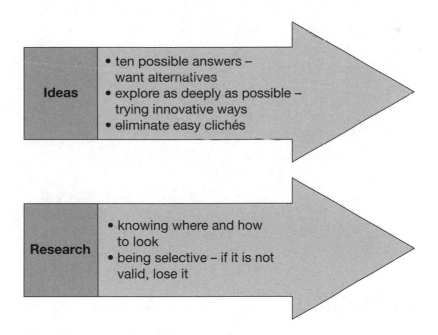

Ideas
- ten possible answers – want alternatives
- explore as deeply as possible – trying innovative ways
- eliminate easy clichés

Research
- knowing where and how to look
- being selective – if it is not valid, lose it

ACTIVITY 18.1 Considering your interests

Having read the chapter on graphic design and illustration you may be engaged by the characteristics and requirements in working in these areas of design. You may wish to evaluate your subject and media interests as part of a self-assessment.

Graphic design and illustration interests me because.............................

I am suited to working in this area of study because...

Reference

Lupton, E. and Abbott Miller, J. (1996) *Design Writing Research*. New York, Princeton Architectural Press, p. ix.

19 Interior and spatial design

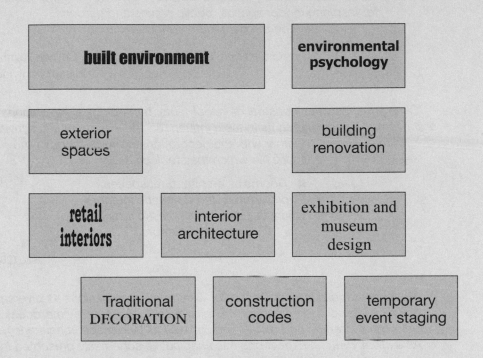

built environment		environmental psychology	
exterior spaces		building renovation	
retail interiors	interior architecture	exhibition and museum design	
	Traditional DECORATION	construction codes	temporary event staging

In this chapter you will cover:

1. discussion of the ideas, concepts and practices within interior and spatial design;
2. students talking about their backgrounds and experiences.

USING THIS CHAPTER			
If you want to dip into this chapter	**Page**	**If you want to try the activities**	**Page**
1 Ideas, theories and contexts	242	1 Considering your interests	247
2 Interior and spatial design practice	243		
3 Interior and spatial design education	244		

1 Ideas, theories and contexts

'Spatial design is a matter of problem solving, breathing life into old spaces and creating new places...exploring the way people live, work and interact to deliver sustainable, socially responsible and innovative design...designs for inspiring indoor spaces, public places and gardens... meeting the demands of modern life.'

Extract from course outline University College Falmouth
www.falmouth.ac.uk/index

'Changing lifestyles, industrial developments, technological innovations, architectural trends and shifts in taste influenced the way domestic activities were arranged, together with the decoration and furnishings of the spaces in which they took place.

- *Rooms as architectural spaces.*
- *Public spaces and domestic interiors.*
- *Changing styles in domestic interiors.*
- *Design for interiors.'*

Leslie (2000)

'Rosamund Inglis Interior Decorator welcomes commissions as diverse as office interiors, commercial and leisure schemes, fantasy marquees, pools, hotel interiors and restaurants, as well as landscape consultancy... As a client you can expect original, imaginative schemes...presented in well rendered visualisations with samples, followed by clear drawings, instructions and schedules.'

www.rosinglisdesign.com

'The study of interior design, its development and change through history, is a useful way both to explore the past and to make sense of the spaces in which modern life is lived. Professional interior designers are expected to study design history, to know the practices of the past in terms of 'styles' and to know the names and the nature of the contributions of those individuals who generated the most interesting and influential approaches to design.'

Pile (2005)

A process of working

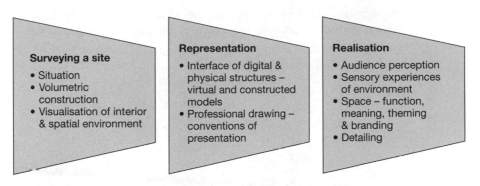

Surveying a site
- Situation
- Volumetric construction
- Visualisation of interior & spatial environment

Representation
- Interface of digital & physical structures – virtual and constructed models
- Professional drawing – conventions of presentation

Realisation
- Audience perception
- Sensory experiences of environment
- Space – function, meaning, theming & branding
- Detailing

2 Interior and spatial design practice

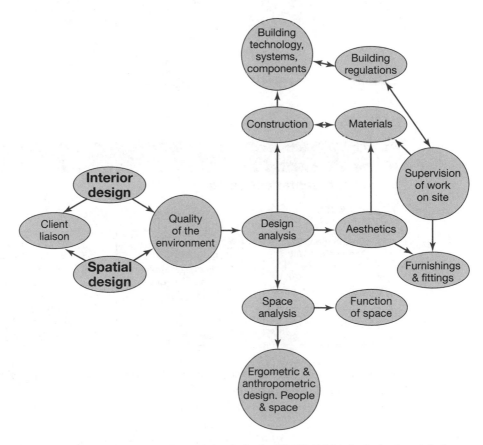

Source: Adapted from Courses and Careers in Interior Design BIDA (British Interior Design Association)
www.bida.org/careerinfo.asp

3 Interior and spatial design education

Interior and spatial design may be taught as separate subjects or linked with a common first year and then with the option to specialise.

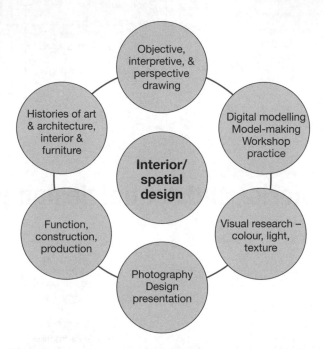

Student Experiences:

Student presentation/critique

The project

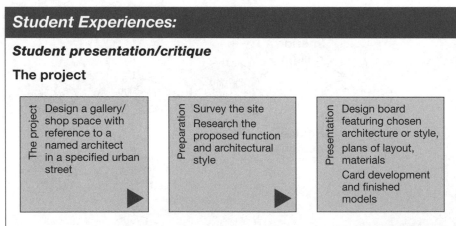

The project	Preparation	Presentation
Design a gallery/ shop space with reference to a named architect in a specified urban street	Survey the site Research the proposed function and architectural style	Design board featuring chosen architecture or style, plans of layout, materials Card development and finished models

Themes proposed by students included Japanese architecture, Mardi Gras and electronic products.

Students present their proposal followed by discussion. Comments made included the following:

- Challenging and comprehensive – project bringing things together from the year.
- Plan your boards carefully and as you are presenting this in person use bullet points to present your research, talk to that and you can avoid blocks of text.
- Refer to everything you have used in your solution.
- Show the context of the design – need to have the feeling of what is happening.
- Take care of the layout of the boards – you could look at the layouts of architectural magazines.
- When making your CAD drawings, use different line weights in the drawings.
- Your illustrations must convince – finesse of detail – use photographs combined with drawing, but make sure that the scales are right.
- You will be using different software and it is essential that you know how to convert your files from one to another and back again.
- Make sure the models are constructed to allow access to both interior and exterior spaces.
- There have been a number of problems with time management. It is vital that you give yourselves a personal deadline so that you can allow for things to go wrong with time to put them right – because things will go wrong. Some of you have had problems with printing, making the models, etc.

Student Experiences:

Interior and spatial design year 3

'When we joined the university the course was new and we were linked to product design during the first semester. This gave some grounding in the design process but it was not our main interest and this was disappointing. The subject is linked to architecture and the design of interior and exterior spaces. We have undertaken a number of live projects and this has involved working with other students in groups and with professionals from industry. I have acted as a team leader at times. An example of this is a lighting project for a new building at the university (a new student centre incorporating entertainment facilities and restaurants is under construction). We were divided into five teams and asked to develop proposals following a briefing from the architect, including sourcing materials and costing. This was developed into a competition, with awards for aspects such as best design, technical solution, overall concept and team working. For the presentation to the architect's team we had to produce a fully professional presentation and explain our ideas. The architects were in their suits and ties and we were all smartly dressed, and it went well. This was a good experience.

Another project has involved working with the local town council design department on a project to enhance public areas, focusing on the subways in the town.

'We have lots of discussion while we develop projects and as ideas develop. You have to learn to see things from a different perspective as you work with the rest of the group. In addition we have group criticisms and tutorials with staff input and this makes for a sharing of research and ideas. As a class we work well together.'

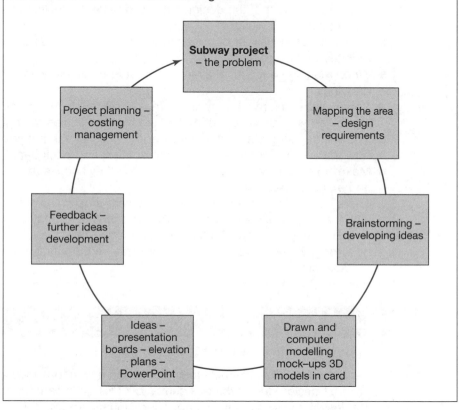

Student Experiences:

Interior and spatial design year 3

'I went to college to study Art and Design and was interested in furniture design initially but decided to do interiors. I am now working on my major project, which is to develop concepts for a rehabilitation centre for girls. My thinking was around aspects of people's lives and the disorientation that they may feel from being wild, and the sick effects from alcohol and drugs. They are placed into rehab and I want to get away from the negative aspects of the clinical atmosphere of hospitals. I have been thinking about how they might feel and want to create an area that is more positive. I have been reading about the ideas of Le Corbusier, in

particular the monastery (The Monastery of Sainte-Marie de La Tourette, Eveux, France built in 1953) where the cells are a particular size and the space is designed to help people to concentrate on the important issues. I have researched prison layouts and the thinking behind them, including the circular Panopticon system of surveillance. But my thinking is this should be designed as a positive thing to allow for communal living with social networking and interaction. There would be individual rooms but also dance and art studios, therapy and meeting areas.

'When I start a project I find it difficult to find ideas and I have been encouraged to read around topics on architecture and designers' work. I develop my ideas through drawing and find this is the quickest way for me. When I have established my approach I sometimes have difficulty in moving on and I recognise this and am working on it.

'Studying in university is expensive and you need to think very clearly about what you want to do. Students I know from other degrees like business think that design courses are a 'doss'. But there is the creative side and the quality of the work you do is so dependent on what you put into it – within what is a very competitive area.'

ACTIVITY 19.1 Considering your interests

Having read the chapter on interior and spatial design you may be engaged by the characteristics and requirements in working in these areas of design. You may wish to evaluate your subject and media interests as part of a self-assessment.

Interior and spatial design interests me because…

I am suited to working in this area of study because…

References

Leslie, F. (2000) *Designs for 20th Century Interiors*. London, V&A Publications, p. 7–24.

Pile, J. (2005) *A History of Interior Design*, 2nd Edition. London, Laurence King Publishing, p. 10.

20 Media

media theory media studies and education communication studies
advertising **apparatus codes content analysis** conventions
crime analysis cultural imperialism cultural studies
culture **discourse analysis encoding and decoding feminism
gender genre** hegemony ideology institutions **intertextuality**
Marxism mediation polysemy postmodernism
psychoanalytical theory power race realism reality representation
rhetoric **sign semiology/semiotics** stereotypes
structuralism and post-structuralism synergy **text** uses and gratification

In this chapter you will cover:

1. animation;
2. computer games/games art;
3. film and TV studies;
4. TV and video production;
5. visual and special effects.

There are a number of activities grouped under the umbrella title of media. These include digital media and video through to model making for 'props' and special effects.

- **Animation** – computer-animated stop-motion feature length films: bitmap graphics, vector 3D animation graphics – tweening, morphing, onion skinning, interpolated 2D animation rotocoping cel-shaded traditional animation - hand drawn, stop motion.
- **Computer games/games art** – digital modelling – characters & environments shader techniques real time 3D graphics game engines levels, puzzle coding and programming audio design interactive story telling.
- **Film & television studies** – access agenda-setting Americanisation audiences children and television class comedy commercial television series cultivation documentary drama educational television entertainment family and domestic viewing fans game shows globalisations mass media video news objectivity ownership public service broadcasting music narrative policy political economy pleasure pluralism regulation scheduling science fiction sex/sexuality soap opera sport taste technology violence women in television.
- **TV and video production** – light sources (position) type of lamp colour white balance soft hard high key low key camera movement view point lens aperture focal length framing composition live transmission editing transitions narrative continuity.
- **Visual and special effects** – properties and model making visual and special effects apply digital technologies and their production is linked and utilise physical models and properties.

Adapted from Casey *et al.* (2002)

1 Ideas, theories and contexts

'We strongly believe that the ability to combine and articulate different approaches is key to thriving in a multimedia environment that includes TV, cinema and video and modern platforms like the web, mobile phones and video games.

Project briefs include 2D drawn animation, 3D model making and computer animation, abstract and experimental animation, mixed media and video'

Extract from course description, University of the Creative Arts (www.ucreative.ac.uk)

'Happy Hour Productions Ltd is an award winning production company producing for TV commercials, corporate videos, music videos and TV production.

3D computer generated animation…services include producing entire animated projects, creating productions that mix animation with live action, and standalone animated segments to a given brief…our animation team can design, model, rig and animate 3D characters, objects or environments.

2D animation and motion graphics…we can produce stylised and effective animation to suit any production.'

Extract from promotional website
www.happyhourproductions.co.uk/animation-production.html

Francis Beckett (2006) writes: 'Journalists sneer at it (media studies) for being too theoretical' and quotes Sally Feldman, Dean of Media, Arts and Design at the University of Westminster, who states: 'Media is so big a part of modern society that it deserves to be studied properly.' Beckett goes on to argue that 'the journalists' contempt for the subject' may stem from a discomfort over their role and the media industry coming under examination or critical scrutiny.

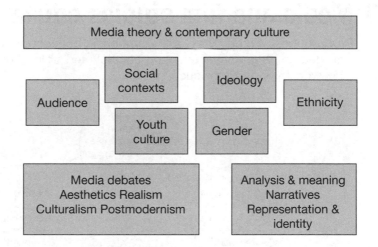

2 Media industries and practices

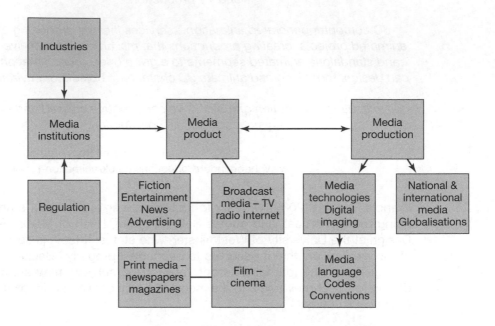

3 Media and film studies education

Programmes of study vary in the emphasis between theory and practice, with degree programmes featuring cultural/media/film theory from 100% to 25% with 75% media production.

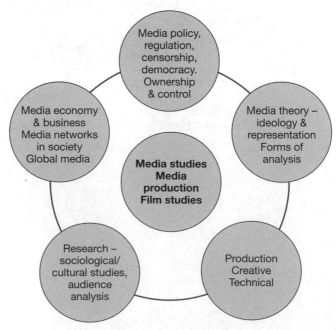

4 Animation industries

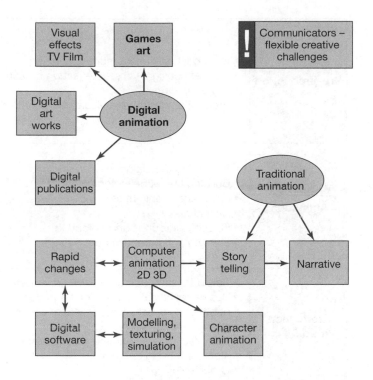

5 Animation and games art education

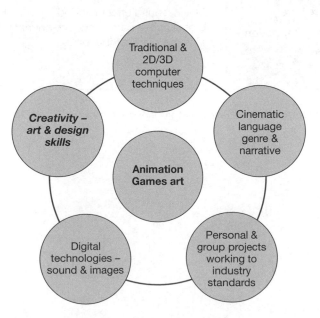

6 Production of a film/video/animated film

Pre-production	• Idea, brief, treatment, script, planning • Concept design – characterisation and style • Storyboarding • Production design and visual development
Production Animation	• Recording the dialogue • Building the models, rigging • Layouts and animatics • Animation • Final backgrounds and colouring • Lighting and compositing
Production Video & Film	• Select location or studio settings, actors as required • Decide technical codes – light sources, lens – local length, depth of field, sensitivity of film or sensor, shutter speed, special effects, sound • Narrative codes – framing & composition, angle of view, static or moving camera • Organise crew • Shoot
Post-production	• Music, sound effects added • Digital image combined with soundtrack • Mastered for distribution

Source: Adapted from www.skillset.org/animation/careers/article_3786_1asp

7 TV production

Case study – rehearsal for live news programme

Studio: control room.

Members of student group given responsibility as producer/director, presenter, floor manager, camera, lighting, sound, teleprompt.

Initial meeting: making editorial decisions about content of the programme – items including credit crunch and effect on student costs, the summer ball, entertainment on campus, sports and weather.

Presenter dressed in suit seated to read the news, weather presenter positioned in front of green screen.

'Cameras 1 and 3 chroma key – check.'

'Go to rehearsal.'

Director: 'Lighting – ready, check. Video – sound, check. Start camera 3. 2 – ready to record. Sound ready. Teleprompt, floor ready – 10, 9, 8, play opening sequence 7, 6, 5, fade, lighting up, 4, 3, 2, 1'.

Director: 'Cut to camera 2.' Close-up of presenter.

Presenter begins: 'Welcome to university news…can the Teleprompt pause between headlines, as I can't read that fast!'

Director: 'Cut – we need to run through again.'

'Go to rehearsal. Lighting – ready, check. Video – sound, check. Start camera 3. 2 – ready to record. Sound ready. Teleprompt, floor ready – 10, 9, 8, play opening sequence 7, 6, 5, fade, lighting up.'

Presenter begins: 'Welcome to University News. The headlines are…'

Director: 'Cue insert.'

Presenter: 'How is the credit crunch hitting students? Our reporter reports…'

Director: 'Play insert 2 (interview with students in and around campus).'

Presenter: 'We now have the weather report, over to Emma…'

Cut to the weather presenter: 'Sorry, the light is reflecting off the autocue and I can't read it.'

Director: 'Cut. Can you change the position of the light? OK, we will go to the last item but one and then do the link again.'

8 Digital animation

Student Experiences:

Case study – lecture/demonstration year 1

Aims of session: an introduction to computer generation imagery.

Software: ZBrush. Allows digital modelling as if with clay. Developed and used in *Lord of the Rings* and *King Kong*.

Computer suite: Students at individual computer stations. Session starts with video clip of computer animator, Simon Blanc of West Studios, discussing working with the software. Merits include flexibility and speed in building characters, spontaneity, the ability to draw shapes with CG, experiment and play with shapes to create scenes.

Lecturer sets exercise: working with a model of a head.

Importing a low-resolution mesh: 'When you have loaded your object you can click and drag it onto your canvas. Remember, you need to go into edit mode to stop the model redrawing on to the canvas.'

Masking: 'Now let's say we only want to work on the top of the head, we can CTRL shift to create a mask on top of the head. As I paint I am not affecting the face. Now we have the top of the head unmasked, let's go to tool, Deformation, and do a negative inflate. Now it looks like it has had a brain operation.'

Painting in the colour of the brain: 'Change the material to basic and go to colour, select a skin colour and paint the brain. Now add an eye mask, click X to make symmetry and remember to switch it off. Now with a little Zadd we can add some depth.'

Changing the head shape: 'Create a new head, edit mode and sub-divide up to level 6. Click shift D and go back to the start. M mirrors, XY&Z for the axis. Larger brush size for large or global edits allowing head to move more easily. Smaller edits with small brush for point edits. The head is now totally different to when we started. ZBrush is all about detail, such as creating wrinkles, a cut across the eye. The layer tool is cool for armour.'

Warning re working practice: 'Keep away from pinch, making the geometry close together. Be careful of using nudge as it can deform the mesh over itself, creating messy mesh.'

Morph targets: 'Load the head again, initialise scene.'

Creating textures: 'Crop and fill head texture.'

'Now we are ready to start painting the model.'

Assessment presentations for year 3

Required to present a 2D or 3D digitally animated film and are responsible for pre-production, production and post-production, including story, styling, character development, sound and use of appropriate animation techniques, such as virtual camera and lighting, application of texture maps, and shading and algorithms for surface characteristics, convincing figure animation as appropriate, application of rendering algorithms and original soundtrack. Students working in teams of 2–4 depending on skills and ability to work together.

Purpose of session: to allow students to present their work in person and to answer questions about issues of production (supported by student-generated report produced to document individual contributions); for staff to give feedback and establish initial confidential grade (discussed and moderated within staff team subsequently); to discuss career prospects with students.

2D animation – *Little Death*.

Story of a 'grim reaper' and the death of a child. Simplified skull-like head of character; backgrounds a combination of colour and monochrome.

Student: 'Last year my planning and work was something of mess; for this year my planning was completely in place and the project seemed to work very well. But I need to tweak the animation and the 'in-betweens.''

Lecturer: 'You have established real emotion through the characters and the narrative is clear, with very effective sound…'

Student: 'I worked with a music student on the music, it is original.'

Lecturer: 'The timing is slow and it is common to need to make the animation faster – you can get the feel when I play it at double speed. You will need to modify the sound, but a very good piece of work.'

Student: 'I wouldn't have done it if I hadn't enjoyed… It's been very satisfying. I am planning to work in music videos, advertising and illustration and have made contacts when doing my work experience.'

3D animation – *Potion*.

Story of a person making a chemical potion. He drinks it and is transformed, and climbs towards the sun and is consumed by the light. A metaphor for addiction?

Student: 'I have mixed feelings about the film, but I am proud of certain shots and the visual style which we worked strictly to. What is important is that we produced a versatile rig and this served us well.'

Lecturer: 'How did you work together?'

Student: 'We both worked on the design elements and had good communication during the production process, though I live on campus and he lives in London. We were bouncing work backwards and forwards online. I am planning to work in digital production and am producing separate show reels emphasising my particular skill.'

Lecturer: 'There is plenty of work available in rigging and that is certainly a way to get your foot in the door. Then you can develop from there. Bring your show reel and I will help you to tighten it up.'

9 Film

Student Experiences:

Film year 2

'I have always been interested in film on the basis that my father bought a video camera to record holidays and so on when I was very young. So I started to use it with friends and we made movies. What interested me in particular was the photographic side and using the images to tell stories. It seemed too much fun to make it a career, but here I am at university studying it. I learn a great deal from making and watching films; being critical and thinking about how certain things were done in a particular film and taking these references and applying them to what I am trying to do; considering a style or atmosphere in the way in which it puts across an idea. I am interested in the area of fiction and art films. We have been working on an external project with an outside director and worked as crew on a documentary film about business entrepreneurs. There was a steep learning curve.'

Student Experiences:

Character creation and special effects year 3

'I worked in Berlin on an unpaid placement in theatre on props and make-up. I was supporting myself through stacking shelves in a supermarket, cleaning and working in an art gallery. I decided I needed to study and develop my interests and applied to study in England. I sent slides and an essay and was accepted. I was not able to visit the university but the virtual tour allowed me to view the facilities.

I was attracted to studying in England because the teaching approach seems very personal. In my area of interest I find I have ideas in my head and I try to bring that out. They are dark and bizarre, and I draw and make mock-ups to turn them into 3D. I now research fine art sources such as Expressionism, Surrealism, Hieronymus Bosch, David Lynch, Tim Burton, in order to get these weird pictures out of my head. Critical and Cultural Studies has been useful as it is more formal, and in spite of the language difference I have been able to look behind the thinking and study the psychological aspects as to why people want to go to Disneyland, for instance. I have problems with time management as I tend to want to do too much and I need to make judgements about how far you need to go – I want to make it too perfect.

In the summer I did some work experience and worked in industry and this has resulted in some freelance work. I worked for a model-making company called ... and was making armour for the film *Prince of Persia*. This helps me to pay for materials as they are expensive and I can't afford to waste anything.

I have learned that the industry is very competitive and one must be very good as an individual to be successful. I hope to be able to work in Britain when I finish my degree because I think there are more opportunities here.'

ACTIVITY 20.1 Considering your interests

Having read the chapter on media you may be engaged by the characteristics and requirements in working in these areas of practice. You may wish to evaluate your subject and media interests as part of a self-assessment.

.. interests me because...

I am suited to working in this area of study because...

References

Beckett, F. (2006) 'Media studies? I'd prefer a law degree', *The Guardian*, Monday 4 September, **www.guardian.co.uk/media/2006/sep/04/mondaymediasection. education**

Casey, B., Casey, N., Calvert, B., French, L. and Lewis, J. (2002) *Television Studies: the key concepts*. London and New York, Routledge, p. xi.

21 Photography

advertising	amateur	architectural	art	darkroom	editorial
family	fashion	film	fine prints	histories	lighting
location	paparazzi	personal	photographic codes	portrait	macro
news	record	scientific	sports	studio	stylists
colour	theory	wildlife	documentary	digital	black & white

In this chapter you will cover:

1. discussion of the ideas, concepts and practices of photography
2. students talking about their backgrounds and experiences.

1 Ideas, theories and contexts

'We are at an exceptional time for photography as the art world embraces the photograph as never before and photographers consider the art gallery or book the natural home for their work.'

Cotton (2004)

'Fashion, advertising, architectural, editorial and portrait photography are all open...as are a whole range of related fields such as art director, picture editing, picture research, photo-journalism and fine art photography.

'It's not just a matter of trying different styles and developing ideas; photographers need transferable skills in analysis, problem solving, synthesis, communication and marketing to achieve success.'

Extract from course description Blackpool and The Fylde College
(www.art-design.blackpool.ac.uk)

'Theory informs practice...if you disregard theoretical debates, taking no account of ways in which images become meaningful, thereby limiting critical understanding and, if you are a photographer, restricting the depth of understanding your own work.'

Wells (1997)

'Over the history of the medium, photographers have been reporters, family historians, satirists and inventors. They have made their work as professionals and amateurs, as doctors, ornithologists, suffragettes and gardeners. Often, the contribution of women photographers, and some of the photographs by and about some of the many minority communities living in Britain, as well as the work of vernacular photographers, has been overlooked.'

Williams and Bright (2007)

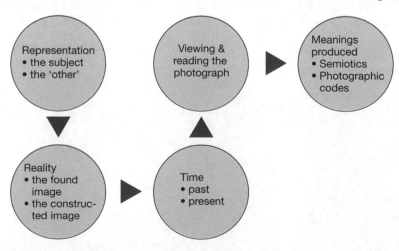

2 Photographic practice

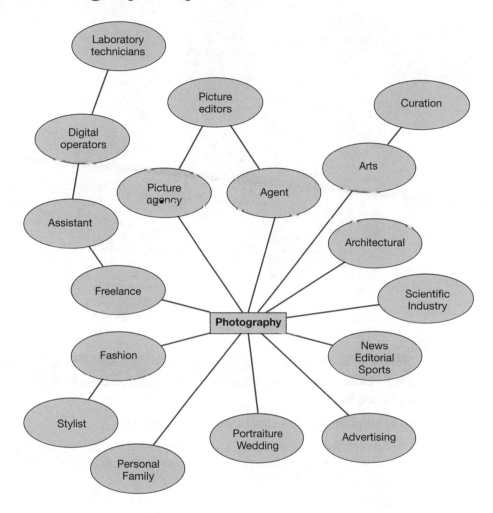

3 Photographic education

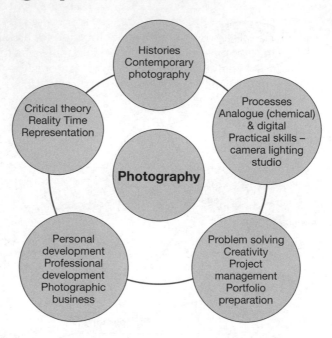

Student Experiences:

Photography year 1

Lighting demonstration: photographic studio

Lecturer: 'We are looking at how we can use different forms of lighting to establish different styles of photography, from 'naturalistic', soft effect to a Hollywood Thirties' glamour atmosphere.

Could one of you take the role of model? Now, using this light (large with a diffuser over the bulb) you can see that there are shadows but the transition from highlight to shadow is gradual. If you want to lift the shadow area you can place a fill-in light or reflector close to your camera position and this will reduce the ratio of dark to light. We can create an even softer light by bouncing the light off a large white surface because the larger the light source, the softer it will be.

Of course, one of the largest light sources you can use is an overcast cloudy sky. When using flash on camera the practice may be to use a silvered umbrella, which will increase the size of the light source.

If you seek to create the feel of the Hollywood portrait you are looking for sharp-edged, deep shadows. The look comes from the focusing spotlights that were used in film studios. They originated from the need in the black-and-white movies of the time for as bright a light as possible, and the most efficient way of doing this was through a series of spotlights to light the film set. The other factor is the smaller the light source, the harder the light becomes. So the classic position for the main or key light is at 45 degrees and above the person. It is best to build the lighting, with one light at a time. First position the main light to your satisfaction; it will tend to illuminate the forehead and side of the face with a deep shadow cast by the nose. Sometimes a pool of light is wanted and then a snoot is used to limit the light into a circular shape. You can also use barn doors to cut off areas of light on to the subject.

To reduce the contrast you will need a fill-in on the same side of the camera as the main light to avoid a double shadow. Remember, the eye is able to accommodate a higher lighting contrast, certainly when shooting on film, but also seek to get the right contrast when shooting digitally. This avoids the need to do post-production work after the shoot. You will often see when you do your research that this style of photographs includes further lighting used to highlight the hair, or may be added to create areas of tone or projected shapes onto the background.

Do some research. You could start by looking at the work of, say, Karsh, David Bailey, Irving Penn, Testino.

For the project (you should) experiment with the lighting related to the people you photograph and how you can change the 'look' of them, using the different forms of lighting. You should also look to produce high key (lit to be largely white with a very small area of deep shadow) and low key (lit to be largely dark in tone with bright highlights).'

4 Photographic projects

Photographic projects

- What story do you want to tell?
- What do you want to explore?
- What do you aim to achieve?
- How will your pictures achieve this?
- Decide on technique – equipment can get in the way – use what is essential for the work.

Ideas come from:

- exploring techniques – camera, lighting, darkroom, manipulation;
- photography of the past and present;
- places and people;
- films, TV, advertisements, magazine stories – how they are shot, what themes do they explore?
- things that go wrong!

Making and taking photographs

- Concentration – focused awareness.
- Precise arrangement of the subject.
- Response as subjects move quickly.
- Encounters with new people.
- Discovery of the unexpected in the image.

Student Experience

Photography year 3

'During the first year I spent time working with different ideas and approaches and it took me until year 2 before I felt that I had something to say. I did a film studies theory course as an option and it dealt with narrative and representation. The lecturer was really passionate about the subject.

'What has developed is an interest in images of women and how body shape is emphasised in the media. So my research led to issues of identity and I became interested in historical practices of how women controlled their body images in order to be 'attractive' or 'beautiful'. This included things like foot binding and corsets, and how demands changed of what was required within different cultures such as Egypt and the Greeks. We are bombarded with images of celebrity body parts and so I decided to print images above life size onto fabric, of breasts, torsos, bottoms. These are suspended from the ceiling so that you can walk through them. When men walk past they stare – you could call it gawp – at them. Women seem to be intrigued and are drawn to the statement of intent and the title of the work: 'Fat bitch'.'

Student Experience

Photography year 3

'I have become interested in working in the advertising area as I like to be able to control the main elements in the images I produce. Last summer I worked as a second assistant to a photographer who worked both on location and in the studio.

ACTIVITY 21.1 Considering your interests

Having read the chapter on photography you may be engaged by the characteristics and requirements in working in this area of practice. You may wish to evaluate your subject and media interests as part of a self-assessment.

Photography interests me because...

I am suited to working in this area of study because...

References

Cotton, C. (2004) *The Photograph as Contemporary Art*. London, Thames & Hudson, p. 7.

Wells, L. (ed.) (1997) *Photography: a critical introduction*. London, Routledge, p. 3.

Williams, V. and Bright, S. (2007) *How We Are: photographing Britain from the 1840s to the present*. London, Tate Publishing, p. 8, exhibition catalogue.

22 Product and industrial design

Product design consumer products home accessories furniture packaging sustainable design service design branding design manufacture liaison people experience research and innovation ergonomics and styling engineering and computer aided design model making and prototyping design strategy

Industrial design new product design, emerging technologies, design to manufacture, technical problem solving, product detailing computer aided design materials and technologies system design (what is required such as components interfaces to meet specific requirements, often applied to computer systems) service design (components of a service, people infrastructure design to improve quality and efficiency of using the service (transport is the service delivered through a system of trains and buses) interaction design, (complex technologies and systems that a user interacts such as electronic and communication systems)

In this chapter you will cover:

1. discussion of the ideas, concepts and practices within product and industrial design
2. students talking about their backgrounds and experiences.

1 Ideas, theories and contexts

*'As a product design consultancy we at Hyphen are human-focused
3-dimensional problem solvers...mechanical solutions or interface that
makes a product intuitive or pleasurable to use...attuned to the
emotional and psychological responses people have towards
products in their environment.'*

www.hyphendesign.com.services.htm

*'Seymourpowell's initial undertaking for Nokia ...took the form of a 10 year
future scenario report, predicting many advances in the industry, including
multi-media...building in music and cameras...The project looked at
social trends and emergent behaviour and considered how different
markets and cultures had differing needs from technology leading
finally into a series of themes and ideas.'*

www.seymourpowell.com/casestudies/view/17

*'Highly skilled engineers and designers get involved with many projects
at the design stage guaranteeing a smoother and cost effective transition
to manufacturing...'*

www.thompsonprecision.co.uk/

*'We shape ideas, making them into successful products from idea
generation, industrial design, prototyping, testing and engineering for
production – our business is product design and it is about creating reality.'*

www.firsthanddesign.co.uk/

2 Product design and industrial design practice

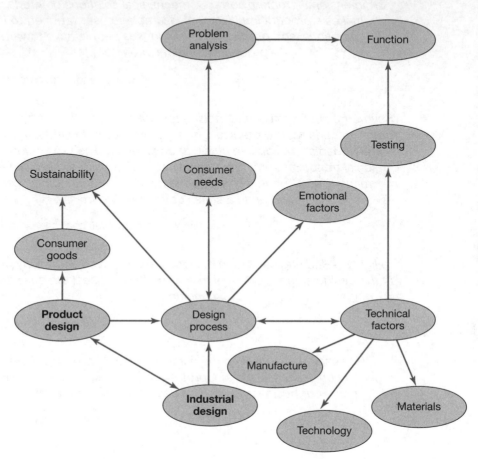

3 Product design and industrial design education

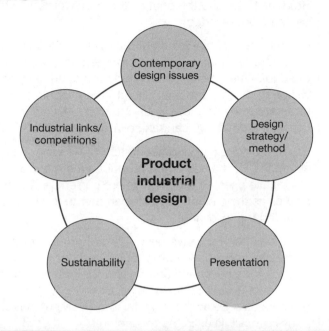

Student Experiences:

Project review/seminar year 1

Performance and production project: torch design

Phase 1: Research

Students are required to answer the following questions:

Use: Who, when, why, where? When in use & not in use?

Technology: Function, components, how will it be made, how many, are there alternatives?

Option: Ease, instructions required? Does it look fir for purpose and value for money?

Submission: Annotated photographs, drawings of existing product showing components, process tree of manufacture, storyboard showing product in use. Summary for ambitions for re-design – improvements

Week 2 of project

Lecturer: 'Initial comment on project so far.'

Student 1: 'I found the brief as it is was worded a little confusing. It seemed long-winded.'

Lecturer: 'I will have a look at that, but in my defence I would say that an important element in design is for the designer to help the client to clarify the brief. Often there will be a meeting at an early stage which primarily will be to present the brief back to the client to ensure that it is clearly understood by both designer and client. As a student it helps to clarify the brief so that you can take ownership of the brief.'

Students make a brief presentation of A2 worksheets setting out possible scenarios for the use of the product, where there was potential for alternative uses, or redesign where current products do not function as well as they might. General comments made by staff and students included the following:

- Stage one of creative design is gathering information – not assuming that we know how a product is used but observing it in use.
- Look for a new need and design for that. No point in redesign if product is successful in its application.
- There may be an incremental improvement in technology or look for new possibilities in the technology.
- Do not jump to design solutions until you have enough information to make a clear case for the redesign.

Lecturer: 'There will be many occasions when you are working on a project and you will not know how something is done, as with medical equipment, for instance, and you will have to observe an existing product or situation when it is in use.'

Phase 2: Ideas development

- Consider ambitions/aims for redesign.
- Connect ideas to need.
- Produce design – 3D drawings that demonstrate the idea as practical, show construction and size and consideration of how the product might be produced (not an emphasis for the project).
- Consider ergonomics – produce a simple foam model for each idea demonstrating shape. From this you can get the feel of the object in the hand. Paint model white so that a judgement can be made of pure form and ergonomics. You do not need to over finish at an early stage – the purpose is to communicate the ideas.

Example of a process tree

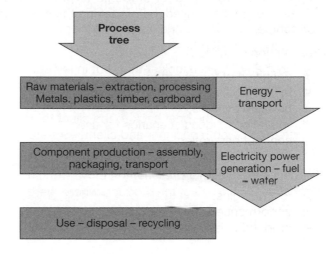

Student review/seminar

Pleasure and wellbeing project year 2

Presented within the context of the four-pleasures framework:

- Physical pleasure – touch, taste, smell – holding the product.
- Social pleasure – bringing status and social identity in use of product, relationships with others.
- Psychological pleasure – cognitive and emotional reaction to using the product, facilitating ease of use and sense of achievement.
- Ideological pleasure – relates to a person's values and how the product reflects them. For example, may reflect environmental concerns, including aesthetics of the product.

Source: Jordan (2000)

The brief

Consideration is required of the social and emotional impact of design aiming 'to make improvements in whatever situation or product' and 'our response to owning and using products'. 'Usability' has been a central issue in the past; now increasingly there is recognition within product design of 'pleasure-based human factors', 'person–product interaction concerned with wider lifestyle issues'. Design needs to fit the 'person's cognitive and physical abilities' but also 'lifestyle and self-image – their hopes, dreams values and aspirations'. And bring pleasure.

'Identify a task or experience that is unpleasant and design with the aim of making it pleasurable or increasing the 'wellbeing' of the user(s).' The target audience must be substantially different to yourself in age, ethnic background, socio-economic status.

Consider the meaning of pleasure... and wellbeing... how they interact.

Purpose of the review is for students to present their design proposition, idea as a response to need, before taking the next stage which is to test out – prototype.

Presentation includes:

- definition of target group;
- task analysis based upon observation;
- problem analysis;
- validation of ideas/scenarios for use;
- concept generation.

Later to include test against stakeholders:

- technologies;
- performance at pre-production;
- production issues.

Students presented scenarios as varied as avoiding spillage and subsequent clearing up for bin men; methods of heating milk for babies; closure of child stair gates; easing a child's experience when visiting the doctor or hospital.

General comments made by staff and students included the following:

- Focus on function and usability, including the emotional level.
- Need to improve or enhance performance – require quantitative evidence to judge if successful.
- Relationship between product and a service system – the system may need to be redesigned and the product forms part of the delivery of the outcome.

ACTIVITY 22.1 Considering your interests

Having read the chapter on product and industrial design you may be engaged by the characteristics and requirements of working in these areas of design. You may wish to evaluate your subject and media interests as part of a self-assessment.

Product and industrial design interests me because...

I am suited to working in this area of study because...

Reference

Jordan, P. W. (2000) *Designing Pleasurable Products*. London, Routledge, pp. 11–58.

Appendices

Appendix 1
Art, design and media glossary

Aesthetic – factors that distinguish taste and beauty, varying according to culture and the experience of the viewer.

Apparatus of viewing – derived from the experience of cinema, viewing film in a darkened space with other people in an audience.

Audience – people who come into contact with a media product. Target audience – the group of people that a media product or an advertisement is intended to reach.

Auteur – indicating the distinctive style of a film director.

Binary opposition or divide – generating meanings within common themes and narrative. Relates to human thought that tends to think in terms of opposites: hot/cold, good/bad, love/hatred (structuralism).

Canon – the inclusion of particular art and artists who are accepted as having been important in the development of any medium and whose works are included in histories or collected by major galleries. Who should be included is open to dispute, for example questions as to why there are so few women artists represented up until the mid to late twentieth century.

Castration complex (Freud and Lacan) – relates to sexuality and gender, with the absence of the penis in women symbolising both difference and lack.

Codes – a set of signs or symbols organised into a system of communication. These are **encoded** through the construction of a series of signs using technical, aesthetic and cultural elements which need to be understood by the viewer so that the message can be **decoded**.

Culture – a common set of values held by a group or society. Used in a wide variety of contexts: 'high/low' culture, popular culture, media culture, multi-cultural.

Deconstruction – postmodern concept challenging generally accepted ways of doing things, as applied in graphics and fashion design. Interpreted in practical media as taking apart elements and reassembling them in a different formation.

Discourse – the development and dissemination of a set of ideas.

Appendix 1 Art, design and media glossary

Ecological design – design that takes into account use of resources and sustainability at all stages (materials, energy, transport, recycling) in the process of production.

Ego – psychoanalytical term concerning sense of individuality and self-esteem.

Ephemeral – a short life, ephemera: designs, objects that are expected to be of value for only a brief time and then discarded. May become collectable after a period of time.

Existentialism – philosophical idea that emphasises the existence of the individual as a free agent.

Feminist criticism – based upon the analysis of images and literature, it highlights the representation of women in 'conventional' roles and 'sexist' imagery.

Fetish – gaining satisfaction and pleasure through substitutes, sometimes obsessive with sexual associations, but can be applied to taking pleasure in an 'aesthetic' experience of an art work (Psychoanalytical theory). Commodity fetish related to satisfaction gained through shopping and consumption of products.

Gaze (or look) – refers to the way in which something is observed. Originates from film theory and men's voyeuristic gaze or **scopophilia** (the pleasure of looking) of women on the screen and how we 'construct our appearance' in relation to the look of others.

Genre – a type of work within the arts or media made to a set of conventions, such as documentary film or action movie.

Global village (McLuhan) – the global dissemination of information through electronic media.

Hybrid – the bringing together of different forms and media in non-traditional combinations.

Hyper reality – 'more real than the real thing': how the reproduced object or event is more convincing and preferable to the original. Simulation – a sign or signifier representing reality (postmodern).

Identity –the set of characteristics by which the self is formed, how an individual 'identifies' themselves. Often associated with gender, ethnicity, race, cultural groups. Idea of fixed identity at birth is challenged with different environmental and media influences creating change (post-structuralism).

Ideology – the set of values and beliefs held by an individual or group. The media is one agent that perpetuates these within a society, as are the government, the church, the education system and others.

Institution – organisation that affect the arts, design and media. Examples include funding bodies, production companies, industrial companies. Alternatively, the conventions, both cultural and political, under which the media product is produced and distributed.

Libido – drive associated with sexual instinct.

Marxism – an ideology that challenges the capitalist way of thinking and consists of two tiers: the base, being economic (means of production, circulation and exchange of goods), and the superstructure, being cultural (the arts, law and religion).

Media technologies – a rapidly changing area of technology, from radio and video to wi-fi, utilised in communication, both mass and personal. This has led to a media and consumer society, with significant effects upon political, economic and individual everyday life. It is studied within cultural, communication and media studies.

Mirror stage (Lacan) – important stage in child development where the child looks in the mirror and becomes aware of self (subject that looks) and an image of self (that of being looked at).

Modernism – of the modern and industrial age, dating from the mid nineteenth century onwards, rejecting the traditions and methods of the past, with an emphasis on progress and innovation. Particular value is placed upon 'high' culture.

Montage – a composite photograph: a constructed image made up of fragments of images (alternative collage); editing of film, style where frequent cuts are made to create a sense of rapid action.

Myth (Levi-Strauss) – ideas about the social world including power relationships and how these may be considered 'natural'.

Narcissism (Freud) – love of self (ego).

Narrative – how a story is told within different structures.

Narratology – relationship between the organisation of content in telling the story and who is telling the story.

Orientalism – perception of peoples of the East who are seen as 'other' and whose cultures were seen as mysterious and exotic but with Western culture considered 'superior' by the West.

Panopticon (Foucault) – a design for prisons used in relation to ideas of surveillance and social control.

Post-colonial theory – recognises the value of differences within diverse cultures and the creative bringing together (hybridity) of different cultural influences.

Postmodernism – after modernism, of the electronic and virtual age: with global communication systems and endless production, reproduction and circulation of images and signs, questioning of the loss of the 'real'. All forms of cultural practice considered worthy of study.

Post-structuralism – after structuralism, questions the idea that meaning and knowledge are systematically formed and that there is a fixed method of analysis of text.

Appendix 1 Art, design and media glossary

Reality – a complex term as applied to photography, film and the media. Questions arise over the image 'representing' the 'truth' of what is in front of the lens, with the potential for selection and manipulation at the making, taking and post-production stages. In film there are different genres such as documentary, Hollywood and social reality in which the material, factual or fictional seeks to connect to the real world. 'Reality' television or 'fictional reality' – a form in which a group of people is filmed continuously as they undertake certain tasks and interact; an edited and constructed presentation is then transmitted.

Semiotics – analysis centred on the generation of meaning through the sign.

Sign – any object, gesture, word, picture, colour that generates meaning.

Structuralism – concerns the structures and conventions by which meaning is communicated through spoken, written and visual forms.

Text – within cultural analysis, the totality of image, words and sound that is studied.

Theory –system of ideas explaining something.

Appendix 2
Educational glossary

Admissions – the university department responsible for the recruitment and processing of applications, arranging interviews and providing up-to-date information on open days and availability of courses. With many Art, Design and Media courses, the decision to offer a place will usually depend upon a combination of qualifications and an interview with a portfolio of practical work.

Admissions tutor – an academic member of staff who takes responsibility for the recruitment and admission of students to courses.

Aims (educational) – general in character, setting out the overall intention to encourage students towards high intellectual and subject-based skills, a positive approach to learning, graduate skills such as communication and organisation, and personal responsibility. These are not assessed directly but are formulated in specific terms through learning outcomes (what a student typically will be able to achieve) for assessment purposes.

Assessment criteria – work produced that is assessed against learning outcomes and aims for a module in terms of the quality of the work.

- **Formative assessment** – a discussion with the aim of providing advice and comment as the work is in progress. This does not contribute to a final grade.
- **Summative assessment** – the mark or grade awarded that indicates the standard of achievement relative to the learning outcomes.
- **Assessment regulations** – a set of academic policies and regulations that governs the conduct of assessment, such as extenuating circumstances and cheating (plagiarism, for instance), Boards of Examiners, external examiners, awarding grades and exit awards (qualification achieved on completion of study).

Clearing – a period in mid August at the point where A level results are published and students who do not have places confirmed on degree courses can make further applications. Universities publish lists of places that are available and applicants are asked to contact them directly. This is a period of intense activity and it is important that you make a considered choice during the limited time available.

Cohort – a group of students studying at one time.

Competences – the ability to undertake a task to a recognised standard.

Coursework – work undertaken as part of a programme of study that may or may not be assessed. Within some Art, Design and Media courses this may constitute the total assessable element.

Credit – awarded for units of modules of study.

Credit accumulation and transfer – where study is considered to be equivalent, it is possible to transfer between degree programmes and universities and use credit previously achieved towards a new degree title. ECTS (European Credit Transfer System) is a Europe-wide system expressed as ECTS Points.

Degree classification – the level of achievement through the accumulation of grades on completion of study, normally based upon the final stages of the degree, such as first-, second- and third-class Honours and non-Honours degrees.

Disabled Students Allowances – provide funding to support learning for students with disabilities and specific learning difficulties.

Entry requirements – qualifications required for entry into a programme of study. These include general educational and subject-specific qualifications, such as Foundation Diplomas and BTEC. Within Art, Design and Media programmes, a portfolio of visual, design and media work is usually required to support the application.

External examiners – people from industry and academia who monitor the delivery and assessment of degree programmes.

Foundation degrees/High National Diplomas – two-year full-time courses including work experience. For certain courses this can allow entry into a degree at an advanced level.

Independent study – the component of study that a student is expected to organise and undertake independent of direct staff supervision.

Learning outcomes – skills that a student will typically have on completion of a period of study. These include:

- knowledge and understanding of the subject area, processes, histories and contemporary practices, professional contexts and organisation;
- intellectual skills – (able to) evaluate debates, critically analyse media artefacts, reflect and evaluate personal practice relative to professional practice;
- practical skills – develop creative work demonstrating competence using techniques and processes;
- transferrable skills – research, formulate arguments, communicate in a variety of forms and to a variety of audiences, work independently, manage time and organise work programme, reflect on personal strengths and identify career goals.

Levels of study – 4, 5 and 6, equating to the number of years of full-time study. Expectation and standards required reflect the time studied.

Modes of delivery – how a course or module of study is delivered: ratio of lecture, seminar, tutorial, workshop and independent study time.

Modes of study or study pattern – range of individual units or components that make up a programme of degree study and the order of their delivery.

Modules

- Compulsory modules have to be undertaken for a given degree.
- Prerequisite modules have to be passed to progress to a further module.
- Optional modules – where there is a choice of modules within a programme of study.

Pathway – some degrees have modules that are common at an early stage but allow for a choice of pathways, such as graphic design or illustration, towards the completion of the degree.

Progression – a student having passed coursework is allowed to progress to a later stage of the course or degree.

Quality Assurance Agency – an organisation that is responsible for 'safeguarding the quality and standards in higher education'. Following consultation with industry, a series of 'benchmark statements' has been produced that describes the qualities that a graduate should achieve in given subject areas, including Art and Design, Communication, Media, Film and Cultural Studies.

UCAS (University and Colleges Admissions Service) – runs the system by which all applications to Higher Education are processed. UCAS tariff points is a system that equates the achievement of qualifications such as A levels, BTEC and Foundation Diplomas in Art and Design to points that are accumulated to a total. This is used to determine whether an applicant is qualified for consideration for entry. Contact UCAS (www.ucas.com) for up-to-date information on all aspects of choice, preparation and application to Higher Education.

Validation – a process by which degree and other programmes of study are approved to run. Staff prepare documents that describe how the programme is to be run following outside consultation. An inspection is made of facilities and resources including staffing, student work and discussion with students.

Appendix 3
Correct English – the mechanics of language

The choice of language will depend on the purpose of the writing. However, it needs to be in a form that is understood, with self-contained sentences that link with other sentences and form into paragraphs that link into an overall structure that develops your discussion.

A **sentence** begins with a capital letter and ends with a full stop, question mark or exclamation mark and centres upon expressing a particular idea. A simple sentence consists of a subject, verb (doing word) and an object, in most cases with an adverb that modifies the meaning of the verb.

> The National Portrait Gallery (subject) exhibits (verb) paintings and photographs of famous people (object).

The test of a sentence is: does it have a subject and a verb?

A compound sentence consists of a double sentence linked by a word such as *and, but, or.*

> The sculptor used traditional materials but the method of construction was experimental.

A **paragraph** is a group of sentences developing a series of related ideas around a particular aspect, theme or topic. The opening sentence should **link** to the previous paragraph and introduce the topic or argument contained within the paragraph. This should be followed by discussion and explanation of this idea with supporting information and examples. The final sentence should sum up the content of the paragraph and introduce the next paragraph. This aids the flow from one paragraph to the next. There is no set length for the paragraph, but two- to three-sentence paragraphs make for fragmented reading, while a whole side of A4 does not give the reader space to pause and reflect on the meaning.

Provide links within the text and indicate how the discussion is developing through *signposting* by using words (such as *initially, furthermore, for example, conversely, in consequence, to sum up*) that are appropriate to create a flow between sentences and paragraphs as you develop your discussion.

Punctuation

The fundamental basis of punctuation is the capital letter at the beginning of the sentence and the full stop at the end. The use of question marks (?) is clear. Exclamation marks (!) are mainly used for emphasis in speech and are rarely used in academic writing.

Capital letters are also used for proper nouns – that is, the name of a person or a place – whereas common nouns do not require a capital letter.

- Common nouns: artist, designer, film director, place, gallery, studio.
- Proper nouns: Barbara Krueger, Vivienne Westwood, Tim Burton, Hollywood, Tate Modern, Leavesden Studios.

Commas

, are used to separate items in lists:

> The key features of postcolonial theory have been described as a representation of different cultures, an acknowledgement of the effects of colonisation, and a celebration of diversity as positive for all cultures.

, are used to join two short sentences accompanied by linking words such as *and* or *but*, and to provide a pause in a more complex sentence:

> The designer was commissioned to produce proposals for the new product. The designs would be developed by the production engineering team.

> The designer was commissioned to produce proposals for the new product, and the designs would be developed by the production engineering team.

, are used to bracket a section of the sentence. The sentence should read correctly without the bracketed section:

> The film *Slumdog Millionaire* (2008) provided an allegorical story, according to some critics, where the characters and plot symbolise a moral dilemma of honesty and virtue in opposition to violence and use of power.

, are used to indicate a gap in the sentence. The sentence would be over-long and repetitive if given in full:

> Some politicians wanted to protect well-known people by creating a comprehensive law of privacy; others, wanted to maintain the freedom of the press to report in the public interest.

> Some politicians wanted to protect well-known people by creating a comprehensive law of privacy: others wanted to protect well-known people by maintaining the freedom of the press to report in the public interest.

Full stop

- is used to separate sentences. Their content is not related:

 The Sensations exhibition was curated by Charles Saatchi. Damien Hurst and Tracy Emin exhibited their work.

Semi-colon

; is flexible in its use and marks a mid point between the comma and the full stop, where the comma is too short a pause and the full stop is too abrupt. It marks a link of some kind between the two statements:

 The Sensations exhibition was curated by Charles Saatchi; Damien Hurst and Tracy Emin exhibited their work.

Colon

: is not used frequently but is useful within more complex sentences. It is placed in the middle of the sentence, where the second part amplifies and demonstrates a relationship with the first part:

 The Sensations exhibition was curated by Charles Saatchi: Damien Hurst and Tracy Emin exhibited their work.

 Because Charles Saatchi curated the exhibition Hurst's and Emin's work was included.

The semi-colon is also used to divide an extensive list following an introduction to the sentence defined by a colon.

 Vladimir Propp made an analysis of folk tales and developed a theory of characters performing particular narrative functions: a hero and a villain; a donor who provides an object with a magical property; the princess who is a reward for the hero, and her father, a person of authority; the dispatcher who sends the hero away to perform a task; and a false hero.

Apostrophe

Used in the singular:

 The illustrator's works…

Used in the plural:

 The group of illustrators' work…

A bracket ()

() is used at the beginning and end of an aside that is not central to the meaning of a sentence and if removed does not alter the overall sense of the sentence:

> Drawing upon his background in art history (not only in the exploration of conceptual theories of art within the practices of photography but also within his writing) Jeff Wall has made a significant contribution to contemporary art. Costello and Vickery (2007)

> Costello, D. and Vickery, J. (eds) (2007) *Art: key contemporary thinkers*, Oxford, UK, Berg, p. 40.

A dash

– is used similarly to brackets to show a move to a related point:

> 'In the 1960s fashion designers such as Mary Quant – drawing upon ideas of youth and the desire for brightly coloured and affordable clothes – received considerable media publicity and became important figures within Pop culture.' Woodham (1997)

> Woodham, J. M. (1997) *Twentieth-century design*, Oxford, UK, Oxford University Press, p. 189.

A hyphen

- is used to link words:

> Twenty-first century companies...

has a different meaning to

> Twenty first century companies...

Inverted commas or quotation marks

" " are used when making a direct quotation from another author;

are used for direct speech with single and double reversible.

The lecturer said "I'm sorry I missed what you said. Was your question 'Could you explain the meaning of post colonialism again?'?"

Accurate grammar

The first stage in checking your grammar is to use the computer's grammar check, but you can check further by reading the text out loud, asking a friend to read it, or using software such as Read and Write.

Subject and verb need to be in the same form:

- They makes should be **They make**
- The film crews was should be **The film crews were**
- The ceramists is should be **The ceramists are**

Verb tenses

Normally the present tense is used when presenting ideas and information because although the original research was published in the past, it is still available now.

Present tense (description)	The artist exhibits globally
Past tense (history)	The artist exhibited last year
Future tenses (to happen)	The artist is to show their work
Future tenses (sets mood)	The artist will exhibit (definitively)
	The artist might exhibit (maybe)
	The artist may exhibit (maybe)
	The artist could exhibit (maybe)

Appendix 4
Tackling an essay project brief

The essay topic

'Advertising is ever present: it pervades every aspect of our lives creating a society based upon dissatisfaction. Discuss the role of advertising in society and its effects upon a specific group of people.'

Highlight key words and words where you are not sure of the meaning.

Advertising pervades every aspect of our lives creating a *society* based upon *dissatisfaction*. Discuss the role of *advertising in society* and its effects upon a *specific group* of people.

Questions to ask

Any words you are not sure of? *Pervades, discuss* – there are different meanings given to the instructional wording in essay questions. Look them up. You will need a good dictionary.

Has there been a lecture or seminar on the subject? Check your notes.

Check the reading list and the library catalogue. It is a good idea to browse the shelves of the appropriate section(s) in the library for a topic of this kind as you will find additional sources as well as the ones that are recommended.

Think about your opinion at this stage – do you agree or disagree with the statement? Do some writing to clarify your thoughts.

What are the factors for or against? List them. Form a mind map, such as the one shown here. This will start to form the basis of key words for your research and reading.

Appendix 4 Tackling an essay project brief

Inspiration software provides a list of the topics developed in the mind map. These can be placed within a logical structure to form an essay plan. There is also a facility to allow notes to be made in relation to each topic and these can be developed into paragraphs. Mind Manager software has similar capabilities.

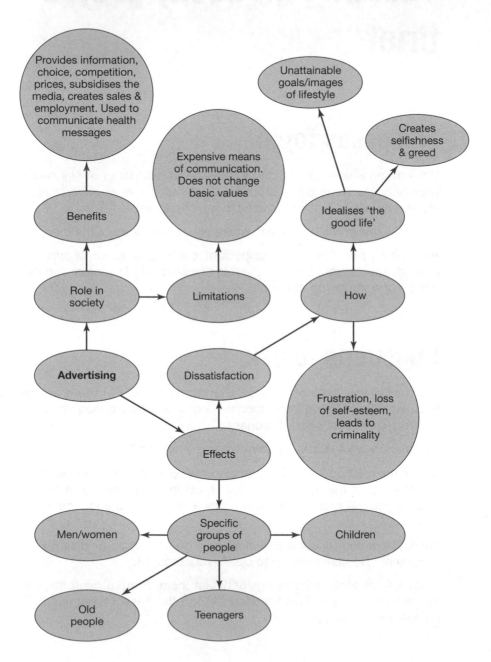

Appendix 5
Essay analysis – assess these examples

This task will take time and you may wish to tackle it in stages, but undertaking a critical assessment of these essays will help you to develop your writing skills.

The brief

This is part of a critical and contextual studies brief that requires an essay of 500 words based upon a lecture series. I have presented three versions based upon student essays that concern the work of the ceramic artist Grayson Perry.

The essay title

'A number of artists and designers explore aspects of their lives in their practice. Make a critical analysis of a practitioner in relation to the reading of their work and their lives.'

First read the section on essay writing. Then I suggest you photocopy each essay and read through and consider the following aspects.

Make a critique of each essay and look for the following:

- Does the essay answer the brief?
- Is there an argument or point of view?
- Is the discussion supported by evidence?
- How are examples or illustrations used?
- Is the structure logical?
- Is the language clear?
- Does the essay keep within the word limit?

Look for:

- quality of research;
- practitioners and contexts of making;

- using appropriate theoretical and critical models as applied to the chosen subject and visual culture;
- analysis and evaluation;
- using reasoned judgements and arguments;
- demonstrating communication skills using academic protocols (referencing and bibliography).

Mark in the margin key points as you read:

- Is the meaning clear?
- Note down any queries you may have.
- Make corrections where you think there is a need for improvement.
- Compare the strengths and weaknesses of the essays.
- Sum up the qualities of the two essays.
- What advice would you give to each of the students?

Sophia's essay

'A number of artists and designers explore aspects of their lives in their practice. Make a critical analysis of a practitioner in relation to the reading of their work and their lives.'

Grayson Perry has become a well known craft artist within the last decade notably for his narrative pottery and ceramic wares showing sexuality, gender and social issues. His work has been both scorned and celebrated for the explicit story telling of his experiences of growing up in rural conservative Essex, and his life as a transvestite man. The pots and wares represent well crafted vases but also tell stories of Perry's past and his social criticism of society.

Perry's childhood was complicated with divorced parents and a stepfather. He lacked affection and abused him and his family. He grew up in an imaginary world with his teddy bear, Adam Measles, as companion and during his teenage years he developed a desire to dress in female clothing. Once his secret was discovered when his sister read his diary he was banished from his father's house and was forced live with his feared stepfather. He went on to explore aspects of his childhood and his transvestite identity through his interest in art and ceramics.

The combination of traditional technical skills, classic pottery forms and luscious glazes and collage of images of sex, gender, and social commentary represent a dialogue between the conventions of traditional and contemporary ceramics. (Buck 2002 p.93) Perry chooses to practice traditional coiling techniques with classic shapes with an important influence on an imaginary world depicted in the shocking, disturbing and emotional narrative work of Henry Darger who focuses on the results of child abuse witnessed as a janitor in a hospital.[1]

1 Jones, Wendy, Portrait of the artist as a young girl, London, Vintage Books, 2007 p. 124–125

His use of provocative images began when he studied ceramics at evening classes and he felt the need to offend by using obscene images. Now as a mature artist Perry explains 'I use such material not to deliberately shock but because sex, war and gender are subjects that are part of me and fascinate me and I feel I have something to say about them'. (Buck 44) His first solo exhibition was entitled *Guerrilla Tactics* in 2002 at the Stedelijk Museum in Amsterdam and Perry (2003) confides that he choose this title because 'A lot of my work has always had a guerrilla tactic, a stealth tactic. I want to make something that lives with as a beautiful piece of art, but on closer inspection, a polemic or an ideology will come out of it.' His work has gained recognition rapidly and in 2003 he was awarded the Turner Prize.

Perry's unique narrative pottery remains celebrated for their level of skill in creation and the intense emotional issues he portrays. His symbolically charged imagery leaves the viewer wanting more knowledge about his life and this provides for a greater appreciation and understanding of his work.

467 words

Bibliography

Jones, Wendy, Portrait of the artist as a young girl, (2007) London, Vintage Books,

Buck, Louisa, 1997 Moving Targets: a users guide to British art now, London, Tate Gallery Publishing-

Buck, L (2002) The personal and political pots of Grayson Perry in Boot, M., Buck, L., Wilson, A., (2002) A., Guerrilla Tactics – Grayson Perry, Amsterdam, NAj Publishers in cooperation WITH Stedelijk Museum Amsterdam

Dormer, P., The new ceramics: trends and traditions, 2nd Edition London, Thames and Hudson. Initial only other entries full fore name. No date of publication

Grayson Perry http://en.wikipedia.org/wiki/Grayson_Perry

Perry (2003) Turner Prize 2003 Shortlisted Artists, http://www.tate.org.uk/btiain/turnerprize/2003/perry.htm

Tim's essay

THE WORK OF GRAYSON PERRY

In this essay I am going to describe the work of Grayson Perry who makes beautiful pots and ceramics with images showing aspects of his life. Perry does not throw his pots but makes them with coiling techniques, sketched images sometimes with words scratched on the pot, transferred images from newspapers and personal photos. The glazed pots are very large and show in-your-face stories about him as a child.

The pots I found most visual and interesting was Hot Afternoon in 75, Strangely Familiar, and We've Found the Body of your Child and I will discuss these and they will form the content of the essay. In the lectures we have worked on the theory of the sign and semiotics which is a way of analysing images. A defini-

▶

tion of a signs is '…a gesture a meaning; a signal; a mark with a meaning; a symbol…' and consists of denotation and connotation. (lecture notes)

In Hot Afternoon in 75 the pot is shaped like a flask with a narrow neck and broad base with a drawing of a person in a patterned red dress holding a large model aeroplane the person looks like a girl and is standing in a yellow field, and there is a blue sky and white clouds, there is also a black and white photograph of a persons face and there hair is curly. This pot shows a summer scene which reminds us of the sun and childhood.

Strangely Familiar is shaped in the same way and shows blue figures on a background coloured in pale orange with a collage of scenes of ordinary houses and streets. The figures are drawn and appear naked, and in different sexual poses and these have been described as perverted and pornographic. There are feint words repeating the phrases 'DON'T HIT', 'DADDY DON'T' and MUMMY STOP'. Perry over the years has tried to shock us with the work which is somewhat autobiographical. I find the highly detailed We've Found the Body of your Child the most beautiful pot. It is orangey yellow towards the neck of the pot and is lighter at the bottom. It has a drawn background of trees, houses and factories. There are people walking in what might be snow, a girl is being attacked by soldiers, a baby is dying in the snow, an old woman and a man who's carrying a bag (they might be foreign by the look of them), and an abandoned teddy bear. Across the pot are hand written words such as 'all men are bastards', 'ungrateful little sod' and 'never have kids'. The images are of violence and neglect, sexual abuse and the teddy bear is Perry's from child hood. He called it Alan Measles and it appears in several of his works.

Perry has become well known and he has had many exhibitions and won the Turner Prize in 2003.

480 Words

Jackie's essay

'A number of artists and designers explore aspects of their lives in their practice. Make a critical analysis of a practitioner in relation to the reading of their work and their lives.'

The ceramist Grayson Perry is known for controversial subject matter which relates to his life as a child, violent events in the world, and his experience as a transvestite man. This subject has been chosen to answer the question due to my interest in ceramics and developing aspects of art that make a personal and social comment.

Grayson Perry lived as a child in rural Essex and when his parents were divorced he lived with his father. An important figure in his lonely life was Alan Measles, a teddy bear, who was a much loved companion. As he grew older he developed a desire to dress in female clothes and when this was discovered he was rejected by his father and forced to live with his mother and an abusive step-father. He became interested in art and attended evening

classes where he gained experience of ceramic techniques but used obscene images 'as provocative statements' (Boot, et al, 2002) He has gone on too exhibit widely and in 2003 was awarded the Turner Prize.

The examples of Perry's work that have been chosen for analysis represent different aspects of his life. The pots are similar in form and are made using traditional coiling techniques in producing classic shapes with a surface featuring scraffitio drawing and photographic transfers on luscious glazes. (Wilson 2002 p. 85)).

As the title suggests Hot Afternoon in 1975 (1999) depicts a scene featuring a your person wearing a red dress (Perry) holding a large model aeroplane standing on a yellow ground which appears to be a corn field Looking out from the surface is a snapshot portrait of a mature Perry. The connotations of these images remind us of nostalgic sunny days in the countryside when as children we could escape into an imaginary world of our own creation. There is a major contrast in Wo've Found the Body of Your Child (2000) where white and gold lustre glazes create a cold and wintry urban landscape with Individual scenes depicted: a girl being molested by soldiers; a baby dying in the snow; an abandoned teddy bear; an old lady dressed like a Russian doll and passers-by ignoring the brutality. There are also scrawled phrases making bitter statements: 'all men are bastards', 'ungrateful little sod' and 'never have kids'. It was observed by Ellis (2003, p.215) that 'the preciousness of a well travelled Russian antique. The image is timeless: it could be yesterday or eighty years ago…it has to be Eastern Europe –nowhere else could such horrific grief be met with such fairy tale romanticism.' At the time of making the work there was conflict in this area and the brutality of people to children and each other makes a searing comment on humanity. Another theme in Perry's work centres on sexuality and hypocrisy which is evident in Strangely Familiar (2000). Blue figures in various sexual positions are super imposed on to a background of suburban streets. We can read into this imagery a comment upon people's hidden interest in pornography and what goes on behind their closed doors.

Grayson Perry draws upon his experiences as a child and as a transvestite man living within the contemporary world to make provocative comment on innocence and violence: he explains of his work 'I use such material not to deliberately shock but because sex, war and gender are subjects that are part of me and fascinate me and I feel I have something to say about them.' (Buck 44) While working within a traditional form of art Perry challenges our preconceptions about both his chosen medium of ceramics and the functions of art within a postmodern era.

550 words

Bibliography

Buck, Louisa, (1997) *Moving Targets: a users guide to British art now*, London, Tate Gallery Publishing-

Boot, M., Buck, L., Wilson, A., (2002) A., Guerrilla Tactics – Grayson Perry, Amsterdam, NAj Publishers in cooperation WITH Stedelijk Museum Amsterdam publicity material on publication (no author\) accessed through http://www.studiopottery.co.uk/news_item.php?id=67

▶

Ellis, P., (2003) *100, The work that changed British art*, London, Jonathan Cape, in association with The Saatchi Gallery

Jones, Wendy, (2007) *Portrait of the artist as a your girl*, London, Vintage Books,

Dormer, P., *The new ceramics: trends and traditions*, 2nd Edition London, Thames and Hudson. Initial only other entries full fore name.

Wilson, Andrew, (2002) Grayson Perry: 'General Artist in Boot, M., Buck, L., Wilson, A., (2002) A., Guerrilla Tactics – Grayson Perry, Amsterdam, NAj Publishers in cooperation WITH Stedelijk Museum Amsterdam

Del Vecchio, Mark, Postmodern Ceramics, London, Thames and Hudson

A critique of the essays

This is not definitive and there may be additional points that you might raise with Sophia, Tim and Jackie. None of them has chosen to include illustrations of any examples that are discussed and you may consider that this reduces the value of the material presented.

Sophia's essay

Introduction

'Grayson Perry has become a well known craft artist within the last decade notably for his narrative pottery and ceramic wares *showing* sexuality, gender and social issues. His work has been both scorned and celebrated for the explicit story telling of his experiences of growing up in rural conservative Essex, and his life as a transvestite man. The *pots and wares* represent well crafted *vases* but also tell stories of Perry's *past* and his *social criticism of society*.'

Includes details of the artist's life and why the choice is appropriate to answer the question. Sources should have been referenced.

Argument introduced …well crafted vases…stories…past…social criticism of society.

Choice of words – showing could be featuring imagery. Repetitive use of words pots, wares, vases. Do not need social and society.

Paragraph 2

'*Perrys* childhood was complicated with divorced parents and a *stepfather. He lacked* affection and abused him and his family. *He* grew up in an imaginary world with his teddy bear, Adam Measles, as companion and during

his teenage years he developed a desire to dress in female clothing. Once his secret was *discovered when* his sister read his *diary he was* banished from his father's house and was forced to live with his feared stepfather. *He* went on to explore aspects of his childhood and his transvestite identity through his interest in art and ceramics.'

Describes childhood and origins of themes related to his identity in his work.

Punctuation – apostrophe Perry's. Short sentence – a colon links sentences, provides flow, stepfather: he lacked. Comma brackets a section of a sentence …discovered, when his sister read his diary, he was…

Repetitive use of He, also use of he causes confusion as to who this refers to: Perry, his father or stepfather.

Paragraph 3

'The combination of traditional technical skills, classic pottery forms and luscious glazes and collage of images of sex, gender, and social commentary represent a dialogue between the conventions of traditional and contemporary ceramics. (Buck 2002 p.93) Perry chooses to practice traditional coiling techniques with classic shapes with another important influence on an imaginary world depicted in the shocking, disturbing and emotional narrative work of Henry Darger who focuses on the results of child abuse witnessed as a janitor in a hospital (Footnote)'

Places Perry's work in context, influences from contemporary artists, describes technical issues and demonstrates a range of reading.

Sources are indicated but citation is not correct within Harvard system – Buck indicates page number, not date of publication, Jardin no information given in reference. Footnote used mixing Harvard and numerical systems. Need for consistency.

Paragraph 4

'His use of provocative images began when he studied ceramics at evening classes and he felt the need offend by using obscene images. Now as a mature artist Perry explains 'I use such material not to deliberately shock but because sex, war and gender are subjects that are part of me and fascinate me and I feel I have something to say about them'. *(Buck 44)* His first solo exhibition was entitled Guerrilla Tactics in 2002 at the Stedelijk Museum in Amsterdam and *Perry (2003)* confides that he choose this title because 'A lot of my work has always had a guerrilla tactic, a stealth tactic. I want to make something that lives with as a but on closer inspection a polemic will come out of it' His work gained recognition rapidly and in 2003 he was awarded the Turner Prize.'

Origins of Perry's approach to his work and career and exhibition success. Use of quotations introduced and referenced. (Buck 44) is not complete.

lives with as a this does not make sense: inaccurate transcription of quotation.

Conclusion

'Perry's unique narrative pottery remains celebrated for their level of skill in creation and the intense emotional issues he portrays. His symbolically charged imagery leaves the viewer wanting more knowledge about his life and this provides for a greater appreciation and understanding of his work.'

Conclusion refers back to the question and the introduction.

Bibliography

Jones, Wendy, Portrait of the artist as a your girl, *(2007)* London, Vintage Books,

Date of publication incorrectly placed by Harvard referencing system.

Buck, Louisa, *1997* Moving Targets: a users guide to British art now, London, Tate Gallery Publishing-

Date of publication correctly placed, but should be in brackets.

Buck, L (2002) The personal and political pots of Grayson Perry in Boot, M., Buck, L., Wilson, A., (2002) A., Guerrilla Tactics – Grayson Perry, Amsterdam, NAj Publishers in cooperation WITH Stedelijk Museum Amsterdam

Dormer*, P.,* The new ceramics: trends and traditions, 2nd Edition London, Thames and Hudson. *Initial only; other entries have full fore name. No date of publication.*

Inconsistent citation – it is important to follow an approved system with consistency.

Grayson Perry http://en.wikipedia.org/wiki/Grayson_Perry

Use of Wikipedia as a source is not advised as the information may not be accurate.

Del Vecchio, Mark, (2002) Postmodern Ceramics, London, Thames and Hudson

Not directly cited in the text but demonstrates some background reading.

Sophia has answered the question in providing an account of the life and work of the artist but has chosen not to make an analysis of any individual artefacts. This is a valid approach and there is a clear rationale given that the

*artist is an appropriate choice. There is an argument that seeks to demon-
strate the importance of knowledge of the artist's life and social concerns as
represented in the work.*

Tim's essay

THE WORK OF GRAYSON PERRY

Should not change the title of the essay.

Introduction

'In this essay *I am* going to describe the work of Grayson Perry who makes
beautiful pots and ceramics with images showing aspects of his life. Perry
does not throw his pots but makes them with coiling techniques, sketched
images sometimes with words scratched on the pot, transferred images
from newspapers and personal *photos*. The glazed pots are very large and
show *in-your-face* stories about him as a child.'

*States the nature of the artist's work but immediately starts by describing
the technique used.*

I am – written in the first person.

*does not throw his pots is unnecessary because the coiling techniques are
described.*

Use of beautiful is a generalisation: beautiful to whom?

Photos is an abbreviation.

in-your-face is a cliché and everyday colloquial speech.

Paragraph 2

'The pots *I* found most *visual and interesting was Hot Afternoon in 75,
Strangely Familiar, and We've Found the Body of your Child* and *I* will dis-
cuss these and they will form the content of the essay. In the lectures we
have worked on the *theory of the sign and semiotics* which is a way of
analysing images. A definition of a signs is '...a gesture a meaning; a signal;
a mark with a meaning; a symbol...' and consists of denotation and conno-
tation. *(lecture notes)*'

*First sentence should be placed in the introduction, if it is needed, as the
examples are mentioned by name later in the essay. This appears to be
padding.*

*Personal opinion: **visual and interesting**.*

*was subject and verb same form – should be **were**.*

Brings in course material through a critical model/theory of the sign and semiotics and a definition. This is in inverted commas but sources lecture notes and this indicates that there has been no background reading. Lecturers expect students to broaden their knowledge of the theory through personal research and to demonstrate in the essay how they would apply it.

Paragraph 3

'In *Hot Afternoon in 75* the pot is shaped like a flask with a narrow neck and broad base with a drawing of a person in a patterned red dress holding a large model aeroplane the person *looks like a girl* and is standing in a yellow field, and there is a blue sky and white clouds, there is also a black and white photograph of a persons face and *there* hair is curly. This pot shows a summer scene which reminds us of the sun and childhood.'

Description of an example with the final sentence referring to childhood in general.

*The image of the person **looks like a girl** but there is no indication of the implications of this.*

First sentence very long, could use punctuation.

*there denotes a place; when used to relate to people should be **their**.*

Paragraph 4

'*Strangely Familiar* is shaped in the same way and shows blue figures on a background coloured in pale orange with a collage of scenes of ordinary houses and streets. The figures are drawn and appear naked, and in different sexual poses and these have been *described as perverted and pornographic*. There are feint words repeating the phrases 'DON'T HIT', 'DADDY DON'T' and MUMMY STOP'. *Perry over the years* has tried to *shock* us with the work which is *somewhat autobiographical*.'

Description of a further example with some reference to the example and its origin.

described as perverted and pornographic – this may be so, but who said it and when? There is no source so it becomes a generalisation.

over the years … shock … somewhat autobiographical – generalisation: need to indicate in what way this is the case.

Paragraph 5

'*I find* the highly detailed *We've Found the Body of your Child* the *most beautiful* pot. It is orangey yellow towards the neck of the pot and is lighter at the bottom. It has a drawn background of trees, houses and factories. There are people walking in what might be snow, a girl is being attacked by soldiers, a baby is dying in the snow, an old woman and a man *who's* carrying a bag *(they might be foreign by the look of them)*, and an abandoned teddy bear. Across the pot are hand written words such as 'all men are bastards', 'ungrateful little sod' and 'never have kids'. The images are of *violence and neglect*, sexual abuse and the *teddy bear* is Perry's from child hood. He called it Alan Measles and it appears in several of his works.\'

Description of example.

I find… first person… most beautiful. Personal opinion and of limited value without evidence from other authors.

Fourth sentence very long list – punctuation is needed.

who's abbreviation – should be who is.

they might be foreign by the look of them. This may be the case but what are the implications of this? Does this refer to Eastern Europe during times of civil war?

Fifth sentence links the teddy bear to violence and neglect, sexual abuse without establishing the relationship to each other.

Conclusion

'Perry has become well known and he has had many exhibitions and won the Turner Prize in 2003.'

Single sentence is not an adequate conclusion. New information about Perry's career is introduced and this should have come earlier if relevant.

Tim has written the essay under a new title and this should not be done. As a result the essay does not focus on the relation of the practitioner's life to his work. The essay is largely descriptive, featuring three examples of the artist's work, and could have been written from looking at illustrations of the examples. Are all three examples needed? Could two have been chosen and allowed space for greater depth of analysis? There is no indication when the work was made until the final sentence.

There is no evidence of personal research providing context or analysis, and no bibliography. There is an absence of proper citation so there is evidence for the investigation of plagiarism in the production of this essay. This may be poor studentship, but referencing is fundamental in academic writing.

A theoretical/critical model is mentioned and this is valid, but there is no indication of how this might be applied.

Jackie's essay

'The ceramist Grayson Perry is known for controversial subject matter which relates to his life as a child, violent events in the world, and his experience as a transvestite man. This subject has been chosen to answer the question due to my interest in ceramics and developing aspects of art that make a personal and social comment.'

Introduction

This indicates the approach to the question, provides reasons for the choice of artist and an outline of an argument.

Paragraph 2

'Grayson Perry lived as a child in rural Essex and when his parents were divorced he lived with his father. An important figure in his lonely life was Alan Measles, a teddy bear, who was a much loved companion. As *he* grew older *he* developed a desire to dress in female clothes and when this was discovered *he* was rejected by his father and forced to live with his mother and an abusive step-father. *He* became interested in art and attended evening classes where he gained experience of ceramic techniques but used *obscene* images 'as provocative statements' (Boot, et al, 2002) He has gone on too exhibit widely and in 2003 was awarded the Turner Prize.'

Provides background to the artist's life.

He is repetitive.

Obscene – choice of word open to interpretation; needs to be more specific.

Paragraph 3

'The examples of Perry's work that have been chosen for analysis represent different aspects of his life. The pots are similar in form and are made using traditional coiling techniques in producing classic shapes, influenced by Japanese Satsuma, Imari and Arita ceramics, with a surface featuring *scraffitio* drawing and photographic transfers on luscious glazes. (Buck 75 86).'

Provides reasons for choice of examples, techniques and influences.

scraffitio – use of specialist terminology.

Paragraph 4

'As the title suggests Hot Afternoon in 1975 (1999) depicts a scene featuring a *your* person wearing a red dress (Perry) holding a large model aeroplane standing on a yellow ground which appears to be a corn field Looking out from the surface is a snapshot portrait of a mature Perry. The *connotations* of these images remind us of nostalgic sunny days in the countryside when as children we could escape into an imaginary world of our own creation. There is a major contrast in We've Found the Body of Your Child (2000) where white and gold lustre glazes create a cold and wintry urban landscape with individual scenes depicted: a girl being molested by soldiers; a baby dying in the snow; an abandoned teddy bear; an old lady dressed like a Russian doll and passers-by ignoring the brutality. There are also scrawled phrases making bitter statements: 'all men are bastards', 'ungrateful little sod' and 'never have kids'. It was observed by Ellis (2003, p.215) that this work shows 'the preciousness of a well travelled Russian antique. The image is timeless: it could be yesterday or eighty years ago…it has to be Eastern Europe –nowhere else could such horrific grief be met with such fairy tale romanticism.' At the time of making the work there was conflict in this area and the brutality of people to children and each other makes a searing comment on humanity. Another theme in Perry's work centres on sexuality and hypocrisy which is evident in Strangely Familiar (20000. Blue figures in various sexual positions are super imposed on to a background of suburban streets. We can read into this imagery a comment upon people's hidden interest in pornography and what goes on behind their closed doors.

This paragraph is very long and could have been divided.

Examples are dated. Each example is first described and then a possible analysis of context and meanings is generated. Provides a reason for choice of three examples by discussing the differences in both imagery and concept.

connotations – correct use of terminology

Use of colon and semi-colon in list.

your – typographical error.

It was observed by Ellis (2003, p.215) that this work shows 'the preciousness of a well travelled Russian antique. The image is timeless: it could be yesterday or eighty years ago…it has to be Eastern Europe – nowhere else could such horrific grief be met with such fairy tale romanticism.'

A quotation that adds to the content of the essay and is referenced using the Harvard system. A quotation of this length should be indented.

Conclusion

'Grayson Perry draws upon his experiences as a child and as a transvestite man living within the contemporary world to make provocative comment on innocence and violence: he explains of his work 'I use such material not to deliberately shock but because sex, war and gender are subjects that are part of me and fascinate me and I feel I have something to say about them.' (Buck 44) While working within a traditional form of art Perry challenges our preconceptions about both his chosen medium of ceramics and the functions of art within a postmodern era.'

Links back to the brief and introduction. Provides an indication of the importance of the artist.

(Buck 44) – citation should include publication date and page number.

Buck, Louisa, (1997) *Moving Targets: a users guide to British art now*, London, Tate Gallery Publishing-

550 words – exceeds the word count for the essay, so some editing would be advised to reduce the number of words.

The bibliography should be presented in alphabetical order by author's name.

Jackie's essay provides a coherent discussion, with clear justification for the choice of the examples. There is a combination of a description of the example plus an associated analysis of meaning and context. Relates the work to contemporary and social issues.

Index

Index

Index

Index

materials *see* equipment/materials
Materials Technology Processes module
 93
media 208, 249–59
 activities under title of 250
 definition 191
 ideas, theories and contexts 250–1
 industries and practice 252
 student experiences 255–9
 see also individual caegories
media studies 252
medium 191
medium-term schedules 75
Meecham, P. 163, 164
mind maps 49, 72, 291–2
mirror stage 159
modernism 163, 164–5, 191
 application of concepts 197
module leaders 15
modules 12, 13, 285
 study time devoted to 13, 78
monographs 58
motivations 25–7
movement(s) 170, 191–2
Mulvey, Laura 159
Munch, Edvard
 The Scream 184
myth 183

narrative 184–7
 closed 184
 discontinuous 184
 open 184
narrative function 185, 187
narrative structure 186–7
narratology 184
National Press Photographers
 Association 95
network chart 81
Neurath, Otto 234
newspapers 59
 electronic databases 60
Nexis UK 60
noise 170, 179
note taking 46–50, 101
 benefits and reasons for 46, 50
 lecturer's notes 48
 pattern notes 49

recording source details whilst 106–7
 self-assessment 47
 using a recorder 48
 ways of 48–9, 50
notebooks 63
 writing for 100–1
Numeric Bibliography Footnote system
 115, 117

Oedipus complex 159
online information
 and electronic databases 60
online registration 10
open narrative 184
opposite values 183
organisation 31–2
Orient 162
orientation sessions 10–11
outside organisations, projects for 140–1
overseas students 8, 237, 258–9

Panopticon 161
Papanek, Victor 207
paragraph 113–14, 286
paraphrasing 117–18
parole 168
part-time study 12
passive form 109
pattern notes 49
peer assessment 125–6
Peirce, Charles Sanders 175
permanent employment 139
personal development 20
personal planning 20
personal profile 41–2
photocopying 55
photographs
 citation and referencing of 117
photography 206, 261–7
 education 264
 and genre 193
 ideas, theories and contexts 262
 practice 263
 projects 265–6
 student experiences 264–5, 266
physical context 170, 194
plagiarism 114, 115
planning

Index